HEAR HER VOICE!

Twelve Jewish Women Who Changed The World

MIRIAM P. FEINBERG
MIRIAM KLEIN SHAPIRO

PITSPOPANY

Published by PITSPOPANY PRESS

Text Copyright © 2006 Miriam Klein Shapiro and Miriam P. Feinberg

Cover and Book Design: Zippy Thumim

Editors: Rahel Jaskow and Daniella S. Barak

ISBN Hard: 1-932687-78-5

Pitspopany Press titles may be purchased for fund-raising programs by schools and organizations by contacting:

Pitspopany Press
114 Spruce Street
Cedarhurst, New York 11516
Tel: 212 444-1657 • Fax: 866 205-3966

Distributed in England by: Menasche Scharf • Tel: 44 0845 698 0044

Email: pitspop@netvision.net.il
Website: www.pitspopany.com

MIRIAM KLEIN SHAPIRO *a"h*

In Memoriam

iriam Klein Shapiro's scholarship and devotion to teaching people of all ages guided this project from start to finish. Her untimely and sudden death on August 5, 2005, occurred just prior to finishing the book. Her dedication to the project assured its completion.

Miriam was a person of great dignity, boundless energy, strong values, an ethical and religious role model, and a lover of Israel. She chose the teaching of Torah as her life's work – and she always took that task very seriously. A prominent Rabbi remembered, "She made it clear that teaching Torah kept her going. She was a woman of great integrity who was devoted heart and soul to God, to the Torah, to the Jewish people."

People knew Miriam as someone with very high principles, strong values, and ethical behavior, always standing up for what she believed in. Her dedication and skill as an educator – professionally, as well as in every other aspect of her life – made her a person from whom everyone could always learn. Miriam not only taught her students, but she touched their lives and influenced their life-styles and life-choices. Her students respected and loved her.

"She lived what she talked about. She was speaking out of inner belief and people respected that," reflected a well-known leader in the Conservative movement.

Perhaps the most important of Miriam's accomplishments was her devotion to her family. This role brought her the greatest satisfaction in her life. Her husband of forty-seven years, her five children, her three children by marriage,

her nine grandchildren, and her two sisters and their families were her greatest pride and joy. Her children remember that though she was a person of great dignity until the end, she was also down to earth. "She was a very accomplished person yet was able to let her family poke fun at any foibles. She had a very humorous and playful side."

Together with her husband, she built a Jewish home, gave her children a day-school education and took enormous pride in the fact that they carried on the lessons that she had learned from her parents.

Miriam was devoted to the idea of advancing the quality of Jewish education for women. In an article titled, "A Perspective on Feminism," which appeared in the journal of the Union for Traditional Judaism, she wrote: "Within authentic Jewish tradition, there is a great deal that gives women pride and stature. There is a tremendously satisfying richness of activity for women. ...There are many examples within our tradition of women who are suitable role models for modern women and girls. Unfortunately, these are missing from our textbooks." It was this feeling that prompted her to join me in writing this book.

It is with deep joy and pride, but also with sadness, that I have completed the book, which Miriam Klein Shapiro and I conceived of, struggled over, agreed on and developed, almost to the end. As you read of the lives of twelve extraordinary women and ways that they changed the world, think of the extraordinary life of Miriam Klein Shapiro. Miriam changed all who came in contract with her in wonderful ways that they never imagined possible.

Miriam P. Feinberg

CHANA SARAH ABARBANEL ANCHKOVSKY *a"h*

Dedication

The dedication of this book is to the memory of our great grandmother, Chana Sarah Abarbanel Anchkovsky. She was a woman to admire.

Born in the small town of Grajewo, Poland, in 1851, Chana Sarah survived poverty, pogroms and anti-Semitism by using her wits. She was a descendant of Don Isaac Abravanel (also referred to as Abarbanel), treasurer to King Ferdinand of Spain in the fifteenth century.

Chana Sarah was married to Yisrael Shraga Anchkovsky, with whom she raised their seven children. They taught their children—Libbe, Moishe, Joseph, Louis, Rachel, Fagel and Chaya—to cherish the importance of education, concern for others, and pride in their Jewish heritage.

After Yisrael Shraga died an untimely death, Chana Sarah continued to raise her family according to the standards that she and her husband had established. It was very difficult, but Chana Sarah was a hard worker with a clear vision of the goals she had set for her family.

Chana Sarah immigrated to the United States in the first decade of the twentieth century, making a home in New York City, first for herself and afterwards for numerous other family members. By establishing a bank account in her new country, she was able to sponsor members of her family for their immigration to America. She helped them to adjust to their new life by finding jobs, housing and appropriate spouses. She was a powerful force in facilitating the adjustment to American life for her children, grandchildren, cousins and other relatives. She died in New York in 1926.

Chana Sarah's grandson, Philip Barbanel, remembers that she was so beloved that each of her children welcomed her visits and tried to extend those joyful times together. Her great-granddaughter, Rita Barbanel Schwartz, recalls that family members frequently discussed the fact that although Chana Sarah was a small woman, she was a seen as large because of her "big heart" and memorable character. Her granddaughter, Lilly Bromberg, remembers the wonderful times during her childhood that she spent with her grandmother. "It was a good thing she came to the United States when she did because we know what happened to our family who chose to stay in Poland," reflected Lilly, referring to their deaths at the hands of the Nazis in the 1940s.

The legacy of Chana Sarah's lifetime accomplishments is reflected on each Shabbat when her Sabbath candlesticks are lit by her great-granddaughter, Miriam P. Feinberg.

We remember her name with love, gratitude and pride.

Miriam Klein Shapiro and Miriam P. Feinberg

ACKNOWLEDGMENTS

We thank a great many people for their assistance in helping with the creation of this book. It could not have been completed without them.

Our granddaughters, Vered Sara Feinberg, Briana Yael Felsen, Margalit Meira Kirzner and Yehudit Arielle Shuter, were our readers, providing us with essential feedback throughout the process.

Mordy Feinberg, contributed to the editing of the text.

We are so grateful for and awed by the opportunity to interview two of our extraordinary women, Justice Ruth Bader Ginsburg and Abby Joseph Cohen. They were willing to take valuable time from their busy schedules to meet with us and followed up by reviewing the manuscript, offering us essential insights into our work. We appreciate the efforts of Cathy Vaughn, assistant to Justice Ginsburg, and Ruth Neshamkin, administrative associate to Ms. Cohen, in facilitating those meetings and gathering essential information and materials.

We could not have acquired the wealth of information about Rebecca Reuben without the assistance of her nieces, Nina Haeems, of Ahmedabad, India, a sociologist and Women's Studies instructor at Wilson College in Mumbai, India, and Dr. Sarah Israel of Mumbai.

The help of many kind and insightful librarians, archivists, museum educators, artists and Jewish community workers guided us in all aspects of the work. They are:

Judy Cohen, Caroline Waddell and Maren Read, The United States Holocaust

Museum, Washington, DC; Claudia Ponton, The Jewish Museum, NewYork; Shoshana Dori, Editor, Kvutzat Kinneret Newsletter, Kibbutz Kinneret, Israel; Gila Flam, Ph.D., Director, Music Department and National Sound Archives, Hebrew University of Jerusalem, Jewish National and University Library, Jerusalem; Rena Fruchter, Deborah Kurtz, Beila Organic and Aliza Land, The Partnership for Jewish Life and Learning of Greater Washington, Rockville, Maryland; Sharon Horowitz and Erica Kelly, The Library of Congress; Washington, DC; Yotam Kenneth, Hebrew translator; Rockville, Maryland; Amalya Keshet, Head of Image Resources & Copyright Management; The Israel Museum, Jerusalem; Ina Lerman, The Jewish Federation of Greater Washington, Rockville, Maryland; Steven Petteway, Photograph Collections, Office of The Curator, Supreme Court of the United States, Washington, DC., Jacob Pins, Artist and Art Dealer, Jerusalem; Irit Salmon, Curator, Ticho House, Israel Museum, Jerusalem; Tzvi Schaick, Curator and Historian, and Mayanna Schechter, Secretary, Casa Doña Gracia Museum Hotel, Tiberias, Israel; and Shoshana Shadmi, Archivist, Kibbutz Mizra.

Naomi Shemer's daughter, Lely, graciously reviewed the text and provided invaluable insights and comments. A dear friend, Yehudit Lean, formerly a member of Kibbutz Kinneret, was extremely helpful in sharing her memories of Naomi Shemer. We thank Alice and Moshe Shalvi of Jerusalem who graciously allowed us to use a photograph of their painting of Glückel of Hameln in our book.

We so appreciate the time that, Lilly Bromberg, (Miriam Shapiro's aunt and Miriam Feinberg's cousin) and our cousins Philip Barbanel and Rita Barbanel Schwartz spent reminiscing about our great-grandmother, Chana Sarah Abarbanel Anchkovsky.

Finally, this project was brought to completion as a result of the patient and devoted direction of our publisher, Yaacov Peterseil, and his conscientious and creative general manager, Daniella Barak.

We are grateful to everyone who so diligently and caringly contributed to the completion of this book.

PHOTO CREDITS

TABLE OF CONTENTS

INTRODUCTION

You may not have heard of all of the women included in this book. While some of them are famous, others are less well known. Each chapter describes the life of an extraordinary woman, focusing especially on her special qualities. The women whose stories we have chosen to tell in this book reflect a wide variety of times and places. Each woman's religious beliefs, practices and social background differ from those of the others. What they have in common, however, is that each woman exemplifies Jewish values that can help you as you make choices in your life.

It was not easy to limit our selection to only twelve women from the tremendous number of extraordinary women throughout Jewish history. We hope that as you read about each woman, you will understand why we chose to tell her story. We hope you will think about these wonderful examples of Jewish values as you grow older and make important life decisions.

Deborah the Prophet chose to follow God's direction, eventually leading the Israelites to victory. You will read about her clear vision, strong belief in God, and special ability to convince others to be brave.

Esther and Doña Gracia Nasi were able to think through extremely difficult situations carefully and devise plans in order to save their people, often at the risk of their own lives.

From Glückel of Hameln we learn the importance of being honest in all our dealings with others, even when life is extremely difficult. The integrity that Glückel demonstrated in every aspect of her life makes us understand how essential that value was to her existence.

Hannah Szenes and Golda Meir each had many opportunities to live their lives more comfortably than they actually did. Instead, each one chose to accept the hardships of difficult challenges, believing that she would be able to change the destiny of her fellow Jews.

Both Rebecca Gratz and Rebecca Reuben devoted their lives to creating important Jewish institutions that forever changed the lives of the Jewish people in their worlds. They immersed themselves completely in the task of improving the quality of Jewish life for other Jews. In order to be successful, they chose to be mother, teacher and community leader to a great many in their communities rather than to only a few in their private lives.

Anna Ticho and Naomi Shemer used their artistic abilities to express their love and attachment to Israel, the place in the world that they loved more than any other. The gifts that they left behind remind us of the importance of their contributions to the Jewish people.

We are proud of the accomplishments of Ruth Bader Ginsburg and Abby Joseph Cohen. They have shown us how modern Jewish women can follow their dreams while being faithful to their families, their communities and the Jewish people. They make choices every day, some small and some large, which can affect many others, Jews and non-Jews, throughout the world.

Each woman described in the book is unique in the way she was influenced by her family, the time in which she lived and by the way she chose to respond to those influences. Each woman's story shows how she lived a Jewish life, rich in Jewish values, while remaining free to pursue her cherished dreams.

We cannot predict how we will respond to circumstances in our environment. We know only that we will have choices. We can think about the way we would like to live while being influenced by those we admire.

As you read about each of these women, think about how you will choose to live your life. Can you be strong and intelligent in making your decisions? Will you be willing to undertake difficult tasks to help those whom you love? Will you be able to pursue your interests and talents while remaining true to your people, your family and your core values? Perhaps the choices you make in your life will make you an inspiration to others as you fulfill your dreams.

1 DEBORAH

Judge, Prophet and Military Leader

A Woman to Admire

Deborah appears in chapters 4 and 5 of the Book of Judges, in the Bible, where we are informed that:

Deborah was a prophetess. She judged Israel at that time.

She is one of seven Jewish women prophets mentioned in the Bible. The others are Sarah, Miriam, Hannah, Abigail, Huldah and Esther.

Deborah was a national leader who saved the Israelites approximately three thousand years ago, during one of their greatest times of need. The respect and love that her people felt for her is expressed in her song of victory, which was written after she helped them defeat their long-time enemy, the Canaanites. The people sang:

Until you arose, Deborah, until you arose, a mother in Israel.

This unusual woman helped her people by taking on responsibilities that no one else was willing or able to accept. How did she save the Israelites?

She and Her People

A leader and unifier of all Israel, Deborah was a prophet who spoke in the name of God. All the Israelites recognized this special quality in her and respected

and admired her for it.

Deborah had special abilities that made her people want to listen to her. The Israelites came to her for advice and judgment. She never went out to meet them, but always sat in the same place so that anyone needing her advice would know where to find her. She sat under a palm tree known as *Tomer Deborah* (Hebrew for "Deborah's palm tree"), between two well-known places in the Land of Israel, Beth El and Ramah.

Deborah gave her judgments outdoors under the tree so that everyone could see her and no one could accuse her of doing anything wrong or dishonest. She also wanted to avoid being alone with a strange man in her home since many of the people who sought her advice were men.

Deborah not only gave judgments, but also gave people guidance when they needed to make important decisions. When people came to her for advice, she would help them understand their responsibilities to each other and to their society.

She never accepted payment for her judgments. She was always happy to help her people in this way.

A Nation Divided

When the People of Israel became a nation, they were divided into tribes, each with its own territory. They did not feel like a united people. They often did not care about the concerns of members of the other tribes.

The Canaanites, neighbors of the tribes of Israel, took advantage of the fact that the People of Israel were not united. They attacked the tribes separately, making the Israelites' daily lives difficult and full of fear.

The Book of Judges tells us:

> *...the highways ceased,*
> *And the travelers walked through byways.*

The people were too frightened to walk down the main roads because the enemy might be lurking in ambush, waiting to attack them. They preferred to walk in safety on back roads where they would not be seen.

Life was very difficult for the Israelites because of the attacks of the Canaanites

and the disorganization of the Israelite leaders. We learn from the Book of Judges that

> *The rulers ceased in Israel, they ceased.*

King Jabin ruled the Canaanite kingdom of Hazor. He and his army, led by a general named Sisera, had made the Israelites suffer for twenty years. In desperation, the Israelites cried out to God for help.

The Book of Judges tells us:

> *And the Israelites cried to God, because he [Sisera] had nine hundred iron chariots; and he oppressed the children of Israel terribly for twenty years.*

These iron chariots enabled the Canaanites to control all the major roads and the passages through the valleys.

She Helps Her People

Deborah believed passionately in her people's ability to win a war against their enemies. Even though she was usually a peaceful person, preferring to sit under her palm tree giving judgment and advice to others, she was willing to fight for them if necessary.

One day, Deborah called for Barak, the chief of the Israelite army. She told him:

> *The God of Israel commands you: 'Go to Mount Tabor and take ten thousand men of the tribes of Naphtali and Zebulun with you.'*

Mount Tabor was a well-known mountain with a rounded summit. If soldiers took positions on top of the mountain, they would have the strategic advantage of being able to see on all sides. By spotting the enemy before being seen from below, they could attack first.

Barak knew that Deborah was a prophet who delivered God's message, and Deborah was very convincing as she spoke with him. Still, he knew how hard it would be to lead his soldiers in battle against such a strong and well-equipped army as the Canaanites possessed. What weapons did the Israelite army have

that could stand against nine hundred iron chariots? Would the Israelite soldiers even listen to him?

Deborah continued to press Barak, telling him:

> God said, 'I will bring the captain of Jabin's army, with his chariots and soldiers to you in the Kishon River and I will make you successful.'

Deborah persisted, emphasizing that at the right time, Barak would be able to move his forces down from Mount Tabor and attack Sisera's camps. Then a battle would take place in a Canaanite town called Taanakh, near the river of Megiddo.

In the end, Deborah's efforts were successful. After hearing her inspiring words, Barak was ready to gather his soldiers and go to war. Still, he was not ready to lead the army on his own. He wanted to make sure that Deborah would be nearby. He told her:

> If you go with me, I will go. If you do not, I will not go.

Barak understood that God would be with Deborah and that if he stayed with her, God would protect him too. Barak was not afraid to lead his army. He simply wanted to be in the presence of God.

Deborah assured him:

> I will surely go with you, but then you will not get the honor [of having saved the people of Israel] because you will not go alone. ... God will make Sisera fall by the hand of a woman.

She predicted that the people would believe that she had won the battle. Still, Barak insisted that Deborah stay nearby as he fought.

The Battle

Deborah arose and went with Barak and his army up to Mount Tabor. When Sisera learned that Barak and his army were on the mountain, he thought of how easy it would be for his soldiers to fight the Israelites. It always had been so before. Believing that he would win the battle easily, he called for his nine hundred iron chariots and the Canaanite soldiers.

Suddenly, Deborah ordered Barak:

Arise! This very day, God will deliver Sisera to you [and you will save your people].

She ordered Barak to take immediate advantage of the flooding of the Kishon brook, where Sisera's soldiers were gathered with their heavy iron chariots. If Barak moved down quickly from the mountain to the valley, he would be able to invade Sisera's camps. Since Barak trusted Deborah's advice, he:

went down from Mount Tabor with ten thousand men after him.

The battle took place at the Kishon brook.

God threw Sisera and all his chariots and army into a panic.

Sisera's chariots sank deep into the muddy earth, unable to move. Now the Israelite army, with its lighter weapons, moved quickly, defeating the Canaanites as they remained stuck in the mud of the Kishon brook. They overcame the chariots and Sisera's army. It was clear that the Israelite army would win this battle, and indeed, the Israelite soldiers killed the entire Canaanite army that day.

Sisera Flees

All, that is, except one. Sisera leaped from his chariot and fled on foot. With no soldiers to help him, he looked around for a safe hiding place. Where could he go? Suddenly he noticed a tent and thought that it might be a good place to hide.

A woman named Yael lived in that tent. She was a member of the Kenite tribe, a non-Israelite group who were friendly with the Israelites. When Yael looked outside and saw Sisera running away from his defeated army, she recognized him as the leader of the Israelites' enemies.

Yael invited Sisera into her tent, saying:

Come in, Sir. Do not be afraid.

The Kenites were also friendly with the Canaanites, so Sisera was not afraid to enter. Yael's tent seemed like a safe place for him to hide and regain his strength. When he entered, Yael gave him a blanket to cover himself. She seemed to be showing him kindness.

Sisera said:

> *Please give some water because I am thirsty.*

Instead of water, Yael gave him milk and offered him a place to rest. After Sisera drank the milk, he became sleepy. He was exhausted!

Sisera said to Yael:

> *Stand at the door of the tent, and if any man comes and asks you, 'Is anyone here?' say 'No.'*

Perhaps he knew that the Israelites had seen him running away.

As Sisera lay down and fell into a deep sleep, Yael killed him. Then, as she looked outside her tent, she saw Barak searching for Sisera. She called to Barak:

> *Come and I will show you the man you are looking for.*

Barak entered Yael's tent and found Sisera lying dead inside. He realized that because of Yael's courage, the Israelites would not have to fear Sisera's cruelty any longer.

This was the end of the hardship caused by the Canaanite army. Without Sisera and his Canaanite soldiers to harm them, the Israelites were now free. They could live comfortably in their own land. They could travel on their roads, free of danger. They celebrated joyfully.

Her Song

After the victory, Deborah led the women of Israel in her victory song found in the Book of Judges and called "Deborah's Song of Victory." It describes all the events of the battle against the Canaanites. It is believed that Deborah wrote it.

The Song of Deborah praises God and tells of the series of events that occurred from the time that the Israelites were oppressed to Sisera's death at the hands of Yael. The song explains that it was God who helped the Israelites to win the war against the Canaanites, as it says:

> *I will sing praise to the Lord, the God of Israel.*

The Israelites sang and gave thanks to God for having made them successful in

the battle for their freedom. The Book of Judges tells us that:

The people of the Lord went down to the gates.

The Israelites' victory over the Canaanites is considered a turning point. From now on, the Israelites felt brave enough to stand up to their enemies. Never again would they allow others to oppress them. This was the beginning of the permanent decline of the Canaanite kingdom and a forty-year period of peace for Israel.

Remembering Deborah

As a woman judge, Deborah was unique. As a woman prophet, she was unusual. She was skillful in using her special abilities to transmit God's message to the Israelites during their time of distress. Thanks to her forceful personality and strong patriotism, Deborah succeeded in uniting the tribes of Israel into a single nation. Today, approximately three thousand years later, we think about the way Deborah took charge of a near-disastrous situation and changed the direction of the Israelites' history. Has the Jewish people ever known another such leader?

Questions to Think About:

- *Why is freedom so valued by so many people? What freedoms are important to have? What should people do to be sure they have all of those freedoms?*

- *Can you think of modern women who have accomplished the kinds of things Deborah did?*

To Learn More:

- Read a description of the War of Deborah and the Song of Deborah in *The Book of Judges* chapter IV, verse I through chapter V, verse 31.

2 ESTHER

The Queen Who Saved Her People

A Woman to Admire

Esther was a beautiful young woman who was placed in a difficult situation unexpectedly and against her will. Nevertheless, her great patience and careful planning assured a positive outcome for herself, her family and her people. Even though she was fearful at times, she learned to be brave and strong, overcoming challenges for which she could never have prepared beforehand. How could anyone in such a dangerous situation, especially someone so young, have saved so many lives?

Who Was She?

We learn about Esther's life from the Scroll of Esther *(Megillat Esther),* which we read every year on Purim.

> *Esther lived in the city of Shushan with her cousin, Mordechai. ... He brought up Hadassah, that is, Esther, his uncle's daughter; for she had neither father nor mother ... and when her father and mother were dead, Mordechai raised her as his own.*

While her Hebrew name was Hadassah, the name by which she was known—Esther—was Persian. A *midrash* (commentary that explains a Biblical story in greater depth) tells us that Esther's father died before she was born and that her mother died soon afterward.

She Becomes Queen

King Ahasuerus ruled over a large empire that was divided into one hundred twenty-seven provinces. His palace was in the capital city of Shushan.

Ahasuerus was searching for just the right young woman to replace his former queen, Vashti. In an effort to help the King find the most beautiful young woman in the kingdom, his officers suggested:

> *Let the King appoint commissioners in all of the provinces of his kingdom, that they may gather together every beautiful young maiden to Shushan the capital ... [to choose one of them as the new queen].*

The King agreed, and many young women, including Esther, were taken to the palace in Shushan, likely against their will. Although Esther preferred her life at home in Mordechai's care, she knew that she had no choice. If she did not do as the King ordered, she might be put to death.

All of the young women were kept in the palace harem for twelve months before being taken to meet the King. The harem is the women's wing of the royal palace, where the King's many wives and wives-to-be lived.

When Mordechai learned that Esther had been taken to the King's palace, he grew worried. Day after day, he walked as close as possible to the harem, hoping for news of Esther's welfare. When he was able to come close enough to speak with her, he warned her never to tell anyone who her family was, or that she was Jewish. Esther promised to do as Mordechai advised.

The young women in the harem were made to look as beautiful as possible before being taken to meet with the King. For many months they were given make-up, perfume and jewelry to prepare them for the meeting, where each woman hoped to be chosen as Queen.

After seeing all of the young women in the harem, Ahauserus decided that Esther was the best choice. He placed the royal crown on her head, declaring her Queen. In celebration, he gave a banquet for all of his officials and servants, and called it "Esther's Banquet."

As Queen, Esther obeyed Mordechai's instructions, never telling anyone about her family or that she belonged to the Jewish people.

A Problem in Shushan

One day, as Mordechai sat at the palace gate, he heard two of the King's guards, Bigthan and Teresh, plotting to kill King Ahasuerus. He told Queen Esther what he had heard and Esther reported it to the King. When the King investigated the situation and found it to be true, Bigthan and Teresh were hanged.

Soon afterwards, King Ahasuerus promoted Haman, one of his officials, to the highest post in the kingdom. Haman was now permitted to sit on a chair that was higher than those of all the other officials. By order of the King, everyone in the kingdom was required to kneel and bow down before Haman. Everyone obeyed—everyone, that is, except for Mordechai.

The royal servants at the King's gate asked Mordechai:

> Why do you disobey the King's command?

Mordechai did not answer. Although they asked this question day after day, Mordechai still gave no reply. Finally, the servants reported it to Haman, who was terribly insulted and angry. When Haman learned that Mordechai was a Jew, he decided to have every Jew in Ahasuerus's empire put to death. This would be an excellent punishment for Mordechai's insult!

Haman thought up a scheme to kill all the Jews. He told Ahasuerus:

> There is a certain group of people scattered abroad and dispersed among the peoples in all the provinces of your kingdom. Their laws are different from those of every other people. ... They do not observe the King's laws, and it is not good for the King to tolerate them. If it please the King, let an order be given for their destruction, and I will pay ten thousand talents of silver into the King's treasury.

Upon hearing this, the King gave his ring to Haman, giving royal backing to Haman's plan. He told Haman:

> The silver and the people are both given to you to do with as you see fit.

The King's secretaries wrote down the decree and Haman sealed it with the King's ring. Messengers then carried the decree to officials throughout the empire. The inhabitants of all the 127 provinces were ordered to kill all the Jews, young and old, children and women, on one particular day, the thirteenth day of the

twelfth month (the Hebrew month of Adar), and to steal all the Jews' property once they had completed their bloody work.

Delighted that his scheme against the Jews would now be carried out, Haman sat down to a banquet with the King.

But when the order to kill the Jews was announced, the city of Shushan was thrown into confusion and the Jews were shocked. Mordechai tore his clothing, put on sackcloth and sprinkled his head with ashes, the customary Jewish signs of deep distress and mourning. In every province under King Ahasuerus's rule, the terrified Jews wept and prayed.

Her Challenge

Since Queen Esther had not been told of the King's decree, she did not know that the Jews were now in danger of losing their lives. Her sheltered life inside the palace did not allow her to receive news freely from the outside.

Mordechai gave one of Esther's servants a copy of the King's new decree. When Esther saw it, she became terribly upset, but she did not know what to do. Mordechai urged Esther to go to the King and plead with him to save her people. After all, she was the queen! But how could she go before the King uninvited? By the law of the kingdom, if anyone, even the queen herself, appeared before the King without an invitation, he or she could be killed on the spot. What, then, could Esther do?

Esther explained this to Mordechai:

> All the King's messengers and the people of the King's provinces know that if any person, man or woman, enters the King's presence in the inner court without having been summoned, there is but one law for him – that he be put to death. Only if the King holds out his golden scepter to him may he live. Now I have not been summoned to visit the King for the past thirty days.

After learning Esther's response, Mordechai sent her a more urgent message:

> Do not imagine that you, of all the Jews, will escape with your life by being in the King's palace. On the contrary: if you keep silent in this crisis, relief and deliverance will come to the Jews from another source,

while you and your family will perish. And who knows? Perhaps you have been chosen to be queen for just such a crisis.

Now Esther was really afraid. What could she possibly do now, after hearing Mordechai's words? He had said:

And who knows if it was for just such a time as this that you have become royalty.

What if he was right? What if she really had been placed there to save her family and her people?

A Change in Her Perspective

Esther thought about what Mordechai was asking her to do, and about what could happen to her and her people if Haman had his way. She began to think of a plan, and she sent her answer to Mordechai:

Go, gather all the Jews who live in Shushan and fast on my behalf. Do not eat or drink for three days, night or day. My maids and I will observe the same fast. Then I will go to the King, though it is against the law; and if I am to die, I will die.

Mordechai left the palace and did exactly as Esther had commanded.

Her Plan

Now came the next part of Esther's plan. On the third day after she had made her decision, she dressed as a queen, putting on her richest robes, jewelry and cosmetics. Even though the King had not summoned her, she was preparing for a special meeting with him, and she knew that she was taking a terrible risk.

As Esther stood with her two maids in the inner court of the King's palace, she looked especially elegant and beautiful. Even though she was trembling inside, she knew she must not show it, and forced herself to smile.

As she stood facing the King's throne room, King Ahasuerus sat on his throne looking toward the entrance. When he noticed Esther, he must have been furious.

Esther could tell that the King was angry, and she was terribly frightened. What would happen next? She kept thinking of Mordechai's words and knew that she needed to be strong. She could not turn back now. She was the only one who could save her people.

The King noticed how beautiful Esther looked. Suddenly, he was struck by how much he loved her. He stretched out his golden scepter to her, giving her permission to come closer. Esther approached the throne slowly, hardly daring to believe that she had been spared. When she reached Ahasuerus, she touched the tip of the scepter, as was the custom, to show her respect for the King. The King said to her:

> What is your wish, Queen Esther? Even if it is half the kingdom, it shall be granted to you.

Remembering her plan, Esther answered:

> If it pleases the King, let the King and Haman to come to the banquet that I have prepared.

The King commanded his servants:

> Tell Haman to hurry and fulfill Esther's wish.

Then Ahasuerus and Haman came to the feast that Esther had prepared.

Why did Esther prepare a feast? Why did she invite Haman to join her and the King? Esther was waiting for the right time to do what she knew she must do.

Haman's Plan

After the feast, Haman was happy and cheerful. He had been honored as a guest of the King and Queen. He alone had been there with them—no one else!

When Haman came to the palace gate, Mordechai remained seated, never rising or bowing to him. This really infuriated Haman. But he controlled himself as he continued on his way home, trying to think of the best way to punish Mordechai for his disrespect.

When Haman reached his house, he called his friends and his wife Zeresh to talk with him. He bragged to them, telling them about his great wealth, his many

sons and how the King had promoted him above all the officials and the royal servants in the kingdom. In addition to all that, he told them:

> Queen Esther prepared a feast and, aside from the King himself, did not invite anyone else but me. She has also invited me together with the King to another dinner tomorrow. Still, it really irritates me when I see that Jew Mordechai sitting in the palace gate.

Then Zeresh and Haman's friends advised him:

> Set up a gallows and ask the King to have Mordechai hanged on it. Then you can go happily to the feast with the King and you won't have to worry about that Jew Mordechai.

Haman liked this idea, and did as his wife and friends had suggested.

Some Surprises

That night the King could not sleep. He just tossed and turned, until finally he got out of bed and called his servants. He ordered the book of records, in which all activities in the kingdom were written down, to be brought to him. A servant read it to him.

As the servant read, King Ahasuerus learned that Mordechai had been the one who learned of the plan of the King's guards, Bigthana and Teresh, to kill him. When he heard this, he asked:

> What honor or dignity has been awarded to Mordechai for this?

His servant answered:

> Nothing has been done for him.

Just then, Haman entered the outer court of the palace. He was coming to speak to the King about having Mordechai hanged to death on the gallows that he had prepared for him.

The King asked:

> Who is in the court?

Haman had just come into the outer court of the palace to speak to the King about hanging Mordechai on the gallows he had prepared for him, so the King's servant answered the King:

It is Haman standing in the court.

The King then ordered:

Let him enter!

When Haman entered the place where the King sat, Ahaseurus asked him:

What should be done for a man who the King wants to honor?

(The King was, of course, thinking of how Mordechai had saved his life.) Haman wondered:

Who would the King want to honor more than me?

He answered:

For the man the King wants to honor, bring beautiful clothes that the King has worn and a horse on which the King has ridden. Let the man the King wants to honor be dressed and paraded on the horse through the city square, while they say about him: 'This is what is done for the man the King wants to honor!'

When the King heard this, he said to Haman:

Hurry then, bring the King's clothing and the horse, as you said and do this for Mordechai the Jew who sits inside the King's gate.

Haman was shocked, but of course he had no choice but to follow the King's orders. Then he returned home to his wife and friends. Now he was *really* upset! He told them what had happened and how upset he was.

His wife said to him:

If Mordechai is Jewish, you will fail to defeat him.

While Haman's wife and friends were speaking with him, the King's guards arrived and quickly took him to the second banquet that Esther had arranged.

Another Banquet

The King and Haman came to the second banquet that Queen Esther had prepared. Once again Ahasuerus asked Esther:

> *What is your wish, Queen Esther? It will be granted. Even if you ask for half the kingdom, it will be given to you.*

Queen Esther replied:

> *If it please my lord the King, I beseech Your Majesty to save my life and the lives of my people, for my people and I have been handed over to be destroyed by an enemy.*

King Ahaseurus demanded:

> *And where is the one who dares to do such a thing?*

Esther answered, pointing:

> *This is he—the evil Haman!*

Now the King was angry. He left the banquet, too furious to stay there, and walked into the palace garden. Haman, shocked nearly speechless, saw that the King was angry enough to have him put to death.

Haman did the only thing he could think of doing now. He stayed in the room to beg Queen Esther for his life. As she reclined on her royal couch, he threw himself upon it to plead with her. Would she ask the King to spare him?

Just at that moment, the King returned from the palace garden to the banquet room. When he entered, he saw Haman lying on the couch upon which Esther was reclining. Now Ahasuerus was *really* furious!

The King shouted:

> *What are you doing? Why are you lying there with the Queen?*

Haman's End

At that point, one of the King's guards said:

There is a gallows at Haman's house which was built for Mordechai, who saved the King's life.

The King then replied:

Hang him on it!

The guards did as the King commanded.

That very day, the King gave Haman's property to Queen Esther. Then he invited Mordechai to come to see him. Esther had told Ahaseurus how Mordechai was related to her. Now it was safe for her to tell the truth about who she was. She was proud that everyone would know that she was Jewish.

The King was grateful to Mordechai for having saved his life when Bigthana and Teresh had plotted to assassinate him. When he met Mordechai, Ahasuerus showed him his gratitude by giving him the royal ring that he had taken back from Haman.

Now Esther spoke to the King again, this time falling at his feet and weeping. She begged him to cancel the terrible decree to kill all the Jews that had been sent throughout the kingdom.

She Saves Her People

It was a law of the Persian Empire that a decree issued by the King could never be changed. So Ahasuerus wrote a new decree permitting the Jews of the kingdom to gather together and fight their enemies, defending themselves if they were attacked. The new decree was sent to every province in the empire.

On the thirteenth day of the twelfth month (in the Hebrew month of Adar on the day chosen by Haman), in every province and in every city throughout the empire, the Jews fought against anyone who attacked them. The next day they rested from battle.

Queen Esther asked the King to give the Jews in Shushan an extra day, the fourteenth day of Adar, to defend themselves. The Jews throughout the kingdom celebrated Purim on the fourteenth of Adar, but in the walled city of Shushan, they celebrated one day later, on the fifteenth.

Mordechai sent letters to all the Jews throughout King Ahaseurus's empire,

commanding them to observe the fourteenth of Adar every year with a festive celebration. We continue to do so every year to this very day by celebrating Purim on the fourteenth day of Adar. In cities that have walls, such as Jerusalem, Jews celebrate Purim one day later, on the fifteenth of Adar.

Remembering Esther

As the Queen, Esther helped Mordechai when he wrote to the Jews throughout the Persian Empire. She wanted every Jew in the kingdom to know the importance of celebrating Purim. She herself could now be a proud Jew, letting everyone know who her people were.

Esther was courageous, intelligent and careful in her planning. Her faith in God's help gave her the strength to see her plan through to the end.

We remember Esther each year on Purim as we celebrate the success of her plan and her courage in acting in a manner that could have cost her life. We read about her in the Scroll of Esther *(Megillat Esther)* when we celebrate Purim.

Questions to Think About:

- *Have you ever been asked to do something that was quite difficult for you but that you knew would help someone else?*

 Did you not want to do it? Did you? Should you ever consider not doing it?

- *Have you ever been given advice from someone that you respect, but felt that it would be dangerous to follow the advice?*

 What did you do? What should you do in the future?

To Learn More:

Check out this book: *The Megillah: The Book of Esther*, edited by Scherman & Zlotowitz and published by Mesorah Publications, Ltd., 1989.

3 DOÑA GRACIA NASI *a'h*

Stateswoman on Behalf of Jews and Judaism

A Woman to Admire

Cecil Roth, the twentieth-century Jewish historian, wrote about her: "No other woman in Jewish history has been surrounded with such devotion and affection. No other woman in Jewish history, it seems, has deserved it more."

Doña Gracia Nasi was a greatly respected Jewish leader who lived in Europe during the sixteenth century. People were even in awe of her. Many people, Jews and non-Jews, thought of her as almost as a queen. Those who knew her had interesting ways to describe her—"the supreme leader," "the crowned one" and "*ha-gevira*," a Hebrew term referring to a queen or to a wealthy and powerful woman. Many compared her to Deborah, the great woman prophet and judge of ancient Israel. Like Deborah, Doña Gracia Nasi protected her people during difficult times.

Doña Gracia Nasi saved the lives of many Jews. An intelligent and hard-working leader, she believed that it was her duty to do whatever she could to help her people. She used her money and influence to help Conversos escape from the Spanish Inquisition. Conversos were Jews who were forced to convert to Christianity by the Spanish government during the fifteenth and sixteenth centuries or else they were killed. Many Conversos only pretended to be Christian and still practiced Judaism secretly at home, risking death if the Christian authorities discovered their secret. In fact, many Conversos lost their lives for practicing Judaism in secret.

How did Doña Gracia Nasi become so wealthy and do so many courageous things? As a Jew surrounded by Christians, and a woman in a world where men held most of the power, how did she accomplish so much? Hers is a fascinating and unusual story.

Her Childhood and Family

Doña Gracia was born in Lisbon, Portugal, to a Converso family. Although the exact date of her birth is not known, she was probably born in 1510. Like all Conversos, she and her family publicly pretended to be Christians while living Jewish lives in the privacy of their home.

Doña Gracia's parents named her Beatrice de Luna, a name that would have been recognized as Christian in sixteenth-century Portugal. Converso parents gave their babies two sets of names: Christian first and last names when they were baptized in the Catholic church, and Jewish names, which were known only to family members. Beatrice was known within her family as Gracia, which means "grace" in Spanish, and is the Spanish translation of the Hebrew name Hannah.

Later in her life, when she reached a place where she felt comfortable living openly as a Jew, she became known as Doña Gracia. "Doña" was the Spanish title given to a distinguished woman. Eventually, she adopted the Jewish family name of Nasi, publicly expressing her connection to Judaism. But Nasi was not her family's actual surname. The word "Nasi" was a title given in biblical times to an important leader of the Jewish community. Conversos often chose their own family names after they began to live publicly as Jews.

Doña Gracia's parents, Alvaro and Phillipa de Luna, came from Aragon, an area in northeastern Spain. The family was well known in business and international trade and was respected for their importance to the Portuguese economy.

The de Luna family fled from Spain in 1492, when King Ferdinand and Queen Isabella expelled all Spanish Jews who refused to convert to Catholicism. After they left Spain, they were welcomed into Portugal, Spain's neighboring country, because they were willing to pay the Portuguese king for this privilege. Six hundred of Spain's wealthiest Jewish families, including Doña Gracia's, paid an enormous amount of money to live in Portugal.

Several years later, the King of Portugal decided that the Jews could continue to live in his country only if they converted to Christianity. The de Luna family, along with other Jewish families, realized that they had no choice but to convert publicly. Doña Gracia probably had to wear a cross around her neck and be seen in church on Catholic holy days. However, things were different inside her home.

In the privacy of their homes, the de Luna family continued to practice Judaism as much as they could. Doña Gracia's parents were very involved secret Jews. For example, they lit candles on Friday night, but only after they had made sure that no one could see into the house. Her parents' determination that Doña Gracia marry the man who served as a rabbi of the Converso community gives us an understanding of the kind of Jewish life the family must have lived.

Still, it was very difficult for many Conversos to continue being secret Jews from one generation to the next. Many of them continued these secret Jewish practices. After a while though, they began to forget what the rituals were, or why they were doing them.

Doña Gracia's childhood was typical of a girl from an upper-class family. Her family was well known and respected by both the non-Jewish and the Converso communities in Lisbon. Although they had many servants. they were careful to hire only Conversos whom they trusted enough to see them living Jewish lives in their home. Another reason that they preferred to hire Converso servants was that they wanted to provide employment to other secret Jews. Doña Gracia continued her family's practice, hiring Conversos in her own home when she was an adult. The example of her parents' life must surely have prepared her for the generosity to others in the Jewish community that she displayed throughout her life.

Her Education

In upper-class Lisbon society, manners, education, social behavior and beautiful clothing were as important for children as for adults. Like other young girls from wealthy families of her time, Doña Gracia was well-educated. It is likely that her teacher was a Converso tutor who was well known to her family. In addition to her Jewish studies, Gracia also learned Catholic prayers so that she

could continue pretending to be Christian in public. She learned quickly and was exceptionally intelligent.

Can you imagine how confused and anxious Dona Gracia must have felt as she was growing up? She always needed to be on guard, making sure to do and say the right things so that no one would suspect that her family was Jewish. Yet although her double life must have been confusing at times, her Jewish identity as an adult was surely encouraged by her upbringing.

Her Marriage

When Doña Gracia was eighteen years old, she was married to Francisco Mendes, a Converso like herself. As was the custom, her parents chose the bridegroom. Although today it might seem that Doña Gracia would have resented her parents for making such an important decision for her, it appears that she did not. After all, Conversos had to be extremely careful of the way they lived and made decisions. Since Gracia's family was influential and wealthy, they had to make sure that she would marry someone who was at least her equal in wealth and education. Although Doña Gracia could not marry anyone she pleased, it seems that she was happy to marry Francisco.

As a Converso, Francisco Mendes was known by his Christian surname, but his Jewish surname was Benveniste. Francisco was the wealthiest, most sophisticated and best-known merchant in Lisbon. His family was well respected and he himself was brilliant. Like Doña Gracia's family, his family was among the wealthier Jews expelled from Spain who had paid a great deal of money for the privilege of living in Portugal.

Before his forced conversion to Catholicism, Francisco, who was very well educated in Jewish studies, had been known among his fellow Conversos as "Rabbi." They told him: "We would like you to lead us in Hebrew prayers because you do it so well." Francisco's accomplishment seems even greater when we remember that Jewish education was forbidden during this time.

Francisco and his brothers were well educated in other subjects too, and also spoke several languages. Because of their education and talents, they became more and more successful in their family's international business, gaining wealth, recognition and respect.

Although we do not know for certain, we may assume that Doña Gracia and Francisco had two weddings, a private Jewish one at home followed by a very public Catholic celebration, as was typical of Portuguese Conversos. After their wedding, the couple moved to one of the most magnificent streets in Lisbon, living there among Lisbon's wealthiest families.

Her Fear of the Inquisition

Yet as time went by, the Conversos' situation in Portugal worsened. It seemed only a matter of time before the Inquisition that had caused the Jews to flee from Spain would be arriving in Portugal as well.

The Inquisition was a special court of the Catholic Church. Its job was to search for and punish any Conversos who were found practicing Judaism secretly. The Inquisition had the power to put Jews to death and steal all their property. Therefore, Conversos lived in constant fear that someone might question their loyalty to Catholicism. The Mendes and de Luna families had more reason to fear than most because they practiced Judaism in secret and were also well known among non-Jews. They worried that some of their neighbors might notice their Jewish practices.

Several years after their marriage, Doña Gracia and Francisco's daughter was born. Although they gave her the Christian name Ana, at home they called her by her Jewish name, Reyna. Doña Gracia had learned to live two lives, a public one as a Christian and a private one as a Jew. Now Doña Gracia would teach her daughter how to live a double life as a Converso.

When Reyna was only one year old, her father died. Doña Gracia, only twenty-five years old, was now a widow. Feeling lonely and worried for the first time in her life, Gracia wondered what would happen now. "How will Reyna and I survive in Portugal when the King is making it so much harder for Conversos to live freely?" she thought to herself. "And as if that were not bad enough, I know that the King is trying to find a way to take my money. What will Reyna and I do without Francisco? What kind of life will we have?"

It was then that Doña Gracia decided to join Francisco's brother, Diogo, who was living far away in Antwerp, Belgium. "Perhaps it will be easier for Conversos to have a good life there," she thought. Antwerp was among the most

interesting and exciting cities in Europe at the time. The fact that Diogo would be there to help her and her daughter settle in their new city was very comforting to her.

Nevertheless, Gracia knew that she must not leave Lisbon too quickly. If she did, she might be suspected of trying to flee the Inquisition. Then others might suspect her of being a secret Jew. Planning wisely and carefully, Gracia waited for the right time to leave. And that was what she did.

Her Journey

Gracia left Lisbon in 1537, two years after Francisco's death. The city of her birth was now too dangerous for her and her family. Her younger sister, Brianda, and other members of her family left with her to join Diogo in Antwerp. As their ship left Lisbon, Doña Gracia thought: "This was the right decision, and I am so pleased to be taking my family to Antwerp with me."

Brianda's Hebrew name, like that of her niece, was also Reyna. Although she was beautiful, she lacked Gracia's maturity and wisdom. It was said of her: "As wise and mature as Gracia was, so silly and childish was Brianda." As she watched her younger sister, Doña Gracia thought to herself: "I must keep a close eye on Brianda to make sure that she doesn't do anything foolish and get us all into trouble."

From Lisbon, the family sailed upon the Atlantic Ocean to the English Channel. The trip was difficult and the sea was rough. After a twelve-day voyage, the ship docked in Antwerp.

Soon after they were settled in their new home, Brianda and Diogo were married. In due time they had a daughter, whom they named Gracia. At home they called her "Little Gracia" so as not to confuse her name with her aunt's.

Doña Gracia learned about the family business from Diogo, who appreciated her help. She was brilliant, eager to learn and had many wonderful ideas for the business.

At first, life in Antwerp was comfortable. The Mendes home became a center for Converso refugees, who received assistance from the Mendes family. But eventually, the Inquisition began to persecute the Conversos in Antwerp, just as it did in Spain and Portugal. "We must be very careful," Doña Gracia told Diogo.

"We must make sure that the Inquisition doesn't create problems for our family. We need to pay close attention to our surroundings and to people who might try to harm us and take away our family's money." Fearing that non-Jews would become jealous of their great wealth and influence, they became ever more cautious in their private lives and in their business.

Her Life as The Inquisition Spreads

Diogo died six years later, in 1543. To make matters worse, conditions in Antwerp were no longer comfortable for Conversos. The Inquisition had begun taking action against Jews there. "We can no longer stay in Antwerp," Doña Gracia realized sadly. "Life is too dangerous for Conversos here, and the Inquisition is trying to steal our family's money. We need to find a safer place to live."

Doña Gracia then lived in various cities in Europe, moving from one place to another when conditions became too dangerous for herself and her family. At first, she moved to Venice, where Jews were forced to live in a ghetto (the section of a city set aside for Jews) and wear special yellow hats. But Conversos, who were Christian in name, were not required to live in the ghetto. The Mendes family decided to continue living publicly as Christians in order to avoid having to live in the ghetto and wear the yellow hat.

At this time, life in Venice was much more interesting than it had been at any other time in history. Once again the Mendes home became a center for Converso refugees who came to Venice or passed through the city. Feeling that it was her duty to assist these refugees as much as possible, Doña Gracia made every effort to help them, telling her family: "These Jews are looking for a safe place to live, just as we did before we came here. We must help them as much as we can."

Yet after several years, Venice too became a dangerous place for the Mendes family. The Venetian government told them that they could continue to live in Venice only if they behaved like Christians in every way, and gave them one month to decide whether to stay or leave.

Doña Gracia told her family, "We must leave as quickly as possible." But Brianda, who often made foolish choices, said, "I want to stay. The clothes are so

beautiful and life here is so exciting." Doña Gracia answered, "I can't tell you what to do, but I am going to save my daughter and myself and go somewhere safer!"

Her Identity in Ferrara

In 1548, Doña Gracia and Reyna fled together to Ferrara, a nearby, busy city that welcomed Jews and guaranteed them the right to practice their religion openly. Some of the Jews there had been Conversos. Now they were finally allowed to live openly as Jews. Others, who had never stopped being Jewish, were either Italian Jews or Jews who had chosen to flee Spain and Portugal rather than convert to Catholicism.

The Duke of Ferrara welcomed Doña Gracia and Reyna, telling them, "I promise that you will be allowed to live freely as Jews here." He was open to the idea of Jews living in his city, especially wealthy Jews who could bring in trade and prestige. Brianda soon came to realize that the situation in Venice was getting worse for Jews, so she and her daughter came to Ferrara to live with Doña Gracia and Reyna.

In Ferrara, members of the Mendes family were able to use their Jewish names officially. This was a very exciting time for them. They changed their surname to Nasi, and from then on the Converso Beatrice de Luna became known publicly and proudly as the Jewish Doña Gracia Nasi. The members of the Nasi family now living in Ferrara were Doña Gracia, Brianda (who publically adopted her Hebrew name, Reyna) and their daughters, Reyna and Little Gracia. "Now the world may know that we are proud Jews," Doña Gracia said happily.

But soon, even Ferrara stopped welcoming Conversos and Jews. The Inquisition began to pursue them once again, making their lives unbearable. New efforts began to pressure Jews to convert, and the Inquisition made plans to destroy all Jewish books, including Torah scrolls and other sacred writings. As the Inquisition grew stronger in Ferrara, the former Conversos who had begun living openly as Jews there had the most to fear.

Doña Gracia sadly told her family that it was time to move once again. "Life is no longer possible for us here in Ferrara," she said. In August 1552, she, her family, and an enormous group of employees left the city.

Helping Her People

As Doña Gracia began her trip through Europe, she took care of the business that her husband and his brothers had worked so hard and so carefully to develop. She shared a great deal of the profits with needy Conversos whom she met along the way, reminding her family, "We must never forget our fellow Jews and how they suffer from the hardships of the Inquisition."

Doña Gracia did everything possible to help Conversos. She helped them to find jobs and used her money to make the lives of her people more secure. At the same time, she encouraged them to become more involved in Jewish life.

As Doña Gracia moved her family from place to place in her constant search for safer cities, she met with other Conversos. She also met people who lived openly as Jews, some of whom greatly influenced her thinking. From them she learned the importance of publishing Jewish books and of building and maintaining synagogues and yeshivot, centers of Jewish study.

Finding a Safe Haven

For a long time, Doña Gracia had hoped to settle in Turkey, which was part of the Ottoman Empire. She knew that in Turkey she would be able to live openly as a Jew, without fear of punishment. She could not go to Turkey immediately because she still had business to take care of in Italy. But during her stay in Italy, she sent a great deal of her property and business to Turkey, little by little. "I must send as much of my property and my business to Turkey as soon as possible so that the family can move there when we are ready," she thought.

By this time most of Europe was now Christian and controlled by the Inquisition. The Jews of Europe slowly came to realize that Turkey was the only safe place for them. The ruler of the Ottoman Empire, Sultan Suleiman the Magnificent, realized that the European Jews who wanted to move to his empire would bring money and jobs there. The Jews who had been expelled from Spain in 1492 needed a place to live, and Constantinople—present-day Istanbul—would be a good place for them.

The Muslim world of the Ottoman Empire was happy to accept the Jews who had fled Christian Europe. The Sultan welcomed them with open arms into his

enormous empire, which stretched across southern Europe and parts of Asia. The Sultan told his advisers, "It is unbelievable that the King of Spain would expel such talented and wealthy people who brought so much to the Spanish Empire." He thought that Ferdinand, the king of Spain who had ordered the expulsion, was a foolish king. "How can anyone call this Ferdinand wise?" the Sultan asked his advisers. "Look how he has impoverished his own dominions in order to enrich mine." The Sultan could not understand how a ruler of a country could chase away his wealthiest and most talented group of citizens.

Any Jew or Converso from Western Europe who could manage to do so went to the largest cities in Turkey, bringing their skills as craftsmen and arms manufacturers. They taught the Turks how to make firearms, gunpowder and cannons, which were eventually used in battle against those who had persecuted them. The Jews were grateful to have found a safe haven in a place that respected their skills and allowed them to establish a community where they could live as Jews.

In the spring of 1553, Doña Gracia arrived in Constantinople with her daughter, Reyna. Their journey from Italy was slow. Even though they had sent many items ahead, they still carried a great deal of property with them, which made the trip long and difficult. In addition, they did not want to arouse the suspicions of the Italian authorities. Doña Gracia told her daughter: "If they see us taking all of our possessions and money with us, they will find a way to stop us from traveling."

Her Arrival in Turkey

Doña Gracia and her daughter arrived in Constantinople richly dressed, in magnificent carriages and with many servants. Forty armed men came with them to protect them as they made the dangerous trip across Europe. Doña Gracia expected her sister, Brianda, her niece, Little Gracia, and other family members to come to Constantinople later on.

The Jews of Constantinople were excited when they heard that Doña Gracia and her household would be arriving. As her carriages entered the city, they gathered around them, shouting, "Welcome! Welcome!" All the Jews knew how Doña Gracia had helped her people.

Doña Gracia was tremendously relieved to leave the Christian world and to live openly as a Jew. She celebrated her escape from Europe and her safe arrival in Constantinople by contributing a large amount of money to the poor, to public hospitals and to community charities. "At last!" she said. "Finally I can live as a Jew, and now everyone can see who I really am!"

Her Life as Businesswoman and Stateswoman

When Doña Gracia left Lisbon for Antwerp in 1537, she was only twenty-seven years old. She brought money from her business in Lisbon and added it to the profits of her brother-in-law Diogo's successful enterprise in Antwerp. Doña Gracia worked closely with Diogo in the business, contributing her own excellent business skills to its success.

In Portugal, Doña Gracia had learned a great deal about the business by helping Francisco, who ran the Lisbon branch of the Mendes business, which had concentrated mostly on the transfer of money, as banks do today. The company, which was known simply as the House of Mendes, imported spices, sugars, wine, cotton, wood, ivory, rare fruits such as figs and raisins, jewelry and precious stones. The Antwerp branch of the business imported various luxury items from the Far East.

When Diogo died, his will named Doña Gracia as administrator of the business. Doña Gracia thus became the head of one of the wealthiest and most important businesses in Europe.

After Doña Gracia's arrival in Turkey, she continued to be in charge of the entire Mendes business. She ran her family's large overseas trade in wool, pepper, grain, cloth and textiles. She traded with Venice and with other cities in Italy. The business was so enormous that Gracia had her own ships carry the goods, and it was said that she even had them built. Her agents operated all over Europe, employing Conversos wherever possible.

Doña Gracia looked more and more to her nephew, Joseph, for advice and help. Joseph gradually began to travel around Europe in connection with the family business.

Now Doña Gracia had the attention of the most important leaders in Europe. They were eager to do business with her and to benefit from the riches of the

House of Mendes. Various royal families in Europe relied upon loans from Doña Gracia to finance their extravagant life-styles. They treated her much better than they did other Jews or Conversos because they wanted to borrow money from her.

At the same time, the Inquisition was causing great hardship to Conversos and Jews who practiced their religion openly. Again and again, Doña Gracia used her money and influence to delay or prevent the Catholic Church from using its cruel laws to harm the Jews.

Her Dedication to Her People

After Francisco and his brothers died, Doña Gracia made a decision. "I must continue the Mendes family's work on behalf of our fellow Conversos," she thought. "I will do all I can to help them to escape from Portugal and transfer their property so that they can settle in a safe place."

Once the members of the Mendes family succeeded in escaping, they developed an elaborate network throughout Europe in order to help other Conversos to do the same. As Conversos were forced to travel from place to place in Europe, Doña Gracia was constantly involved in organizing their journeys, and helping them with supplies, money and food.

All Conversos, who were also known as "New Christians," were in constant danger throughout Christian Europe. They moved from city to city, including to London, Antwerp and places in Italy. Then, if they were lucky, they traveled to Turkey.

The Conversos' religious life was the same everywhere in Europe. They rested as much as possible on Shabbat, tried to avoid non-kosher food, ate only unleavened bread on Passover, fasted on Yom Kippur, and gathered together in each other's homes for prayers whenever they felt that they could do so safely.

Still, they had to remember that their enemies were always watching. In order to avoid suspicion, they had to attend church Mass regularly and to perform Catholic rituals in public. Though they felt Jewish in their hearts and souls, they did not dare to show that in public anywhere in Christian Europe.

One of the Mendes family's London agents was responsible for bringing

Conversos to the Mendes ships when they stopped at Plymouth or South-ampton in England. When Conversos boarded the ships, they would be told whether they could continue safely to Antwerp, or whether the Inquisition had sent spies to wait for them. Another Mendes representative helped the fugitives find possessions they had brought with them. If Conversos were in need, they received money to help them begin new lives in Antwerp. Once they arrived in Antwerp, Conversos were given jobs in the Mendes family business.

Representatives of the House of Mendes traveled throughout Europe making sure there were safe routes to Italy or Turkey for escaping Conversos. Before they started their journey, Conversos received detailed instructions as to which roads to take and which to avoid, which hotels were safe and where help could be found if necessary. At every stage, the Conversos found people to help them. The House of Mendes helped them transport their property too.

There was probably no other time in history when Jews who were in danger had such a successful plan to help each other until the Holocaust in the twenti-eth century.

Her Support for Jewish Education and Culture

Shortly after Doña Gracia arrived in Ferrara, she began a new tradition of supporting Jewish printing. First, she paid for the printing of Jewish prayer books in Spanish for Conversos who did not know Hebrew. Then she paid for the translation and publication of a Hebrew Bible that has since become known as the Ferrara Bible.

Doña Gracia also financed the publication of other Jewish books that had been translated into Portuguese in order to give spiritual guidance to Portuguese Conversos who had suffered from the Inquisition.

The publication of all of those books would not have happened without Dona Gracia's financial help and encouragement. The Ferrara Converso community was deeply grateful to her.

Once Doña Gracia left Ferrara and settled in Constantinople, she lived a com-pletely open Jewish life. She devoted herself to saving and improving the lives of Conversos more completely than ever before. She was one of the most important

Jews in the Ottoman Empire and the only woman in the history of the Diaspora (the Jewish settlement outside of the Land of Israel) to play such an important role.

In her new home, Doña Gracia continued, openly and uninterruptedly, to work to rescue Conversos from all over Europe. If she received news that pirates had captured Jews at sea, she ransomed them. Jews considered this charitable tradition, known in Hebrew as *pidyon shevuyim*—the redemption of captives—a high priority because it saved lives.

Whenever there was a plague, or if economic conditions threatened the lives of Jews, Doña Gracia sent large sums of money to help them. She gave a great deal of money to hospitals all over the Ottoman Empire. Her main concern was to save Jewish lives, followed closely by her desire to help them learn about their Jewish identity.

Doña Gracia established synagogues and schools and supported scholars, thus ensuring the continuation of Jewish life. She founded a yeshiva in Constantinople and a synagogue alongside it. It became known as "the synagogue of the Señora" ("señora" is the Spanish word for "lady"). This synagogue was well known throughout the Ottoman Empire for several hundred years. The yeshiva that Doña Gracia established was officially called "The Academy of the Spanish Exiles that is the House of the Geveret, Gracia Nasi." *Geveret* is the Hebrew word for "lady."

In Salonica, a city in the Ottoman Empire that offered safety to Conversos, Doña Gracia set up a new synagogue for Conversos arriving from Lisbon. It was called Livyat Hen (The Little Chapel of Grace, referring to Doña Gracia's name). She also established a *bet midrash* (study center) in Salonica for the study of rabbinic literature.

Remembering Doña Gracia Nasi

Doña Gracia's most memorable characteristics were her strong Jewish pride and her quick response to any report of persecution against Jews or Conversos anywhere. When there was a need, no effort was too much and no cost too great for her. For this reason, Jews throughout her lifetime expressed tremendous admiration and love for her, describing her as "adorned with all the virtues,"

"the Lady, crowning glory of goodly women," "the crowned Lady" and "the heart of her people." No written appreciation for a woman such as that of the Ferrara and Constantinople communities appears anywhere else in Jewish literature.

We also remember Doña Gracia Nasi for having worked to establish a Jewish homeland in Tiberias, a city in the north of present-day Israel, located near Lake Kinneret (the Sea of Galilee). She successfully convinced the Sultan of the Ottoman Empire to provide land there for Jewish settlement. At that time, the Sultan controlled the territory of present-day Israel, which was then called Palestine. He was very impressed by Doña Gracia and granted her request to provide land for the Jewish settlement that she proposed in Tiberias

Her influence on the Sultan guaranteed a better life for Jews than was possible for them in Europe. "I want to help all Jews who wish to live there to do so," she told her family.

Doña Gracia was excited by the prospect of a Jewish state in the place where the ancient one had existed. Perhaps she chose Tiberias because Moses Maimonides, the famous physician and commentator on the Torah, had been buried there centuries before.

Doña Gracia arranged for the bodies of her parents and husband to be secretly removed from a Christian cemetery in Lisbon and reburied as Jews in the new Jewish settlement in Tiberias.

Although Doña Gracia hoped to return the Jewish people to the Jewish homeland, not many Jews were willing to settle there. They had found a good life in Turkey, where they could live openly and comfortably as Jews. The Arabs in Tiberias frequently attacked the small Jewish settlement and proved to be a constant source of irritation. In the end, the settlement failed.

Nevertheless, Doña Gracia was successful in keeping the memory of the Jewish homeland alive. Four hundred years later, the Jewish people and the United Nations were ready to accept the establishment of a Jewish state in the ancient homeland, and the modern state of Israel was born.

Doña Gracia Nasi, a wealthy and influential woman, could have used her resources in any way she wished. She chose to use them to help save her people and to strengthen their connection with Judaism.

Questions to Think About:

· *Do you have a Jewish name?*
· *What is your Jewish name?*
· *How is your name connected with Judaism?*
· *Is it a Biblical name?*
· *Is it a Hebrew word connected with the Land of Israel?*

Do some research to find out the origin of your name and its connection to Judaism. Here are some suggestions on how to begin:

Ask your parents, look it up in the *Encyclopaedia Judaica* or find a book of Jewish or Hebrew names in a synagogue library or Jewish bookstore.

· *Are there worthy projects in your community that could use your help?*

For example, could you raise money, collect toys or clothes or volunteer to work for a project that would help needy people.

Spend some time speaking with your parents, your neighbors, your teachers, and your classmates.

Keep a list of the projects, their needs, ways in which they might be helped, and whom to contact should you decide that you would like to help them.

Contact a representative from a project to find out how you can help. Share the information with friends working with you on the project.

To Learn More:

A visit to the Casa Doña Gracia Museum/Hotel in Tiberias, Israel, will teach you a great deal about Doña Gracia Nasi and her life. If you would like to find out more about it, check out the Museum/Hotel's website at http://www.donagracia.com/DonaGracia/DonaHouse/english/index/.

Here is another website to check out: http://sefarad.org/publication/lm/049/html/page46.html/

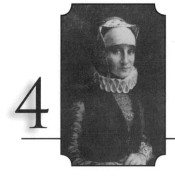

4 GLÜCKEL OF HAMELN a'h

Model of Highest Business Ethics and Jewish Values

A Woman to Admire

"Above all, my children, be honest in money matters with both Jews and Gentiles lest the name of Heaven be profaned." That was the advice Glückel (pronounced "Glickel") of Hameln wrote to her children in her diary.

Have you ever known someone who was so honest that you wished you could be like her? Glückel was one of those people. She told her children, "If you have money or goods that belong to other people, take better care of them than you would if they were your own things." Moreover, she lived that way. She was honest in her business dealings and in her interactions with her husband, with her children and with members of her community. All who knew her respected her ability to show honesty in every part of her life. In the diary that she wrote for her children and grandchildren, we learn how she lived by the wonderful values in which she believed.

Her Childhood And Family

Glückel Pinkerle was born more than 350 years ago, in 1646, in Hamburg. This city in northern Germany is not far from Denmark. Even though Glückel's family lived comfortably, they were not completely happy in Hamburg. Jews were treated poorly there at that time. She wrote in her diary that Jews were considered no better than "chalk, cheese, charcoal ..."

When Glückel was three years old, the Jews of Hamburg were forced to leave their homes. Her family moved to the small nearby town of Altona, which was then under the control of Denmark. Glückel praised the Danish king for always having "dealt kindly with us Jews." Because of his kind protection, Jews were permitted to live there. They traveled to Hamburg for their jobs during the day hours, and returned to Altona as soon as evening came.

When the Jews were permitted to return to Hamburg in 1658, Glückel's father, Lob Pinkerle, was the first German Jew to settle there. Still, Jews had no "right of residence" in that city. They stayed there "purely at the mercy of the Town Council."

In the seventeenth century, Jews in many countries in Europe were forced to ask for special papers and permits of residence. They needed to pay for that permission. They were allowed to live in some cities for long periods. In other places, they were forced out until they paid to renew their residence permit. Many European rulers got money from the Jewish community by making them feel that they would be forced to leave their homes if they did not pay.

Glückel recalled, "From time to time we enjoyed peace and again were hunted forth; and so it has been to this day and, I fear, will continue in like fashion as long as the burghers rule." The burghers were the people who ran the cities of Europe.

Still, the little Jewish community living in Hamburg was very close and took good care of each other. Glückel wrote, "... in general, they all enjoyed a better life than the richest man ..." because they had great respect and love for one another.

Glückel's father was the *parnas*. This Hebrew title was given to the president of the Jewish community. Everyone in the community respected Glückel's father and felt that he deserved to be *parnas*.

Through his work for the community, Glückel's father showed his children the importance of honesty, hard work and caring for one's community and family. He was also a very religious person. Glückel remembered that even though he did not have a great deal of money, "He trusted in the Lord, he left no debts and worked himself to the bone to provide decently for his family."

It was unusual for girls of Glückel's time to be educated, and even many boys did not have much schooling. Nevertheless, this was not so with Glückel.

Her father made sure that she, along with all his other children, received both a general and religious education. She attended school where she learned to read, write and pray. She was an excellent student.

Glückel also learned a lot from her grandmother, who lived with Glückel's family. Among the many things she learned from her grandmother was the importance of being welcoming to visitors to their home. Her grandmother showed her how to help those in need.

Glückel remembered how hospitable her parents and grandmother were when they welcomed to their home ten Jewish refugees from Vilna, which is located in Lithuania today. Those Jews feared being killed by their neighbors in a pogrom (a riot against Jews, which often resulted in death and destruction of property). They had left their homes in Vilna and fled quite a long distance to Hamburg. When they arrived at Glückel's home after such a long journey, many of them were sick. Glückel's grandmother took care of them in the Pinkerle home. She tended to the visitors' needs day and night until they were well enough to leave and continue on their journey.

Glückel loved to listen to her grandmother's tales. She would say "Please, Grandmother, tell me more about your life." Her grandmother would also tell her about how hard life was for Jews of that time in Europe. Glückel, who had a wonderful memory, never forgot anything her grandmother taught her. There had been a war and epidemics of disease. It was dangerous for Jews to do business or to travel to other towns. There were often robbers along the way who would steal their money and other possessions.

She noticed how wonderfully her parents treated her grandmother. They were all so happy to live together. Her grandmother thanked Glückel's father for all he had done for her over the seventeen years that she lived in his home. She made sure to thank him publicly so that others would know how kind he was. For example, he insisted that she sit at the head of the table during meal times. Glückel remembered when her grandmother said to her father, "I have been in your house and you have cared for me as though I were your own mother."

Everyday life in the Pinkerle household taught Glückel important values that stayed with her throughout her life. They influenced the way she raised her children, and her business ethic too.

Her Marriage

When Glückel was barely twelve years old, her parents decided that she should become engaged to a thirteen-year-old boy named Chaim Goldschmidt. In those days, parents arranged marriages for their children at a very young age. Parents who did not arrange early marriages for their children were considered neglectful. Children understood that such arrangements were done in order to make their lives successful by finding appropriate spouses for them.

Two years after the engagement, Glückel and her parents traveled from Hamburg to the small town of Hameln, where they were to meet Chaim and his family for the first time. It was a long and tiresome trip to Hameln. "Carts pulled by horses took us to Hameln," Glückel remembered. After this difficult trip, when the family finally arrived, everyone enjoyed a joyful wedding celebration.

After the wedding, Glückel's parents went back to their home in Hamburg. Glückel remembered: "Immediately afterwards, my parents returned home and left me – I was a child of scarcely fourteen – alone with strangers in a strange world." Can you imagine how hard it must have been for her? However, Glückel said, "It was not hard for me because my new parents made my life a joy. Both dear and godly souls, they cared for me better than I deserved."

During the first year of their marriage, Glückel and Chaim lived with Chaim's family in Hameln. It was quite a different life for Glückel. Until then, she had lived in a bigger Jewish community, in a more sophisticated city. However, even though there were only two Jewish families living in the town of Hameln, Glückel said, "I thought nothing of it because of my father-in-law's piety." Glückel, raised in a religious home, admired this wonderfully religious man. She noted, "Even though Hameln was a dull, shabby hole, I forgot all about Hamburg."

Glückel was delighted with her new husband's religious behavior as well. She wrote in her diary, "Even among the great rabbis, I knew but few who prayed with his fervor."

Chaim did not like living in Hameln. He felt it was too hard to be successful in business in that tiny town. So a year after their marriage, even though

Glückel liked being with her new family in Hameln, they moved to Hamburg, where they lived with Glückel's parents.

Glückel and Chaim had a very happy marriage. They had such deep trust in each other that, as they got to know each other better, Chaim learned to take advice only from Glückel. Before he would do something of importance to the family, he would discuss it with her first. Once, when asked to make a business decision while he was away at a business fair, he responded, "Once home, God willing, we can talk further, and my Gluckelchen [his nickname for her] will be there to give us her sound advice."

Glückel truly admired Chaim. She respected him for his modesty, his patience and his honesty. She recalled that he always set aside a time for study, he fasted on Mondays and Thursdays whenever he could, and he worked extremely hard earning a living for his family.

She wrote in her diary about Chaim, "However hard he worked, and he really ran around doing his business all day long, he never failed to study Torah every single day. Still, with all that he had to do, he was a wonderful father, and he loved his wife and children more than you could imagine." Glückel made sure that her children knew that "so good and true a father one seldom finds and he loved his wife and children beyond all measure."

Glückel wrote of her shock when Chaim died in 1689, thirty years after their marriage. She was only forty-four years old and Chaim was a little older. The youngest of their twelve children was still an infant. Glückel wrote about this terrible time in her diary when she reminisced in moving detail in her diary about her "beloved companion." She admitted, "I truly believe I shall never stop thinking of my dear friend."

Her Family's Business

After moving back to Hamburg, Glückel remembered: "We were both children, young and inexperienced, who knew little or nothing of the business ways of Hamburg." Nevertheless, Chaim was happy to live in Hamburg, a much bigger city, where he was successful in his business. He bought old gold and sold it to jewelers and merchants.

Still, life was hard for the family because Chaim had to travel for his business

quite often. It was common for businesspeople at that time to travel to business fairs in other cities, where they bought and sold merchandise. It would have been very hard for Chaim to support his family without going to the fairs. He traveled to many different cities far away from Hamburg and usually needed to spend several days there in a hotel. Life was not easy. He traveled very often and for long periods of time.

Glückel was very good at taking care of the business in Hamburg while Chaim was away – and even after they had children, she never had trouble taking care of them and the business at the same time. She always worked very hard. Even with all of the work involved, she was happy to work with her best friend on behalf of their family.

Glückel worried about Chaim all the time. His health was not good and it was dangerous for Jews to travel away from home in Europe in those days.

Sometimes it was just too difficult for Chaim to be away from home for long periods of time. Then they hired workers to help them with their buying and selling at the fairs. Occasionally, they were disappointed that a person whom they trusted to do their work cheated them by stealing their money and disappearing. It was painful to them that this would be done by someone they had trusted, especially since they were so completely honest themselves. Still, they never lost faith in others, and they always treated their employees fairly.

Her Honesty

Glückel had worked side by side with her husband, learning all the details of the business. After Chaim died, Glückel was able to keep the business going by herself. But she had many debts to repay. She was so worried about repaying those debts that she made a plan that would help her make payments while having enough income to take care of her children. She estimated the value of the possessions that she would need to sell in order to pay back what she owed. Then she arranged to auction some of her possessions. In this way, she paid all of her debts within one year.

From that point on, Glückel worked harder than ever, thinking constantly about how she could pay all of her bills. It was important to her to live independently without owing anyone money. She did not want her children to

worry about taking care of her. Most of all, she did not want to bring harm to others by owing them anything.

Glückel often needed to borrow money to buy pearls, the business that Chaim had started. If she sold the pearls, she made a good profit. But if she was not able to sell them for some reason, she never failed to repay the loan. In addition, there were times when she lost money in order to repay the loan.

She taught those business practices to her children, too. Once, when her grown-up son found himself in debt in his business, she advised him, "Think of God and of your good and honest father, so that you do not bring our family to shame." Then she made a plan to help her son pay off his debts. She lost a great deal of her own money while helping him, but she knew that it had to be done.

Her Children

Glückel and Chaim had thirteen children. When their first child, Tzipporah, was born, Glückel was still a teenager. Glückel recalled: "I was still a young girl, but luckily, we lived with my parents so my mother was there to help me." Glückel's mother also gave birth to a little girl a week after the birth of Glückel's baby. Thereafter, Glückel and her mother took care of their babies together, which was how Glückel learned to be a mother. Afterwards, Glückel and Chaim had twelve more children.

It was very, very sad for the family when their little daughter, Mata, died. Mata was only two years old and a beautiful child, and Glückel and Chaim mourned terribly. However, the other twelve children grew up to be healthy and successful and made their parents very proud.

Since Glückel and Chaim were always concerned about making sure their children had happy marriages with Jewish people from good homes, they took very seriously the responsibility to find spouses for their children. When Chaim died, eight of their twelve children were still unmarried. The youngest child was only a year old, and some of the others were also still quite young.

Over the next ten years, while she raised her children, Glückel worried about arranging good marriages for them. In those days, when people married, their parents had to give them a certain amount of money with which to start their

married life together. This money was called a dowry, and Glückel worked very hard in order to provide her children with proper dowries.

At the same time, she worked very hard in her family's business. Her activities in her business and in making matches for her children made her a center of the Jewish social life of her time. She traveled often in Germany, France, Denmark, Holland, Austria and Poland either in order to do business or in order to arrange marriages. It was quite dangerous for a Jew, especially a woman, to travel throughout Europe in those days, but Glückel felt that she had no choice. She could rely only on herself to succeed in business or in finding the right spouse for her child.

Her Diary

After the death of her husband and dear friend, Chaim, Glückel decided to write her diary. She was having trouble sleeping because she missed Chaim so much. She thought, "I want to make sure that my children know about my family and Chaim's. I want them to know about the important things in life such as honesty, hard work, and taking care of their families. Maybe I should write something to guide their lives." She wrote to her children that she wanted them to know "from what sort of people you have sprung, lest today or tomorrow your beloved children and grandchildren come and know naught of their family."

Glückel wrote her diary in seven books. It included information about her family, Chaim's family, and the life of the family they created together. She wrote in detail about births, weddings, illnesses and deaths. She wrote about things that had happened and the way she felt about those events and about the people in her life.

Glückel gave important advice to her children. She wanted to make sure that they would value honesty as much as she did. She was also concerned that they remain religious. She wrote, "The best thing for you, my children, is to serve God from your heart without falsehood or sham, not making people think that you are one thing while in your heart you are another." Not only was Glückel honest in her business dealings, but she valued straightforward interactions with her children as well, and she gave them clear directions

for living their lives. "Say your prayers with awe and devotion," she advised them.

Glückel's diary was written in Yiddish, the language of the northern European Jews of her time. It had many Hebrew words and phrases, as well as prayers and quotations from the Bible and the Talmud. She was a wonderful writer, and she used interesting words to give information and express her ideas.

When Glückel began writing her diary in the Hebrew year of 5451 (1690–1691), she could not have foreseen what an unusual document she would create. Her memoirs have since become recognized as an important source of information about the period during which she lived. Because of her writings, we learned a great deal about her life and what life was like during her time. Her diary gives us a better idea of what it was like to be a Jew in Europe at that time than any history book could.

Glückel was a wonderful storyteller and told her stories with lively language. She loved to teach her children through the stories she told in her diary. Sometimes, she made her point by telling stories about kings and princes. She assured them that she would not write a book teaching them how to act, but that she would only let them know what was important to her and about her life as she remembered it.

Sometimes, her stories were about birds. For instance, when she wanted to impress upon her children the importance of honesty, she used the example of a father bird who set out to cross a windy sea with his three fledglings, one by one. When the father bird was halfway across the sea with his first child, he asked the fledgling if he would take care of him in his old age. The little bird replied, "If you bring me to safety, when you are old I'll do everything you ask of me." At this point, the father bird called his child a liar and dropped him into the sea. Then the father bird returned to shore and set out to cross the windy sea with his second child. When they were halfway across, the father asked the same question of this child. Receiving the same answer, he dropped him into the sea. But when he asked the same question of the third child, the little bird answered, "Although it might be wrong for me not to promise to take care of you when you are old, I cannot know for sure that I will be able to do it." This seemed like an honest answer. Then the fledgling continued:

"But I can promise that when I'm grown up and have my own children, I will do as much for them as you have done for me." Upon hearing this, the father carried his child to safety. The telling of this story indicates how important honesty was to Glückel.

Glückel completed the first five books of her diary in 1699. Then there was a long silence. In 1715, she started writing again, and she completed the seventh and final book of her diary in 1719.

The tone of her sixth and seventh books is much sadder than that of the first five. Her last two books tell us how tired she was because of her frequent traveling for business purposes and in order to arrange marriages for her children. It also tells us of her constant worry about failing in business, which would make her dependent on her children's help. Unfortunately, her worst fears came true.

The End of Her Life

In 1700, Glückel married Cerf Levy, the *parnas* of Metz, France. Levy was the richest banker in Lorraine, a city located on the border of Germany and France.

Two years after their marriage, Levy went bankrupt, losing all of his own and Glückel's money. Luckily, he was never sent to prison for not paying his bills. He died in 1712, disappointed and poor. Glückel had struggled through ten years of poverty with him, and lost her money helping him pay his bills.

Still, Glückel refused to give up and move in with her daughter and son-in-law, as they begged her to do. Her independence was very important to her and she never wanted to be a burden to her children. Three years later, she gave in and agreed to live with them, and never regretted her decision. She let it be known she was extremely well-treated in her daughter's home where she was "paid all honors in the world."

Remembering Glückel of Hameln

Glückel of Hameln had a difficult life. She worked hard as a young widow trying to keep her family together. She wanted to raise her children in the

way that she and Chaim had hoped would be possible. After Chaim died, she always felt that it was hard to make enough money for her family's needs or for her children's dowries.

At the end of her life, she hoped that things would improve for her through her marriage to Cert Levy. Unfortunately, her life became even more difficult. In addition to that, anti-Semitism that was common in Europe in her time made her life even harder.

Still, Glückel was lucky in many ways. She had the good fortune to enjoy a wonderful relationship with Chaim, to have caring children, and to have a clear, intelligent mind as a businesswoman and as a writer.

Most of all, those around her were lucky to learn from her the lessons of honesty and the importance of living a Jewish life with high standards. We are lucky to have many examples from her diary of ways to live honestly and caringly with those we love. Her name, Glückel, which means "luck" in Yiddish, can remind us of the kind of person she was.

When Glückel died on September 19, 1724, at the age of 78, she left her diary as a gift to her family and others. We value the information to this day. We are lucky that we can know Glückel and her life through her writings.

Questions to Think About:

- *How much do you know about your family? Do you have information about your parents' families?*

Interview your parents when you can talk with them about their family backgrounds. Have paper and pencil (or tape recorder or video camera) handy. Be sure to let them know ahead of time what your questions might be so that they can think about the answers.

- *Do they know both the Hebrew and the English names of all those family members?*

- *Where did those people live?*
- *What kind of work did they do?*
- *What did they look like?*
- *What were their hobbies?*
- *Do they have photos of those family members?*
- *Do they know some stories about them?*
- *Have you ever considered writing a diary?*
- *What would you include in your diary?*

Buy a small notebook. Plan to write in it on a regular basis—daily, every other day or once a week. Always include a date on your writing. Occasionally, look back on what you have written.

- *Do you know any women who are in business?*
- *What kind of businesses are they in?*
- *Are you interested in being in business?*

If you know a businesswoman personally, ask her what she likes about her work and how she prepared for that profession.

To Learn More:

- Check out this website:
www.jewishvirtuallibrary.org/source/biography/glueckel.html

- Check out this book:
The Memoirs of Gluckel of Hameln, by Marvin Lowenthal and published by Schocken Books in 1977.

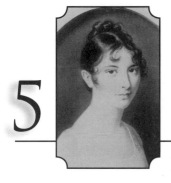

5 REBECCA GRATZ *a'h*

Early American Pioneer in Jewish Education

A Woman to Admire

Rebecca Gratz knew how to make her world a better place and she had the determination to make it happen. She impressed everyone who knew her with her intelligence, concern for others and lovely personality. They saw in her the persistence of one who would not rest until her goals were accomplished. A woman who believed that she could overcome all of life's challenges, Rebecca Gratz used that energy and belief to create institutions to help those in need.

Rebecca Gratz's niece, Sara Ann Mordecai, wrote of her aunt: "True she never married, but she was a mother to the orphan and the destitute, to the friendless and oppressed, to those in poverty and want, and to the sinner and contrite."

Rebecca Gratz was so concerned about helping her fellow Jews to learn about their heritage and keep their Jewish identity that she worked constantly to establish the Hebrew Sunday School Society. The organization she created more than two hundred years ago still exists today as an important part of American Jewish life. What do we know about her that can help us understand her why she made the choices that affected her own life, as well as the future of American Jewish education?

Her Childhood and Family

Rebecca Gratz was born in Philadelphia on March 4, 1781, the seventh of twelve children. Her family was respected in Philadelphia's refined upper-

class society. A beautiful, elegant, cultured and educated young woman, Rebecca was very active among Philadelphia's social and literary upper-class groups.

Rebecca's father, Michael Gratz, was a descendent of many generations of rabbis. He immigrated to Philadelphia together with his brother, Barnard, in 1754. They had come from Selicia (in present-day Germany). They found that Philadelphia, then the capital of the American Colonies, was the most ethnically and religiously diverse of all of the American cities. As Jews, they felt most comfortable living in a city that accepted religious and cultural differences.

The Gratz brothers were successful shippers and traders. They traveled down the East Coast of North America to the West Indies, as well as among Indian tribes farther west. They specialized in the fur trade and did business in Pennsylvania, Virginia, and what today are the states of West Virginia, Ohio, Kentucky, Indiana and Illinois.

Rebecca's mother, Miriam Simon, was from Lancaster, Pennsylvania. Miriam's father, Joseph Simon, had been an important merchant and landowner there, and a leader in Lancaster's tiny Jewish community.

Members of the Gratz family were influential and respected in Philadelphia and throughout the American colonies. Rebecca's parents were so prominent, wealthy and admired that their family portrait was painted by three different leading American portrait artists of the time. In those days before photography, artists painted portraits of those who could afford to pay the high prices required to have it done. More famous portrait artists would certainly have charged a great deal more than those who were not as famous.

The Gratz family owned a large personal library, something that was more common among educated and wealthy people of Rebecca's time. Rebecca's brothers, nephews and nieces were graduates of the University of Pennsylvania and worked as physicians, lawyers, politicians, college professors and in the military. Her older sister, Richea, was the first woman to attend college in America.

It was not simply their wealth that made the Gratz family so famous in the American colonies. They were also extremely generous people who donated

tremendous amounts of money to organizations that helped those in need. They were known in their community as financial contributors and workers for important projects.

Rebecca had a close relationship with everyone in her family. She wrote letters to many of them throughout her life, showing interest in their health, their interests, and their activities. Later, when they married, she wrote to their spouses and children.

As a teenager, Rebecca had a very active social life. She had many friends and was involved in many activities. However, her life changed when she was still a young single woman. She was the only family member who agreed to take care of her father, who had been crippled by a severe stroke. There simply was no one else in the family as capable and available as she was at that time. Her mother had died in 1808, and her siblings were either taking care of their own families or were too young to take charge. She therefore took over the running of the household, including taking care of her unmarried brothers.

Although Rebecca resented her role as family nurse at first, she later came to appreciate it. She participated in the births of twenty-seven of her nieces and nephews and cared for other family members whenever they fell ill. As time went on, she realized how well this role suited her, and she enjoyed helping those around her.

When her sister Rachel died in 1823, leaving nine children and a terribly upset husband, Rebecca took the children into her own home, where she cared for them. Eventually, she took on more and more responsibilities as family nurse and as community organizer. She eventually became a different person from the young, popular teenager who danced at parties.

Her Role as a Literary Model

While no one has ever been able to confirm that this is true, some people believe that Rebecca Gratz was the model for Rebecca of York, the main character in the popular novel *Ivanhoe* by the British writer, Sir Walter Scott. Mr. Scott published his famous novel in 1820. He learned of Rebecca Gratz and her amazing personality from his meeting with Washington Irving, an American author and a friend of Rebecca's. Washington Irving suggested that Rebecca

Gratz would be an appropriate model for Rebecca of York. When Rebecca was asked if she was the model for Rebecca of York, she replied, "They say so," but she never gave any more definite information on this issue.

Her Involvement in Early American Life

Although Rebecca Gratz was completely American in her background, beliefs and concerns, she loved her Jewish heritage. She worked hard to hold on to her Jewish identity as an American. A religious woman, she was always concerned about her Jewish community, just as her parents had raised her to be. She became the first American Jewish woman known for her own accomplishments rather than for those of her husband.

Members of the Gratz family kept strictly kosher homes and held onto Orthodox Jewish traditions as much as possible. At the same time, they always felt completely accepted by their non-Jewish fellow citizens in the newly-established United States of America. Like other American Jews, they were delighted to be citizens of their new country and they worked hard to earn its privileges.

The period during which Rebecca lived was known as the Era of Good Feeling. During this time, the small group of Jews in the United States lived well. They were accepted by their neighbors, and many of them enjoyed financial prosperity. They showed their love for their new country by donating money to the Revolutionary War effort and that of the War of 1812, and by fighting in those wars. During the American Revolution, some Jews fought against the British in almost every land campaign.

During the next several decades, American Jews continued to serve as good citizens by protecting their country's freedom. Members of the Gratz family supported their new country in any way that was needed, both by making financial contributions and by serving in the army.

In August 1814, the British Navy landed an expeditionary force in Chesapeake Bay, in the present-day state of Maryland. They then captured and burned some parts of Washington. They tried to capture Baltimore the following month, yet were unsuccessful because of the heroic defense of Fort McHenry. This inspired Francis Scott Key to write the words of the United

States of America's national anthem, "The Star-Spangled Banner." Some forty Jews participated in the defense of Fort Mc Henry.

The events in Washington and Baltimore frightened Philadelphia's residents. Under a real threat of invasion, the residents of Philadelphia worked frantically to strengthen the city's defenses.

Rebecca worried continuously over the hardships and dangers that her brothers faced in the army. She wrote to her brother Benjamin, the sibling with whom she was closest, now a soldier in the American army, "I hope it will be in your power to come home for a short visit."

It is clear that her brother was committed to serving his country in whatever way was possible when Rebecca wrote to him: "Your military zeal is very fine but I hope your wishes will not prevail — an armistice would be more glorious to the country than all the laurels heroes can gather. ... I sincerely hope we shall see you ere long."

Her Prospects for Marriage

When Rebecca was in her early twenties, she became a very close friend of a successful Philadelphia lawyer, Samuel Ewing, whose father was the president of the University of Pennsylvania. Rebecca and Samuel went together to the City Dancing Assembly on Washington's Birthday in 1802.

Rebecca therefore chose to befriend Samuel Ewing. However, when their friendship turned into love, each felt that it was impossible to consider marriage. Rebecca was deeply committed to Judaism and Samuel was equally committed to his Christian faith. Rebecca wrote to her dear friend, Mrs. Ogden Hoffman, in 1817: "I believe it is impossible to reconcile a matrimonial engagement between persons of so different a creed, without requiring one or the other to yield."

Rather than marry outside her religion as two of her brothers had done, Rebecca chose not to marry at all. Perhaps she was thinking of her brothers, who had married Christian women, when she wrote to her friend: "In all instances we have heard of in real life, this has been the case and where a family of children are to be brought up, it appears necessary that parents should agree on so important a subject."

Rebecca's decision was also supported by series of intermarriages involving Jews, including some of her own relatives, which upset the Jewish community terribly. If Rebecca chose to associate only with Jews her own age, her friends and social life would have been extremely limited since she lived in such a small community of Jews.

Rebecca's commitment to family and community and her devotion to living a Jewish life were more important to her than marrying a non-Jewish man.

Samuel Ewing married in 1810. He is known to have told his wife that he had deeply loved Rebecca Gratz and that only the difference in their religions had kept them apart.

Rebecca lived at a time when it was expected that women would devote their lives completely to their husbands and children. She certainly could have chosen to go in that direction, especially after her father's death in 1811, when she was no longer had to take care of him. Her beauty and charm would have made her very attractive to young, single men. Her choice to remain unmarried must have been surprising to outsiders. However, this beautiful young woman with the lovely and caring personality chose not to intermarry.

Instead, she chose to direct all of her energy to her charitable work, devoting herself completely to helping those in need. She transferred her concerns from love and marriage to her work on behalf of the Philadelphia Jewish community, explaining: "There appears no condition in human life more afflictive and destructive to happiness & morals than ... an ill-advised marriage."

Her Charitable Causes

Members of the Gratz family were known to be generous with their time and money when it came to helping build their community and their new country. They helped establish the first Philadelphia synagogue, Congregation Mikveh Israel, which still exists today in Philadelphia.

The Gratz family also paid for the founding of Gratz College, which is the oldest independent American college of Jewish studies that accepts Jews from all religious backgrounds. Located in Philadelphia, Gratz College continues to offer outstanding Judaic higher education to this day.

At the end of the eighteenth century, many citizens of Philadelphia became concerned with helping the needy. However, it was not easy for Jews to become part of those efforts. The organizations that helped the less fortunate were run by religious Christians who were interested in converting others. When charitable groups not connected to any specific religion were finally formed, Jews quickly joined them. The enthusiasm of Jewish women in these organizations was extremely impressive. At last they, too, had an opportunity to contribute meaningfully to their new community and country.

Eight Jewish women, including Rebecca, her mother, her sisters and several friends, together with twelve non-Jewish women, helped to found the Female Association for the Relief of Women and Children in Reduced Circumstances in 1801.

This was the first time that Rebecca joined an organization to help the less fortunate. Only twenty years old at the time, she devoted herself completely to this cause, as she did with all of the causes in which she became involved throughout her life.

Later, she became involved in several organizations to which she continued to devote her energies. In 1815 she helped to organize the Philadelphia Orphan Society, a private organization with no religious connection. Its members worked to educate poor, orphaned children and gave them a place to live. The children stayed in the orphanage until adoptive homes could be found for them.

Rebecca was a board member and secretary in the organization from 1819 until her death in 1869. After her death, it was recorded that "To her energy and ability, during the struggling infancy of the Society, and to her admirable administration of its expenditures, much of its prosperity is due."

During the autumn of 1819, several Jewish families in the community had difficulty supporting their families. Rebecca and several of her friends learned about this situation. With Rebecca as their leader, the women of the leading families of Congregation Mikveh Israel decided to help in any way they could. As a result of this decision, Rebecca helped to establish the Female Hebrew Benevolent Society. Her strong ties to her synagogue and Jewish community prepared her to lead this organization. With her previous experience as an

active member of the Female Association for the Relief of Women and Children in Reduced Circumstances and the Philadelphia Orphan Society, she was able to lead Jewish women in this work for many years.

The Female Hebrew Benevolent Society was the first charitable organization founded by Jews in Philadelphia that had no religious or congregational connection. It was a model for independent organizations that had no connection to a particular synagogue.

Jewish women throughout Philadelphia worked together for this organization. It gave them a cause that they all believed in no matter which synagogue they belonged to, and even if they belonged to no synagogue at all. They were glad to work together for an important cause. The Female Hebrew Benevolent Society is the oldest Jewish charity in continuous existence in the United States.

Her Letters

Rebecca was an active and reliable letter writer. In addition to her family members, she knew many other people, many of whom were quite famous, and she enjoyed writing to all of them. Thanks to her love of letter writing, she left us a tremendous amount of information on life in America during her time. Through her wonderful ability to express herself carefully and beautifully, we know a great deal about the Philadelphia Jewish community during the late eighteenth and early nineteenth centuries.

Rebecca's letters show her warm feelings for family members. We learn of the heartbreaking losses of families whose members fought in the American Civil War. Rebecca's nephew Cary, the son of her youngest brother, Benjamin, enlisted in the Union army. Cary was killed in a battle in Missouri in 1861. Rebecca responded to this catastrophe with a beautiful letter of comfort to her sister-in law, Maria Gist Gratz, Cary's mother.

Even when she was well into her eighties, Rebecca continued offering advice through letters to her nieces and nephews. We know her opinions about slavery by reading her letters advising family members against owning slaves. She also advised them on the importance of being charitable and working for the community's benefit.

Her Problem

American life during the nineteenth century was very exciting for many people. There were many opportunities for work, a new life and new freedoms that would not have been possible in the "old country." The United States offered a wonderful new world of hope and opportunity.

However, it was difficult for Jews to continue to practice their religion. Often isolated in small towns, they had no community to help them arrange for kosher meat or synagogue services. The America in which Rebecca Gratz lived had no strong, organized Jewish community services, such as schools and hospitals.

Before the 1830s, when a new group of German Jews arrived in the United States, the American Jewish community was small and disorganized. Many Jews lived in small towns, scattered throughout the New World. There was little opportunity for Jewish education for them or their children, and as a result, many Jews converted to Christianity. This situation worried some American Jews.

In the early nineteenth-century, Christians in America were trying to spread their religion by encouraging others, particularly Jews to convert to Christianity. The Christian Sunday School movement began during this time.

At this time, many American Jews realized that they knew far too little about their own religion. Jewish education in America was poor for both boys and girls. Although Jewish girls in Europe usually learned to read Hebrew prayers — without understanding them — they were rarely taught any other religious information. However, in America most Jewish girls and women were not even taught that much.

The German traveler Israel Joseph Benjamin II reported in his book, *Three Years in America,* (1863): "I must say with the deepest regret that the study of the Holy Scriptures ... is much neglected among the daughters of Israel."

But boys in America did not receive a strong Jewish education either. Their Jewish education generally focused on preparing them for their bar mitzvah ceremony, teaching them to read Hebrew prayers and to chant from the Torah. Israel Joseph Benjamin II explained: "Jewish boys after a fashion — for that is the established way — are instructed in their religion, as is also the case with

the sons and daughters of Christians. The Jewish boys attend some Hebrew school or other or are instructed privately." Nevertheless, these boys did not understand much of what they read.

In nineteenth-century Europe, Jewish women were not allowed to teach Judaic subjects to Jewish boys. However, things were different in America, where men spent long periods in the factory, shop or office. Out of necessity, women were required to take more responsibility for the education of all children, boys and girls alike. But were they really prepared to teach their children Hebrew and Judaism? At that time, it appears that they were not. Israel Joseph Benjamin II wrote: "How sad is the provision for the religious instruction of these Jewish housewives and others of the future! How little do they learn of their duties toward God and man!"

Some early synagogues in America established schools that taught both boys and girls. Nevertheless, Mr. Benjamin wrote: "It is with regret and astonishment that one learns that half of the American Jewesses are at present unable to undertake and fulfill worthily the place in life for which they are intended."

Her Solution

In 1818, Rebecca Gratz decided to resolve this problem by hiring a man named Solomon I. Cohen as a Hebrew tutor. She arranged for Mr. Cohen to come to her home where he taught Hebrew to her and a number of her female relatives, both adults and children. She wrote of the experience: "Elkalah Cohen, Maria and Ellen Hays and [eleven] little ones ... have been for the past month outlining pronouns, etc. With as much zeal as success, I expect we shall make out very well if [he] continues here long enough to take us though the grammar."

The small religious school that Rebecca organized for her family's education became the model for the Hebrew Sunday School, which she created twenty years later. This school's success encouraged her to accomplish her dream and enrich her entire community, eventually changing the direction of the American Jewish educational system.

Rebecca realized that she would need to take charge if she wished to make

a change in the Jewish education of American Jews. She read a book, entitled *Elements of Jewish Faith,* that her Hebrew tutor had written, and gave copies of it to her friends. These readings and her interactions with Mr. Cohen were important steps in preparing her for her leadership role in her community's Jewish educational system.

Two years before Rebecca started her little home Hebrew school, she learned of a successful Christian Sunday School that had been started by Joanna Graham Bethune, a Protestant woman in New York. Rebecca knew that most people felt that it was not necessary to teach Judaism to women, and she was concerned about the future of Philadelphia's Jewish community. The success of Mrs. Bethune's independent Sunday school, which was run entirely by women and was the first of its kind in America, gave her confidence to start a similar project to educate Jewish women.

Rebecca was determined to find a way to pass on her Jewish heritage to others, and by 1835, she decided upon a solution. At the same time, she was determined to establish a Jewish learning environment that would help its students adapt well to an American lifestyle. She convinced members of the Female Hebrew Benevolent Society to create a Sunday school. They agreed to appoint teachers for the school from among the members of the Mikveh Israel Congregation, Rebecca's own synagogue.

Rebecca decided that her Jewish school would not concentrate only on teaching children to live Jewish lives. They would also learn how to defend Judaism against those who were trying to convert them to Christianity. She also decided that her new school would be independent, not connected with any particular congregation. Rebecca decided that her new school would serve the entire community, just as the Female Hebrew Benevolent Society did. She wrote, "My Hebrew school will offer people from different parts of Europe and with diverse economic standing a similar American-style Jewish educational experience."

On February 4, 1838, with the encouragement of her rabbi, Isaac Leeser, Rebecca called a meeting to establish her Hebrew Sunday School Society. Classes began four weeks later, on March 4, with six women teachers and fifty students. An additional twenty youngsters were enrolled in the school by the autumn of that year.

Three years later, there were twenty-five women teachers and 250 children in the Hebrew Sunday School. For twenty-five years, the school met once a week, with Rebecca Gratz serving as principal.

During the years of the school's existence, thousands of Jewish children in Philadelphia received a Jewish education. Rebecca was president of the Hebrew Sunday School Society from its founding in 1838 until 1864 when she was eighty-three years old.

In 1858, the name of the school was changed to the Hebrew Sunday School Society. It combined religious studies with job training. For example, the Rebecca Gratz Sewing School opened in April 1876 with eight teachers and fifty-three students. By 1912, four thousand students were enrolled in the school, which had in several branches in different locations throughout Philadelphia.

The Benevolent Society and Hebrew Sunday School, both started by Rebecca Gratz 150 years ago, continue to offer Jewish educational programs to children and women in Philadelphia today. In 1986, the Hebrew Sunday School merged with the Talmud Torah Schools of Philadelphia. Almost two hundred years later, the coeducational Jewish studies program started by Rebecca Gratz is still important to the future of Jewish education for children and women in Philadelphia.

A New Educational Idea

Rebecca's school was unlike any educational institution the Jewish world had ever known. The school did not hire men who were deeply knowledgeable in the Hebrew Bible, the Talmud, and other commentaries, as was traditional in Jewish schools. Instead, the teachers in this school were American-born women who were well educated in English but had little or no knowledge of Hebrew. The school offered Jewish education to many families for the first time.

Only those who could afford to pay tuition were required to do so. Donations from charitable individuals helped to provide the rest of the budget. Most of the students, boys and girls, attended public schools and were from hard-working middle class families.

Her Curriculum

It was decided that the teaching would be in English rather than in Hebrew. Rebecca and her staff of teachers developed the curriculum themselves. Boys and girls studied religion together in a Jewish school for the first time ever. Also, for the first time women were hired as teachers. Never before had women taught Jewish children in a school. As soon as it became possible, Rebecca began to hire her school's graduates as teachers. Her school became a model for other schools throughout the United States.

Students in the school remembered later that "Miss Gratz always began school with prayer, opening with 'Come ye children, hearken unto me, and I will teach you the fear of the Lord.'" Rebecca Gratz then read a prayer that she had written, and all the children in the school repeated it. "Then she read a verse of the Bible, in a clear and distinct voice."

The school then divided into separate classes, eventually coming together again for "closing exercises [which] were equally simple; a Hebrew hymn sung by the children, then ... simple verses, whose rhythm the smallest child could easily catch as all repeated."

Remembering Rebecca Gratz

Rebecca Gratz died on August 27, 1869, at 89 years of age. She is buried in the Mikveh Israel cemetery in Philadelphia.

She was loved and honored by both Jews and Christians as one of the most important American Jewish women. Her faithfulness to Judaism is demonstrated in her last will and testament, in which she wrote, "I commit my spirit to God who gave [me my body and mind], relying on His mercy and redeeming love, and believing with a fine and perfect faith in the religion of my fathers, 'Hear, O Israel, the Lord our God is one Lord.'"

In 1893, Rebecca's niece, Sara Ann Mordecai, published a small book about her aunt in which she wrote: "Nothing could be lovelier than her everyday life, which commenced every day with prayers and thanks to the Creator for support and for protecting her through the night and ended with renewed thanks for blessings bestowed during the day."

In remembering Rebecca, one thinks about how religious she was, both privately and publicly. She cared deeply about helping others and worked on behalf of her society more than any other woman of her time.

Questions to Think About:

- *Have you ever considered volunteering for an organization?*
- *How would you choose one?*

Ask family and friends if anyone volunteers. Find out where and why. Be sure to write them down. Then you decide which one might be best for your interests.

- *What would you do if you lived in a place that had few or no Jewish institutions (schools, Jewish Community Centers, synagogues, or youth groups)?*

Spend time thinking about this question, write down your answers.

To Learn More:

Check out these websites:
http://jwa.org/exhibits/wov/Gratz/index.htm and
http://jewishvirtuallibrary.org/jsource/biography/Gratz.html/

6 HANNAH SZENES *a'h*

Poetess Turned Freedom Fighter

A Woman to Admire

There are some people whose courage inspires others. Hannah Szenes (also spelled Senesh) was one of them. The decisions she made might be surprising to some. Many people might have made different decisions if they had been in her place. Nevertheless, she provided a ray of hope to those who had nearly given up in despair.

Hannah Szenes left the safety of Palestine to help Jews caught in the Nazi death net in Hungary. After her execution in a Budapest military prison, the story of her extraordinary actions gave survivors hope to begin a new life in the Land of Israel. She had learned to love that land and the Jewish people, and her spirit lives on today through her poetry,

> *We gathered flowers in the fields and mountains*
> *In our homeland, in our beloved home.*

Her Childhood and Family

Hannah was born on July 17, 1921, in Budapest, the capital of Hungary. One of the most charming cities in the world, Budapest sits on the lovely Danube River. Together with its beauty and culture, after World War I it also had the worst slum in Europe because of the unemployment situation in Hungary after the war.

Hannah grew up surrounded by wealth, comfort and a loving family. A slightly spoiled, upper-class Jewish child, she attended excellent schools and had plenty of fun, vacations and friends. The Szenes family included Hannah's parents, Bela and Catherine, her grandmother, Fini Mama, and her brother, George. They lived together in a large apartment in a charming Budapest suburb. George, who was a year older than Hannah, was her best friend and constant playmate. Hannah told her secrets to Fini Mama.

Hannah adored her father and wanted to be just like him. He was a respected writer for Budapest's main newspaper, *Pesti Herla*. He was also a famous writer of comic plays. Famous artists, writers and actors often gathered at parties in the Szenes family living room, where Bela was fun and the center of attention.

Bela would tell fantastic and imaginative stories from Hungarian folklore to George and his "Aniko," as he called Hannah. But Hannah did not know that her father was extremely ill. Because of a weak heart, he spent his mornings resting in bed while Hannah and George played nearby.

This wonderful time with their father ended suddenly, when Hannah was only six years old. Bela died of a heart attack in 1927, at age 33. Hannah never stopped missing her father. She often thought about Fini Mama's words to George and her after her father's death: "Never forget—you are great!"

When Hannah was thirteen years old, she and her family moved from their apartment to a house on nearby Bimbo Street. She and George, their mother, Fini Mama and their housekeeper, Rosika, loved living in this beautiful house with its lovely rose garden.

Hannah and George were popular teenagers. During the summer, Hannah swam in the city pools, hiked in the Buda Hills and spent time at nearby Lake Balaton with her best friend, her cousin Evi. During the winter, she skied, skated, danced at friends' Christmas parties and sang at family Hanukkah parties. She was the center of a wide circle of friends from her school. She was fun, and everyone loved being with her. Nevertheless, her personality had its sad side.

Her Poetry

Throughout her life, Hannah often thought about her father and her special

relationship with him. One day, when she was twelve years old, she wrote a poem to express the emptiness in her heart.

> *I would like to be cheerful but can't.*
> *However I would like to, however I try,*
> *The flower has faded in my heart.*

Hannah was so pleased with her poem that she wrote more of them. She was proud when her teachers told her that her poems reminded them of the poetry that her father had written. She thought: "Some day I will be great, just like Fini Mama said."

She had many hobbies, but most of all she loved to write. She joined the Literary Society at Bar Maadas, the exclusive girls' school where she was a student. Club members loved to read their works aloud at meetings. When Hannah read hers, the response was so positive that she continued to write poetry and read it aloud.

Her Introduction to Anti-Semitism

Hannah's school was expensive, especially for Jewish students. The school was Protestant. Catholic students paid double the fee paid by Protestants. Jews paid triple. Hannah's mother was furious about this injustice and declared: "In any school, my daughter would be awarded a scholarship, but in this one I'm paying three times the fee!" Hannah's teachers were so upset that such a good student might withdraw from the school that they begged the principal to change the rules. The principal agreed that because of Hannah's excellent schoolwork, the family could pay only a double tuition "even though we are Jews," Hannah's mother explained to her.

Hannah loved her studies and her friends at school, but hated the intolerant rules. She asked her mother: "Why do so many people dislike us because we are Jews?" Catherine explained that it was not that they disliked Jews, but that they had been taught to distrust them. She added, "Even though Papa was so famous, his plays could not be performed at the National Theatre because he was Jewish."

Catherine explained that the Hungarian leader, Admiral Miklos Horthy,

was influenced by the anti-Jewish propaganda from Germany. "Horthy and some parliament members are saying we made Hungary lose the last war," she told her daughter. When Hannah protested to her mother that this kind of talk was nothing but lies, her mother answered, "Yes, Aniko, but people will believe lies if no one tells them the truth."

At about this time, Hannah began to notice changes in Budapest. She had seen Germans wearing brown shirts and swastikas in the streets and shouting "Rid Hungary of the Jewish menace!" She had heard radio programs discussing the Jews' bad influence upon Hungary and saw people reading newspapers published by the Hungarian Society for the Extermination of Noxious Insects. The headlines said, "The Jews must be relegated to an inferior role because they are an inferior race."

Hannah heard her neighbors whispering about the cruelties that Jews in Germany suffered after Hitler came to power in 1933. They were no longer considered citizens. They no longer had the right to free speech, to attend meetings or to vote. They could not receive hospital service or buy medicine or food in most stores. There were daily riots in Germany. Jewish religious objects were covered with dung, synagogues were destroyed and innocent Jews were murdered.

Hannah heard her neighbors saying in hushed, fearful voices, "Hungary is too friendly with Germany. Hitler promised to help regain Hungary's lost territory, but in return he wants anti-Semitic laws here."

One day, as Hannah and George were walking in Budapest's downtown square, they saw thousands of soldiers who were members of the Hungarian Fascist party, the Arrow Cross. The soldiers were marching in praise of Hitler as the crowd around them screamed for joy. Hannah was more frightened than she had ever been in her life.

Hannah could not find anyone with whom to discuss her anxiety about the dark cloud spreading over her beloved Budapest. Adults would not speak of it with her. Her school friends talked only about parties, dances and hairstyles. Even her best friend, Evi, could not understand her sadness.

In the fall of 1934, when she was thirteen, Hannah realized that she must keep her thoughts to herself. Needing a secret place to write down her private thoughts, she bought a notebook and began a diary. She promised herself

that she would never write about parties and dresses as girls her age usually did. She kept the diary hidden so that no one would read her most personal entries. She began by writing about her father:

> *I can hardly remember Daddy (his face), but just the same, I love him very much and always feel he is with me.*

By the summer of 1937, the situation for Jews throughout Europe became worse. As she did every summer, Hannah visited her cousin Evi at Dombovar, a resort on the shores of Lake Balaton.

In the past, the girls had had fun talking, swimming and dancing with boys whose families stayed at that resort. This summer, there were signs on the beaches, parks and hotels which read "No Jews Please" or "Christian Hungarians only." The girls now experienced anti-Semitism first-hand as Christian youngsters made great efforts to avoid contact with them. Hannah wrote in her diary:

> *This segregation often seems comical but actually it's a very sad and disquieting sign.*

One week after Hannah returned from that summer vacation at Dombovar, her beloved Fini Mama died. Catherine was so upset about the situation that Hannah hardly had time to cry and feel sad herself. She had to help arrange the funeral and contact relatives. Once again, she turned to her secret source of comfort, her diary.

Her Disappointment

Hannah had always loved her school, Bar Maadas, and been very involved with her studies and friends there. She was especially proud to be a member of the Literary Society and hoped to be elected an officer in it one day.

On September 16, 1937, as the school year began, Hannah heard that Jewish girls would no longer be allowed to serve as officers in the school. She hoped that was not true.

When she entered the first meeting of the Literary Society for that school year, she immediately forgot her concerns. The girls in her class were very

warm toward her and elected her one of the society's officers.

Suddenly, older students in the society shouted, "A Jewish student cannot hold office. You must hold new elections."

Hannah sat through this argument, followed by the new election, without saying a word. She tried to control the anger burning inside her.

The class then elected Maria, a Christian girl. Maria said kindly to Hannah, "I won't accept the appointment because I do not deserve it. You are the one who should have it." Hannah responded, trying hard not to cry, "Accept it calmly, and don't think for an instant that I begrudge it to you. If you don't accept it, someone else will."

As Hannah left the meeting, bitter about the injustice done, she thought. "Now I know what it means to be a Jew in a Christian Society." At home, she wrote in her diary:

> *I don't want to take part in or have anything to do with the work of the Literary Society, and don't care about it anymore.*

By 1938, the situation for European Jews had worsened even further. Hannah was thinking of leaving Hungary, maybe for Switzerland or England, where the situation was more comfortable for Jews. George planned to study in Austria.

However, on March 11, 1938, everything changed. On that day, Hitler invaded Austria, Hungary's neighbor. As Hitler entered Austria with his Nazi police, some Austrians cheered wildly, while others were silenced by fear.

At this terrible sight, Austrian Jews rushed to leave the country. Those who tried to leave by train were beaten and robbed by Nazis. Some Jews were sent to concentration camps, while the Jews who had stayed in Vienna were forced to do degrading and embarrassing work. They were thrown in jail and their homes, money and jewelry were stolen.

Wherever she went in Budapest, Hannah heard Jews whispering, "What does the invasion of Austria mean for us? What will Hitler's next move be?" Hannah was so worried that she could not write in her diary for weeks. Finally, she wrote:

> *One is so nervous about the local situation that by the time it comes to writing about things, one feels too depressed and discouraged.*

In May 1938, the Hungarian parliament passed its first anti-Jewish laws, making Hungary an ally of the Nazis. The new laws limited Jews' involvement in business and professional life and caused thousands of them to lose their jobs. The Jews of Hungary felt more frightened than ever before, and many committed suicide.

Anti-Jewish behavior now became more acceptable in public. At Hannah's school, many Christian girls made fun of Jewish classmates and spit at them. Teachers spoke about the danger that Jews posed to society.

George, now eighteen years old, was concerned about being forced to join the Hungarian army. He left for Lyons, France, to study textile production.

It was hard for Hannah to say goodbye to her tall, handsome brother. He was her best friend, on whom she depended for friendship, fun and security. After his train was out of sight, she and her mother went home together. When she was alone in her room, Hannah wrote in her diary:

> *You left. We waved a long while.*
> *Porters clattered behind.*
> *We watched and you disappeared.*

Her Change in Direction

In the summer of 1938, Hungary's leader, Miklos Horthy, grew closer to Hitler. He agreed to assist Hitler in return for Hitler's help in regaining Hungarian territory lost in World War I. The whole country began to prepare for war.

Hannah was so upset with life in her world that she refused to talk about it. She even refused to go to the synagogue on Yom Kippur. She stayed in her room, thinking of her Hungarian history teacher's words: "The Jews are parasites of the society. They are generally lazy and motivated by greed; they want only to reap the rewards of others." Those lies hurt Hannah deeply. She began to read her parents' Jewish history books.

Fascinated, Hannah read Jewish history all that Yom Kippur. She learned of the persecution of Jews from biblical to modern times and of Diaspora Jews (those living outside the Land of Israel) who were persecuted in foreign lands.

She was thrilled with the writings of Theodor Herzl, a Jew born in Budapest, just as she had been. Herzl advised Jews to return to Zion, their ancient home in Palestine, where the new State of Israel would be reborn.

Her New Outlook

On October 27, 1938, Hannah, now age seventeen, was ready to write in her diary:

> *I don't know whether I've already mentioned that I've become a Zionist. To me it means that I now consciously and strongly feel I am a Jew and proud of it.*

Then, she wrote:

> *My primary aim is to go to Palestine and work for it.*

Hannah felt that she needed to make a difference in the world. She wrote:

> *One needs something to believe in. ... Zionism fulfills all this for me.*

From then on, Hannah was a new person. No longer interested in tennis, parties, school or even becoming a Hungarian writer, she thought only about becoming a Zionist. She joined the Hungarian Zionist Youth Society. She spoke, read and sang only about Palestine. She was ready to begin working the land of Israel with her bare hands.

When she wrote to George at the University of Lyons about her dream to immigrate to Palestine, she was surprised to learn that he had the same dream. She hoped to leave for Palestine in a few months, right after her graduation from high school. George planned to follow her in a few months, when he finished his own studies. They were excited about meeting soon in Palestine.

In February 1939, Horthy appointed a new Prime Minister, Count Pal Teleki, who believed that Jews were inferior and dangerous. Hungarians were now distrustful of Jews and accused them of doing many terrible things, from kidnapping children to poisoning the water.

By March, the second anti-Jewish law was passed, forbidding Jews to

hold government positions. Jews could no longer work as editors, publishers or writers, or as directors or producers in the theater. They were no longer allowed to teach in primary or secondary schools, and they could not receive business licenses or buy or sell land without special government permission.

A few months later, eighteen-year-old Hannah graduated from high school with highest honors. But she did not care about those honors. All she thought about now was living in Palestine and working the land. When her mother suggested that since she had been such a good student she should consider continuing her studies at a university, Hannah asked, "Who will work the soil if not the youth?"

Hannah worked hard preparing for her new life in Palestine. She studied Hebrew by herself every morning. In the afternoons, she worked in her family's garden, preparing for the outdoor work she would meet in Palestine.

Hannah had applied to the Nahalal Girls School of Agriculture in Palestine, completing the application in Hebrew. Now she waited anxiously for acceptance to the program. When she received the letter of acceptance four days after her eighteenth birthday, she wrote:

I've got the certificate. I'm filled with joy and happiness!

For the next two months, Hannah prepared for her journey to Palestine. On September 1, 1939, Germany invaded Poland and World War II began. England and France entered the war to fight with Poland against Nazi Germany.

This was an especially dangerous time for a sea journey. Jewish officials, travel agents and Catherine warned that few ships would sail to Palestine now that the war had started. But Hannah's mind was made up. Finally, she was told that if she was willing to leave the next day and travel on a Romanian ship, she could go.

Hannah and her mother spent the entire night packing. Evi and other relatives came to say goodbye. Finally, Hannah said goodbye to her mother and to her home. Mother and daughter hugged each other and cried. But nothing could change Hannah's determination. After Hannah's train disappeared from sight, Catherine walked home alone, entered the empty house and lit two candles to welcome Rosh Hashana.

Her New Life in a New Land

Hannah's ship entered Palestine at the port of Haifa. As she left the ship, carrying her suitcase and typewriter, she was excited. She could not stop looking at all the new sights. The young Jewish Palestinian women, well-tanned and simply dressed, seemed so comfortable in their own land. Arab men rode on donkeys, British soldiers rode in jeeps and Jewish mothers drove tractors. These sights and the sound of Hebrew delighted Hannah, who thought: "Now I'm in a Jewish land."

After a bus ride to her new home that lasted several hours, Hannah stepped into the fragrance of orange orchards. She wrote in her diary: "I am in Nahalal, in *Eretz*. I am home."

From the very first day, Hannah loved Palestine, or as she referred to it, *Eretz* (the Hebrew word for "land"). She loved the gardens, the fields, the mountains and the clear blue Mediterranean sky. Her poem expressed her love for *Eretz*:

> *From where comes the new light and voice?*
> *From you, fertile Emek, from you, my Land.*

However, she knew that she needed to overcome her upper-class habits. Rosika, her family's housekeeper, had always done everything for her. Now she learned to get up at 5:30 A.M., climb olive trees, plant pomegranate trees and shovel cow manure. Her roommates and good friends, Miriam and Penina, helped her learn to do physical work.

By the summer of 1940, Hannah had become one of the best students in her new school. She learned to do manual labor. She also organized plays and concerts and arranged for visiting speakers from nearby settlements. She was successful in getting used to her new life. She wrote to her mother, "The hoe feels as comfortable in my hand now as the pen once did." Nevertheless, she continued to write poetry.

Meanwhile, Hitler's Nazis marched over Europe, occupying most of it. They also occupied Syria and North Africa. The Nazis invaded Russia and were planning to invade England and Ireland. Wherever they went, they imprisoned the Jews in detention camps, from which they deported them to death

camps in Germany and Poland. Jews were being murdered at a rate of 10,000 per day in concentration camps such as Dachau, Auschwitz and Treblinka.

The more Hannah learned of these horrible events from the newspapers and the radio, the more she worried. Although she appeared bright and cheerful, she was constantly anxious. She wrote in her diary: "Suddenly I was gripped by fear."

Searching for Her Permanent Home

Hannah graduated with honors from the Nahalal Girls' School of Agriculture in September 1941. Then she traveled with Miriam and Penina throughout Palestine, visiting kibbutzim and hoping to find one to join. She wrote: "I don't want anything ready-made." She wanted to make an important contribution to a struggling new kibbutz.

In December 1941, she joined Kibbutz Sedot Yam, which is located on the shores of the Mediterranean Sea at the ancient Roman port of Caesarea. She was excited to work with the struggling members of this kibbutz who hoped to earn a living from fishing and farming.

The work was hard and exhausting. In the few restful moments she had, she wrote, "Today I washed 150 pairs of socks. I thought I'd go mad."

However, she found joy when she visited nearby settlements. She organized groups of children and spent hours telling them stories of brave Jewish heroes and heroines. Everyone who knew her admired and respected her for her hard work and dedication.

Concern for Her Family

Hannah continued to receive letters from her mother and Evi, from which she learned that the Hungarian government had passed the third anti-Jewish bill in the fall of 1941. Relationships between Jews and non-Jews were now forbidden. The Jews of Hungary feared for their lives. Hitler was obsessed with murdering all 800,000 of them. He demanded that the Germans "resettle" them. They were required to wear the yellow Star of David armband while the Nazis stole all their money, land and possessions.

Hannah was frantic when she thought about her mother. She wrote to Catherine, urging her to come to Palestine. She tried desperately to get a visa permitting Catherine to enter Palestine, but without success.

The British had limited Jewish emigration to Palestine to 75,000 people. Millions were stuck in Europe, facing certain death. Many Palestinian Jews worked hard to smuggle Jews from Europe to Palestine, but the task was extremely dangerous. Sometimes the European Jews were caught and sent back, while at other times the rickety, unseaworthy boats sank.

During the summer of 1942, Hannah read a book called *Broken Grindstones* by the Hebrew writer Hayyim Hazaz. One sentence in the book stayed in her mind: "All the darkness cannot extinguish a single candle, yet one candle can illuminate the darkness."

Her Important Decision

Finally, in January 1943, Hannah wrote in her diary:

> *I was suddenly struck by the idea of going to Hungary ... to help organize youth emigration and also to get my mother out.*

Realizing now what she must do, Hannah went to Tel Aviv to enlist in the Haganah, the Jewish Palestinian defense unit of the British army. As she waited anxiously to learn whether she would be accepted, she told her diary:

> *I ... think about leaving the Land...leaving the freedom ... to breathe it even in the Diaspora's stifling atmosphere ...*

At last, in December 1943, she learned that she had been accepted into the Haganah. She would train with the British army at Kibbutz Ramat ha-Kovesh near Tel Aviv. Then she would go to Cairo, Egypt, for a dangerous, secret mission. With great joy, Hannah wrote:

> *I see the hand of destiny in this just as I did at the time of my Aliyah. ...*

To her brother she wrote:

> *Darling George, there are times when one is commanded to do something, even at the price of one's life.*

On January 11, 1944, after completing her training, she wrote ecstatically:

This week I leave for Egypt. I am a soldier. ... I want to believe that what I've done and will do are right.

This was her last diary entry. The next day, Hannah, dressed in a British Air Force uniform, left her life in Palestine forever. She and four companions began their secret, dangerous mission in Egypt.

They were excited about liberating Hungarian Jews. But they soon learned that the British, for whom they were to fight, would not permit them to parachute into Hungary. It was too dangerous. Instead, they would be dropped into Yugoslavia to search for Resistance fighters (local soldiers fighting against the Nazis) and for British pilots whose planes had crashed. While Hannah's companions accepted this change of plans, Hannah was furious. Although she was determined to save her mother and other Hungarian Jews, the British would not hear of it.

In March 1944, Hannah and three companions—Reuven Dafne, Abba Birchner, and Peretz Goldstein—were flown to Italy. The British had liberated Italy from the Nazis, so it was now safe to go there. From Italy, the partisans would parachute into Yugoslavia. Hannah, who had permission to cross into Hungary soon after landing in Yugoslavia, wrote, "We go out to our brothers in exile."

While the jump into Yugoslavia was successful, the Nazis controlled the area where they had jumped. Hannah and her companions now made their way to neighboring Croatia, which was still controlled by the Resistance. Hannah and her friends continued on their slow, dangerous journey, trudging through forests, swamps and rivers. Whenever Hannah traveled among the Resistance fighters, they admired her bravery and optimism. They had no idea that she was trembling inside.

Along the way, strangers told them of terrible events in Hungary, where the Nazis controlled everything. Jews there now had to register their property. All Jewish-owned shops, offices and factories were closed. Nazis stole all Jewish money and property. Jews were forbidden to buy meat, butter, rice and eggs, to listen to the radio, to make telephone calls, to use public transportation, to ride bikes, to sit in a park, to leave home without permission or

to look out the window. They were gathered in special apartments called "star houses," from which they were sent to their deaths in concentration camps in Germany and Poland.

As thoughts of this situation turned over in Hannah's mind, she wrote with determination:

> *Blessed is the match consumed in kindling flame. ...*
> *Blessed is the heart with strength to stop its beating for honor's sake. ...*

Hannah was no longer the cheerful and outgoing young woman she had been. She now felt fearful and lonely, speaking rarely and then only to say, "I want to enter Hungary no matter what." Now, nothing would change her mind.

By April 1944, when Hannah crossed the border into Hungary, the Nazis had murdered half of Hungary's Jews. Every day, thousands of Jews were forced to enter the "yellow star houses," where they stayed until they were deported to concentration camps.

Her Capture

But crossing into Hungary proved far from easy. Hannah and her three comrades were caught and taken to a local police station, where they were beaten to force them to reveal strategic information. Despite the beatings, Hannah refused to talk. When the soldiers discovered that she had carried parts of a radio transmitter into Hungary, they sent her to a military prison in Budapest. She was disappointed in herself for having been captured before she could carry out her mission.

At the military prison in Budapest, Hannah refused to reveal her identity even when she was beaten. Finally she was told that her companion, who was being held in the next room, would be killed unless she gave her real name. Only then did she say: "My name is Hannah Szenes." She was put into a cold, mildewed prison and given a thin, dirty cot on which to sleep.

One day, when she was brought to the commander's office, she found her mother there. The Arrow Cross, the Hungarian Nazi party, had arrested Catherine Szenes when they discovered that Hannah was her daughter. For the

next several months, Catherine was imprisoned too. She rarely saw Hannah, who was kept alone in a separate cell.

Their Reunion

Hannah was fortunate to meet a sympathetic prison guard, Hulda, who arranged for Hannah and Catherine to meet briefly every day. On July 17, Hannah's twenty-third birthday, Hulda brought her a package. It was a birthday gift from her mother with a few rare luxuries: marmalade, soap, a sponge and a handkerchief. Hannah sent a "thank you" message to her mother through Hulda and found that she could send many messages this way. Afterwards, she used the messages to tell stories of Palestine and to teach Hebrew, Zionist songs and Jewish history to her mother and to the other Jewish women prisoners.

The End of the War

It was now almost September. The Nazis were losing the war, and the Allies bombed Budapest daily. The Russians soon would free Budapest, and many Nazi soldiers fled. Prison rules became more relaxed. It was now easier for Hannah and her mother to spend more time together in the prison yard. On Yom Kippur, Catherine and several other Jewish women were released.

Their Hope

Catherine was now allowed to visit Hannah. She brought her a package containing cheese, fruit, a sweater, underwear, paper and pencils. Mother and daughter were delighted to spend this time together.

Now that Catherine was free, she worked nonstop to find a lawyer to defend Hannah in her upcoming trial. Since Jews were permitted on the streets for only two hours a day, she had to work quickly. At last, she hired a young lawyer named Dr. Andre Szelecsenyi.

Dr. Szelecsenyi visited Hannah on October 13. "She is brave," he told Catherine. "I greatly admire her." He was convinced that although Hannah would be convicted, she would be released soon afterward, when the war ended.

Unfortunately, Catherine would not be able to see Hannah until after her trial.

On October 28, Hannah's trial date arrived. Finally, she was allowed to speak. "I do not confess to treason against my native land, Hungary," she began.

In her long speech, Hannah explained how she and other Jews had been stripped of Hungarian citizenship by a government that chose to introduce evil into the society. "It is not I who am the traitor. The traitors are the ones who brought this calamity upon our people," she said, pointing to Arrow Cross members sitting in the courtroom.

Her braveness and beautiful words were impressive. When the trial was completed, the judges ordered Hannah back to her prison cell to wait until November 4 for their decision.

The End of Her Life

Over the next several days, bombs exploded and artillery fire became stronger in Budapest. Houses and buildings were destroyed. Jews were killed. The Russians were closing in. Many believed that the city would be freed in a few days. On November 7, Judge Advocate (military judge) Captain Simon suddenly entered Hannah's cell. "You have been sentenced to death," he announced. "Do you wish to ask for mercy?"

"Mercy from you?" Hannah retorted. "Do you think I'm going to plead with murderers?" Captain Simon ordered his soldiers to take her to the prison yard, where a firing squad shot her to death. No sentence had been passed. Captain Simon executed Hannah completely on his own because she had had the nerve to call the Arrow Crossers "evil."

Before she was shot, Hannah was permitted to write letters. Unfortunately, they were not delivered. Three months after Hannah's execution, the Russian army liberated Budapest. Catherine Szenes continued to live there.

After Hannah's execution, Captain Simon met with Catherine and told her, "I must pay tribute to your daughter's exceptional courage and strength of character—Both of which she manifested until the very last moment. She was truly proud of being a Jew."

Remembering Hannah Szenes

In 1950, Hannah Szenes was buried in the National Military Cemetery on Mount Herzl in Jerusalem. People visit her gravesite with respect and admiration to this day.

The land that Hannah loved has honored her memory by naming streets, a forest, farming settlements and a refugee ship after her. Plays and books have been written about her. Her poetry is read throughout Israel and around the world, and her words continue to inspire courage and hope. At the Hannah Szenes Museum in Kibbutz Sedot Yam, visitors can learn about her life and amazing courage.

Teachers can learn from the ways Hannah found to teach her heritage to others. Poets and writers can be inspired by her words. Those who love freedom can hope and work for the future she worked so hard to bring about.

Questions to Think About:

- *Have you ever considered expressing your feelings through poetry?*

 Read the poetry of Hannah Szenes.

- *Do you get any ideas about how to write your own poetry by reading the words of others?*

 Start to write about your feelings. Set the writing aside. Look at it again in about a week and see how you feel about what you have written. Keep a special book for writing your feelings. Be sure to write a date on each entry as a reminder of how you felt at different times.

- *Have you ever tried to do something you have never done before?*

 Make a list of new things to try. Choose one or two of them. Keep doing it for a while to see how it feels.

To Learn More:

- Check out these websites:
 http://hannahsenesh.org.il/documents/frameseteng.
 html and http://utoronto.ca/wjudaism/encyclopedia/e-
 s.html

 In Israel, you can visit the Hannah Senesh House and learn more about her life. This museum is part of the Antiquities Museum in Caesarea, north of Haifa. For more information check out this website:
 http://ilmuseums.com/museum_eng.asp?id=122

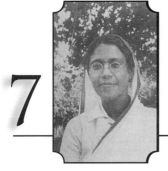

7

REBECCA REUBEN a"h

Teacher and Community Leader

A Woman to Admire

"Her love for India and her equal devotion to Israel, her motherly care for her pupils in India and in Israel were a source of inspiration to all who knew her," said Dr. Immanuel Olsvanger when he spoke of his friend Rebecca Reuben after her death.

Although most people in the Western world have never heard of Rebecca Reuben, the members of the Bene Israel, the largest Jewish community in India, cherish her memory. They speak of her with love and admiration to this day, nearly fifty years after her death. Those who knew her speak of "her natural love of learning, her philosophy of simple living and high thinking, and her kindly and affectionate treatment of all."

Most of all, Rebecca Reuben is admired as a role model and a teacher for the Bene Israel community, and also as one who educated others about her community. Because she was such an outstanding student, she could have chosen any profession, but she chose teaching as her way to contribute to society. "The image of her, seated in the chair, dressed in white, her face with an intent [serious] yet smiling expression" is the way her former students remember her.

Her Childhood and Family

Rebecca Reuben was born on September 18, 1889, in her grandfather's

house in Shimoga, in a part of India called Mysore. The oldest of six surviving children born to Ezra and Sarah Reuben Nowgaonkar, she was known to be loving, generous and, at times, stubborn.

Her family and friends called her Daisy. When she was born, it was common for the Bene Israel to use nicknames, especially for girls, in addition to their Jewish names. Her mother, who had British friends, adopted some of their names and used them as nicknames for her daughters.

The members of Rebecca's family were unusually well educated for their time. Her mother's father, Abraham Samuel Nagavkar, who was born in 1843, was the first member of the Bene Israel to receive a university education. His children and grandchildren followed his example, reaching high levels in education and were extremely successful achieving great success in their professions. They became physicians, judges, teachers, mathematicians and community leaders. This was quite an unusual accomplishment for Jews of the Bene Israel, most of whom were still living in small villages near the big city of Bombay.

The academic and professional example of the Nagavkar family became a model for others in the Bene Israel community. Bene Israel families usually made a living as oil pressers and farmers, making oil from seeds and coconuts. Only a small percentage of the Bene Israel from the villages continued their education beyond elementary school. Only a few knew English. However, once they left the villages and moved to Bombay, they were eager to educate their sons and daughters and to have them learn English.

Rebecca's father, Ezra Reuben, was a lawyer. He was appointed Chief Judicial Officer of an area in India called Junagadh. Known as a strict man, he was concerned with upholding truth and justice. He raised his children in an environment of strict orthodox morality and he wasted no time in gossip. Rebecca grew up in this environment.

All of the children in Rebecca's family graduated from college. Rebecca became a teacher and a school principal. Rebecca's next younger sibling was Solomon, who worked for the government. After Solomon came David, who became Chief Justice of the High Court, followed by Mary, who studied languages and history. Judah (also known as Lennie), the family's youngest son, studied engineering and worked in that field. The youngest daughter was Esther, who studied French.

Most people outside India have never heard of the Bene Israel. Rebecca, who was proud to be a member of this community, was eager to help outsiders and members of her own community learn about the Bene Israel.

She edited *The Bene Israel Year Book* of 1917–1918, which included an article written by Dr. J. Bamnolkar, describing the Bene Israel community's history:

"It has been handed down to us by tradition that in the early part of the Christian era [about 2,000 years ago], a handful of our people from the land of our ancestors were thrown adrift on the shores of the Konkan [near modern-day Bombay] ..."

In the *Year Book,* Dr. Bamnolkar described his ancestors' life: " ... where they were obliged to take to agriculture and oil pressing. ..."

He also told how important Jewish religious life was to them:

"In spite of the unfavorable environments of our forefathers ... to their great credit ... they did not forsake their religion, but remained true to it. They ... observed the Sabbath, the Laws about Circumcision and the Dietary Laws, the Jewish festivals, and the Jewish funeral rites."

Her Studies

When Rebecca was eight years old, she was sent to study at the Huzur-baga School in Poona, where she lived together with some other girls in the school's dormitory. The school was known as the High School (the name given to Indian elementary schools) for Native Girls. Bene Israel families liked to send their girls to this school because of its high academic standards. The school was known for its excellent teaching of Marathi (one of the many Indian languages), Sanskrit (the ancient Hindu language) and English. Even though there were many brilliant students there, Rebecca stood out because of her unusual intelligence.

Rebecca was an outstanding student whose industriousness and politeness made her beloved by her teachers and classmates. Because she was the only student in her school who studied Hebrew, she had no teacher to work with her. She studied Hebrew only during vacations with the help of her father, who had studied Hebrew when he was young.

In 1905, Rebecca received the highest score among all the pupils who took the examination required to graduate from high school and enter university. Rebecca was the first girl ever to achieve the highest score in the examination, which was given by Bombay University.

She also won the Chatfield prize and the Science prize and, like her father before her, she was awarded the Hebrew Scholarship as well. She then studied for a bachelor's degree at Elphinstone College, in Bombay. Later on, she studied at Deccan College in Poona, and during the following year, she taught at her old school, Huzurpaga.

Even though Rebecca had won the science prize, she chose to study education rather than science. She had always known that she was born to be a teacher. Her friend, Mr. I. A. Ezekiel, later remarked, "As a little girl, she told me once, she would gather little children around her, organize them into a class and become their 'teacher.'"

In 1911, at age 22, Rebecca left for England in order to study for the Teachers Training Diploma Course at Maria Gray College. While she was in England, she also studied Hebrew with Dr. Israel Abrahams at Cambridge University.

Even though Rebecca was excited about the opportunity to study in England, she missed her family terribly and suffered from homesickness. On her way to England, as she sailed on the SS *Salsette*, she wrote in her diary: "August 19: A dull dreary wretched day ending in a night of sleepless misery. All the pent up feelings of the day finding their way out in a violent fit of sobbing."

As Rebecca started her new life in London, she thought about the responsibilities ahead of her. On September 18, 1911, she wrote in her diary: "My birthday. ... The great thing is, I have gained my wish of training in England, and must work heart and soul to deserve the privilege and to deserve the confidence of my dearest parents. What is the opening year to bring? Plenty of work I am sure. What else? Who knows? Let me not dare to pry into the future."

Although Rebecca had made friends in England who tried to make her feel at home, she could not help feeling homesick, and she longed for letters from her family. When she did not receive mail from home, she was terribly

disappointed. On one such day, she recorded in her diary: "September 23 (Rosh Hashanah). A most disappointing day in all sorts of ways. No Jewishness about the New Year celebrations. No letter from either father or mother. What means this? One weary week more to pass to understand the reason of this unusual silence."

Her Career

In 1913 Rebecca returned to India, where she taught for three more years at Huzurpaga and introduced a Hebrew class as part of the school curriculum. She had not had such an advantage when she was a pupil. By this time, many Bene Israel girls were enrolled in the school, many of whom were excited to study Hebrew with her.

Three years later, Rebecca was appointed headmistress of Practicing School, which was connected with the Training College for Women in Poona. In her position there, she successfully introduced several new teaching methods and soon became famous for her remarkable work.

From 1917 to 1920, she was appointed Principal of the Government Teachers' Training College at Baroda, a city north of Bombay. She also served on several government education committees, guiding educational policy in western India.

Yet throughout her years of service, Rebecca thought constantly about how she might work for her own community, the Bene Israel. She was most concerned about the children of the community's needy families. For this reason, in 1922, she refused the higher paying job in the Government Training College. Instead, she accepted the job of Principal of the Israelite School at Mazagaon in Bombay.

From that time until her retirement in 1950, her work focused on the Israelite School, where she worked tirelessly on behalf of the children there. She worked constantly to raise the school's standard so that children from poorer families would have excellent educational opportunities. The school, which was founded to offer the community's children with both religious and general education, provided both Hebrew and religious studies.

In her report on the school's progress in 1947, Rebecca wrote: "It is

practically the children of the very poor who take advantage of the School, except those few who attend out of their love for the Hebrew language and the religious education that the School provides. The majority of the children receive free education in the School, many with clothes, and about 75 are given one free meal a day."

Rebecca told her friend, I. A. Ezekiel, "When I came here I found the children so depressed that I thought it my first duty to remove the pall of gloom." Long before she retired from that position, the school's atmosphere became joyful. Rebecca explained, "You can teach them only by love; there is no other method. And if love fails, nothing else can succeed."

Running the Israelite School was the most important thing in Rebecca's life. Therefore, when she heard that Sir Elly Kadoorie, a very successful Jewish businessman from Shanghai, was on a ship that would be stopping in Bombay, she went to see him. During their meeting, she convinced him to donate a large amount of money to the Jewish school. His generous donation paid for the construction of a beautiful new building. The school was then renamed the Sir Elly Kadoorie High School.

At first, only girls and boys from the Bene Israel community were admitted to the school, but Rebecca changed this policy, making sure that children from all communities would be permitted to study there. Rebecca's niece, Nina Haeems, remembers: "She was committed to the education and welfare of her own Jewish community as well as of the wider Indian society."

After devoting forty years of service to the Israelite School, Rebecca prepared for her retirement. She advised Flora Samuel, the school's future principal: "Never forget one thing. This school belongs to our community. Its objective is the all-round progress of our children. ... Keep the goal of helping the community as best as you can, close to your heart." Rebecca was so devoted to the school that she continued to volunteer her time working there even after she retired.

After her retirement, Rebecca began to work on the Ashok Readers Series. In the late 1940s, Mr. Irani of the Macmillan publishing company from Bombay invited her to write a series of textbooks for teaching English for use in schools that did not teach English as a second language. Rebecca welcomed the opportunity to benefit children once more and wrote the Series, about a

boy named Ashok and his family. She worked on this series for two years.

These very popular books were used successfully to teach English in eighth through eleventh grade in many schools throughout Bombay and were published until 1965. Rebecca donated all of the royalties (payments to authors by publishers) she received from her writings to charity.

Nina Haeems remembered that the Ashok series was written "simple and straightforward," adding: "It was so much a part of the school scene and the education system that it was featured in an advertisement in the newspaper." Many other people also remembered the books remarked, "Her style of writing was as simple as her nature."

Her Simple Style

Rebecca Reuben had many talents. She could read, write and speak fluently in Marathi (the local language of the Indian state where she lived). She was also fluent in English, Hebrew and Sanskrit. An outstanding writer, she published some of her short stories. She also loved to do needlework and played the sitar (an Indian musical instrument) and piano.

Reading was one of Rebecca's favorite hobbies. She read from her large personal collection on various topics and was a regular user of the public library. She read as much as she could about events in India and throughout the world. She was particularly interested in learning as much as she could about the development of the newly established State of Israel, in which she took pride.

When she was a young woman, Rebecca loved to dress in fine, colorful silk saris with matching shoes and stockings. A sari, the dress of Indian women, is a long piece of cotton or silk cloth that is wrapped around the body and sometimes covers the head as well.

Later, when Rebecca began her work in the Israelite School, she stopped dressing in this way because she wanted to be accepted by everyone in the community. She wished to be seen not as a woman from a privileged family—which she was—but as someone whom even the poorest of her students' families could approach. Thereafter, Rebecca became well known for her new manner of dress: simple white cotton saris with light-colored narrow

borders, with the end of the sari covering her head and held in place by pins. The simplicity of her white sari was a symbol of the simple lifestyle she had chosen. She wore her hair parted in the middle and drawn back into a neat bun. She also wore simple, flat shoes. Two thin gold bangles (bracelets frequently worn by Indian women) and a simple watch were her only jewelry.

Rebecca's needs were also simple. She is remembered as being able to enjoy life's simple pleasures very deeply. Before leaving for school each day, she would eat a small breakfast. Then she would walk to the train station, take the train to the stop closest to the school, and walk quite a long distance the rest of the way to the school. She then spent the entire day at school, taking only tea and a few cookies. She returned home late in the evening, again taking the train and walking long distances. She loved to walk, to teach and to interact with the community, and she had few physical needs.

Rebecca Reuben never married. She kept a beautiful home for herself and her widowed father. She was a gracious host and frequently welcomed family and friends. When she was at home, she spent her time caring for her pet dogs, as well as knitting, sewing and entertaining guests.

Her Love of Teaching

Despite her many talents and abilities, Rebecca's greatest love was teaching. She had the ability to teach any subject to anyone of any age. While she insisted on strict discipline in her school, her students respected her and loved to learn with her. She was able to understand the needs of students on any level, and gave attention and encouragement to those who needed it. She was involved in all aspects of the school, including singing and dramatics. She even started a Boy Scouts troop in the school.

Her niece, Sarah Israel, remembered, "Rebecca was one of the wisest and most skillful teachers I have known and was as involved in teaching the senior-most in the school as in teaching the youngest. Whether the subject was English, mathematics, geography or science, she could deal with it in her own … way and make it of absorbing interest."

Sarah explained that when Rebecca's youngest sister needed to prepare

for a French exam, "Rebecca, who had never studied French, went through the text-book and then coached her in the subject."

Rebecca was a master at reading poetry or telling stories. Her former student, Isaac Talkar, remembered, "Her recitation of poetry was something to be heard." Sarah Israel recalled, "She particularly loved to read and teach poetry and from earliest years instilled in me a love of poetry."

Rebecca wrote many charming stories, which she often signed 'Riv-ven' (a combination of the first and last syllables of her name in Hebrew). She is remembered not only for the stories she wrote, but also for the way she told the stories and for the sound of her voice. Whenever she read aloud, recited poetry or spoke publicly, her listeners gave her their full attention.

Rebecca's friend I. A. Ezekiel remembered, "Teaching was in her blood. That was her destiny, not merely mission." He continued, "When hardly thirty, she used to conduct Jewish history classes which men twice her age used to attend. It was a sight, these old men asking her questions, and Miss Reuben explaining things to them."

She was skillful at teaching people of all ages, always with love and respect for them and for her subject. "To those who gathered round her, she talked common sense and truth, justice and righteousness, fair play and farsightedness in everyday affairs of the world—politics, psychology, and sociology: she covered all these and many other subjects," I. A. Ezekiel recalled.

Her former student, Sipporah Elijah Chincholkar, referred to Rebecca as "Bai," an Indian term of respect, recalling: "Bai loved young children. If there was a school function then Bai herself taught the children songs. Earlier ... Bai herself played the piano. She was very fond of music. 'My school,' 'my children' ... must have been the words that gave her great happiness."

Kumari Mabel Koletkar, a former student, remembered: "Bai told us that if ever we had any problem we should go to her. 'I will help you solve it.' she would say, and she was true to her word." Miss Koletkar explained that once when she was having problems with math, Rebecca helped her. "I racked my brains till I was tired but I could not get the sum right. And then I remembered Bai. Because Bai spent so much time with us, we students felt that she was one of us. The thought that we were small children and she was a grown up person never entered our minds. We always felt free to go to Bai."

Her Love of Family, Friends and Community

Rebecca was known for her caring attitude and willingness to share her time with those in her world. Sarah Israel remembered that she "gave of her time to her family, friends, teachers, students, and past students, whenever they approached her either at the school or at her home for advice or assistance."

Sarah told of Rebecca's relationships with family and friends when she noted: "She was a most loving daughter, sister, and aunt to her nine nieces, and a sincere friend to the innumerable people not only from her own community but from all other communities as well as from other countries who came to know her."

Rebecca's siblings and their families were very attentive to her throughout her life, as she was to them. Nina Haeems remembered: "We (my parents, my sisters, and I) visited regularly. My elder sister and I often spent a part of the school vacations there. Later, when I could be trusted to travel the distance from where we lived to Chembur [Rebecca's home] on my own, I often went to spend a weekend there." She also remembered "My aunt was always interested in what we studied at school. ... There was a special magic about going to Chembur, and my elder sister and I went there often, as often as we could."

Her nieces wrote letters to her, "each of which was promptly and carefully answered ... as though the little details of the lives of teenaged nieces were as important as more serious correspondence."

Rebecca often wrote rhyming, fun notes to her nieces, and they responded the same way. Here is a note that she wrote to Aviva and Nina:

Avi, Nina
How are you?
What's the news
You Naughty two?
Do you worry
Aunt MQ?
Do you harass Uncle too?

She "was a real 'fun' aunt, with her sense of humor, her fund of stories and jokes and her ability for recounting them, her extensive information about natural history, and her love of walking," Sarah Israel said.

Rebecca loved her family as much as they loved her. She wrote to her father from pre-state Palestine. Delighted with the warm reception she received as well as the compliments given her on her Hebrew pronunciation, she wrote: "All this is for you, Daddy. You have been my inspiration and I know you like to know about my successes as well as my failures."

Most of all, Rebecca was concerned with improving life for the members of her community. She saw that a way to do this was through education. She was prepared to help them in any way that was necessary, from teaching them careful English pronunciation to writing stories for them that she adapted from folk legends.

Rebecca wanted the Bene Israel to see themselves and be seen by others as an educated and important community. For this reason, she published *The Bene Israel Year Book* for three years. Those books gave important information about community members and institutions and helped the community members to stay connected with each other.

Her Love for Her Two Countries

Rebecca's Jewish identity meant everything to her, and the way she was able to integrate it with her identity as an Indian was quite remarkable. She recorded in her diary that when she was once asked, "Do you feel yourself loyal?" she responded, "Of course, I feel myself an Indian as well as a Jew." Then she added a quotation from Israel Zangwill: "Jews are Jews everywhere, and patriots everywhere."

Sarah Israel recalled that, "She was … religious and had a thorough knowledge and understanding of the Bible, but she never imposed her view on others, or moralized, or insisted on children putting aside an interesting activity to read the Bible or listen to a religious talk. Her religion lay in everything around her – books, music, art, birds, flowers and trees, and above all people, young and old, to whom she gave willingly of her time, knowledge, and [great] love."

Rebecca spent July through September 1947 in Palestine. She was proud and excited to attend the First World Conference for Jewish Education, representing Indian Jewry as a delegate of the Bombay Zionist Association. She also attended the eight-day conference at the Hebrew University in Jerusalem. The purpose of the conference was to establish an educational standard throughout the Diaspora (Jewish communities outside the Land of Israel). One of the speakers at the conference explained that the gathering was intended "to find means of rescuing Jewish youth from the danger of loss of their identity."

In Rebecca's speech to the conference, she said: "Only Jewish education has kept us alive as a people dedicated to truth and righteousness. ... Our people will perish if the Torah perishes from among us. ... I believe with all my heart and soul that Jerusalem will be a well of living waters for all the lands of the dispersion."

Rebecca's deep love for the Land of Israel was obvious in her writings and in her conversations with others. Upon her arrival in Palestine in July 1947, she wrote to her father: "It was a thrilling experience crossing the Yarden [Jordan River] and entering Palestine. I am more fortunate than Moses. I said the Shema and felt it. Flying over Palestine is a fascinating and inspiring experience ... a marvel of the Jew's courage, determination and his intense love for his country."

During her trip to Palestine, Rebecca presented a 'Greetings' speech at the opening of a conference on Jewish education. She told the group: "I have come from a far country, from India. We are only 25,000 people among four hundred million. I am a daughter of an ancient people, the Bene Israel, and I bring greetings from all the Jews of India for the success of the work for which we have assembled here from all the ends of the earth. "

Those who had gathered to listen to her were fascinated when she told them: "From my childhood, a great longing had captivated me to see the land of my fathers, and behold, I am here, in this holy city, the city of kings and prophets; more than that – a city that is ours and our sons and our daughters, and of the generations to come."

Later, after she returned to India, she heard the announcement of Israel's independence on the radio. She wrote of the excitement she felt when listening to the proclamation of the establishment of the Jewish state. "I was thrilled

to hear over the … [radio] that the new state was to be known as ISRAEL. An ancient people has come back to its ancient inheritance, with all the wisdom of the east and the vigor of the west. … Therefore, with confidence, we look to the new-born State of Israel to stand for justice and peace."

Her neighbor, Amiruddin Jabir Ali, a Muslim man, recalled: "Obviously, she was very devoted to the Jewish cause and to Israel, but at the same time, she was very Indian and she was very sympathetic to all Indian causes. Those were the years of the formation of the State of Israel and the Government of India was not favorable in its attitude and had not established full diplomatic relations."

Rebecca was very devoted and grateful to India. Throughout the Jews' long history there, they had never experienced anti-Semitism. She once remarked to I. A. Ezekiel: "I hope you will make it your job to bring India and Israel together. It will be a real service." She herself tried hard to make it happen.

In May 1953, Rebecca wrote a forceful letter to Pandit Jawaharlal Nehru, India's first president, explaining: "Despite our names, alien to India, we are an Indian people, proud to call ourselves Maharashtrians (natives of an Indian state) and to speak the [language] of the Marathas (an Indian language)."

She explained further: "We are Indians, Sir, but we are Jews as well and, as Jews, we have an equally deep-rooted love and loyalty for the spiritual heritage of our people and for the land of Israel, which is the fountainhead of that heritage."

She hoped her letter would help President Nehru understand that Bene Israel Jews were a people equally and fully loyal to two countries.

"We have been sustained and nourished by India and Israel, and to both we owe a deep debt of gratitude," she wrote. "'Seek the peace of the land in which you live,' says one of our sages. And to our children our teaching has always been. 'Be good Jews so that you may be good sons and daughters of India.'"

The End of Her Life

At the end of her working life, Rebecca developed an illness called tubercular pericarditis. As was her style, she remained patient and cheerful through-

out this illness, as well as during her final illness following a heart attack. Her whole family was with her when she died on November 16, 1957, at the age of 68. More than a thousand people attended her funeral.

During the shiva (seven days of mourning), Rabbi Hugo Gryn said of her: "Miss Reuben was the great teacher of the Bene Israel community."

Remembering Rebecca Reuben

Rebecca's neighbor, Amiruddin Jabir Ali, remembered: "Her humility, simplicity, everything about her was so striking." He added: "Here was this person ... who had done so much for the community and the school, in whose company we always felt so comfortable and happy."

Rebecca enjoyed the friendship of many different kinds of Indians. Among them was Safia Jabir Ali, a Muslim who wrote to Rebecca's family: "I have always admired her mental abilities, her gentleness, broad sympathies, her desire for doing good to others, her tolerance and forgiving spirit, her thirst for knowledge and for giving this to others. ... These memories of my dear, dear friend I shall always cherish, and I shall always feel an especial regard for her people for her sake."

One of Rebecca's admirers, Elizabeth Corley, recalled: "She was an enthusiastic worker for social causes and her noble character is an inspiration to all. She symbolized 'Simple living and high thinking' and was herself like a candle giving light to others."

Rebecca's former student, Kumari Mabel Koletkar, recalled: "Everything about her was beautiful – her writing, her way of teaching. She taught us so well, and with keen interest in each subject. ... Her dress, though of course very simple, was graceful, but even her movements and speech were graceful."

Her friend, Abraham M. Chincholkar, remembered Rebecca with the words of King Solomon: "Many daughters have done valiantly, but thou excellest them all" (Proverbs 31:29).

"Such noble women are rare," her friend, Dr. Olsvanger, said. "She was a noble offspring of an ancient and noble family of [a] remarkable community."

In choosing to serve her family, her society, and her nation, Rebecca helped her Bene Israel community progress in ways not imagined when she began her career in the early twentieth century. Indian Jewry has never known such a lovely, loving and loved Jewish person as Rebecca Reuben.

Questions to Think About:

- *Have you ever felt unsure about what to do because of your connection to more than one country?*

Read some historical background material on each country. Ask a librarian for help in finding materials.

Interview your parents, other relatives, your friends and your teachers about their feelings about the countries that are important to them.

- *Do they feel connected to more than one country?*
- *Is that a problem for them?*
- *If so, how have they dealt with it?*
- *Do you know anyone who shares your feelings about being Jewish or about Israel, but comes from a different background than your own?*

Purchase a notebook and use it only for this project. Be sure to put the date on your writing. Every once in a while read what you have written previously.

To Learn More:

Read the article about Rebecca Reuben by C. S. Lakshmi that appeared in the February 4, 2001, online issue of *The Hindu:*
http://www.hinduonnet.com/thehindu/2001/02/04/stories/1304067s.htm

Read the book *Rebecca Reuben: Scholar, Educationist, Community Leader*, compiled and edited by Nina Haeems. Mumbai: Vacha Trust, 2000 (email: vacha@vsnl.com).

Postal address:

VACHA Trust
5 Bhavan Opp. GTC, S.V. Road
Vile Parle West
Mumbai 400056
INDIA

or

Ground Floor Municipal School Building
Tank Lane
Behind Akbarallys
Santacruz West
Mumbai
India

Telephone: 022-605-5523 or 671-3469

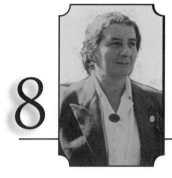

8 GOLDA MEIR *a"h*

Political Fighter for Her People's Existence

A Woman to Admire

Golda Meir's personality had many sides. Henry Kissinger, the United States Secretary of State under President Richard Nixon, wrote of her: "I loved Golda Meir because of her strength, her warmth, her humanity, her sense of humor." Golda Meir had great wit, intelligence, determination, deep love for her causes and a remarkable ability to break complicated issues into smaller, manageable parts.

Golda Meir loved her Jewish people deeply. Her many talents and her refusal to give up enabled her to be part of the creation of a homeland for them in Israel. During her term as Prime Minister of Israel, Simcha Dinitz, an Israeli diplomat, said of her: "Golda Meir has the best qualities of a woman – intuition, insight, sensitivity, compassion – plus the best qualities of a man – strength, determination, practicality, purposefulness. Therefore, we are lucky. We have double qualities in one person."

Her Childhood and Family

Golda Mabovitch was born on May 3, 1898 in Kiev, Russia, to a poor Jewish family. She was the middle sister of three. Her older sister was Sheyna, and the younger one was Clara.

Even as a very young child, Golda was aware of the fear that afflicted her

Jewish community. In 1902, when she was four years old, she watched as her family and her neighbors nailed boards across the doors and windows of their houses to protect them from a threatened Cossack (Russian) pogrom.

Pogroms were government-controlled riots against Jews that occurred periodically in Russia. Although the Cossacks did not come to Golda's community on that particular day, they arrived there in April 1903, when the terrible Kishinev pogrom took place. Forty-five Jewish men, women, and children were killed during the pogrom, and more than one thousand Jewish-owned homes and shops were looted and destroyed. In protest, the entire Jewish community decided to fast for a day in the synagogue. Two years later, on Bloody Sunday of 1905, another pogrom killed more Jews.

Golda's father, Moshe, was a skilled carpenter who made beautiful furniture. His non-Jewish workers and customers often cheated him. As a Jew in Russia at that time, he had no choice but to take the insults and injustices shown toward him and his community. This kind of persecution happened regularly to the Jews of Russia.

In 1903, as was usual at that time, Golda's father left his family behind and immigrated to the United States. He planned to send for his wife and children as soon as he found a job and a new home. Golda moved with her mother and sisters from Kiev to her grandparents' house in Pinsk, Russia, where they waited for her father to send for them. Finally, in 1906, Moshe Mabowitz found work as a railroad carpenter in Milwaukee, Wisconsin. Although he had never heard of the place, he was willing to move there in order to have a job. After settling in Milwaukee, he sent travel documents for his family.

Golda arrived in Milwaukee with her mother and sisters when she was eight years old, and the new sights there amazed her. She wrote later, "Everything looked so colorful and fresh, as though it had just been created, and I stood for hours staring at the traffic and the people."

Although the family was not much better off financially in Milwaukee than they had been in Russia, at least they did not have to fear for their lives. While her father worked as a carpenter, Golda's mother managed a small grocery store.

When Golda was fourteen years old, she left her parents' home in Milwaukee to live with her older sister in Denver. While there, she met many fascinating

Jewish immigrants from Russia. She loved listening to them talk of their ideas of creating a national homeland for Jews where they would live without fear. Two years later, when she moved back to Milwaukee, her parents' home was often filled with guests who were young Jewish men whose goal was to free Palestine (today's Israel) of its Turkish and Arab rulers. Golda noted, "I cannot remember any period when we thought of our personal affairs. Our home was always involved in causes of some kind."

The stories told by immigrants in both Denver and Milwaukee, of the struggle and courage of the Jewish community in Palestine moved Golda. She decided that as a Jew she belonged in Palestine, helping to build the Jewish homeland.

After her graduation from high school, Golda enrolled in the Milwaukee Normal School (a teacher training college), expecting to become a teacher. However, she never finished those studies. Her life took her in a completely different direction.

Her Marriage

While Golda was living in Denver, she met her future husband, Morris Meyerson. Morris, a quiet, soft-spoken and self-educated man, was also an immigrant from Eastern Europe. The fifteen-year-old Golda admired Morris for his wide range of knowledge. She later wrote that he "was not a public figure but a retiring individual, with a deep appreciation of art, music, and literature. ... I was always grateful to him for giving me much that I did not get from my home."

Although Golda persuaded Morris to move to Palestine with her, he was not so sure that a life in Palestine was what he wanted. However, he did want to be with Golda. They were married on December 24, 1917 and left for Palestine in May 1921.

Her Life on the Kibbutz

Before leaving America, Golda had chosen Kibbutz Merhavia as the place where she and Morris would settle. Kibbutz members owned everything equally and had no private property. There was equality among all kibbutz members.

Golda's job was to take care of the chickens. "Imagine!" Golda exclaimed. "Just imagine living by our own labor in a community where we're all equal, no rich or poor, no snobbery." Golda loved the idea that all kibbutz members had equal rights.

In the autumn of 1921, Merhavia had only a few frame houses, a simple shack that was the communal kitchen and bakery, and a cluster of trees. The rest of the kibbutz consisted of rocks and empty, sun-scorched fields. At first, the kibbutz members, 32 men and eight women, were not sure that they wanted to accept Golda and Morris. They were afraid that Golda would be coming to the kibbutz as a pampered American girl who was not prepared to work hard.

However, Golda proved to be hardworking and well-organized. She had amazing energy and skills, and she was also excellent at problem solving. She was capable of carrying out long and complex projects, keeping track of every detail until the work was completed. She organized Merhavia's chicken coops so efficiently that poultry workers from neighboring settlements came to study Merhavia's techniques.

Golda wrote of that time: "I enjoyed everything about the kibbutz – whether it was working in the chicken coops, learning the mysteries of kneading dough for bread in the little shack we used as a bakery or sharing a midnight snack with the boys coming back from guard duty and staying on in the kitchen for hours to hear their stories. After a very short time I felt completely at home, as though I had never lived anywhere else."

Within a year of her arrival, the kibbutz members elected Golda to the committee that made policy for the kibbutz. Since she was so fluent in English and good at public speaking, she was given the responsibility of explaining the kibbutz's goals to important visitors to Merhavia. She found all of her kibbutz experiences happy and fulfilling.

But Morris was not so enthusiastic about living on the kibbutz. After two and a half years on Kibbutz Merhavia, he found life there exhausting and unpleasant. It was hard physically and he was not as inspired by the idea of living in Israel as Golda was. He was a shy person who longed for a quiet, private life, and the strenuous work made him ill. The doctor said that if Morris stayed at Merhavia, his health would get even worse. When Morris felt that he could no longer bear kibbutz life, he and Golda reached a compromise. Golda agreed to

leave the kibbutz, find an apartment and start a family, and Morris agreed that they would stay in Palestine. The couple then moved to Jerusalem.

Her Life in Jerusalem

Morris loved living in Jerusalem and recovered his health there. However, Golda was depressed. She missed life on Kibbutz Merhavia, her friends there, and the wonderful accomplishments that came from hard work. Nevertheless, she made up her mind to try to be successful in her new life. Golda and Morris each found jobs, Golda as a cashier and Morris as a bookkeeper. Less than a year later, on November 23, 1924, Golda gave birth to a son, Menachem.

When Menachem was four months old, Golda decided to spend some time at Merhavia. She still missed living there and was not sure about what to do about her marriage. She needed to decide which came first: her husband and child or the life that she missed. After spending some time at Merhavia, she decided to return to Jerusalem and her family and to make the best of it.

Their daughter, Sarah, was born in 1926. Life was difficult for the Meyersons. They were so poor that it was a constant struggle to provide food for the children. During the winter, they had no heat in their apartment. Golda did laundry for Menachem's nursery school as a way to pay for his enrollment there. Since she could not afford a babysitter, she took the baby with her to work.

After four years of struggling without money to buy necessities for her family, Golda could bear no more. Though she loved her children and husband deeply, she felt that something had to change. She missed working for her country. She hoped that Morris would understand. She wrote to her sister Sheyna: "My social activities are not an accidental thing: they are an absolute necessity for me."

In 1928, Golda decided to become an active worker for her new country. When the Labor Party (one of the political parties) heard that Golda wanted to do political work, the Histadrut (the national labor union) asked her to become the secretary of the Women's Labor Council. In 1929 and 1930, she often had to travel for her work. It was difficult for her to leave Menachem and Sarah, who cried when she left. Sarah was often ill. Still, Golda felt she needed to fulfill her responsibilities for her job.

In 1932, when Sarah was six years old, she became critically ill with kidney disease. Golda brought her and eight-year-old Menachem to the United States for Sarah's treatment while Morris stayed in Jerusalem. This separation, which lasted for two years, was the beginning of the end of Golda and Morris's marriage.

In 1934, when Golda and her children returned to Palestine, Sarah was healthy and Menachem had learned to play the cello. The children were overjoyed to be with their father again. Golda now threw herself completely into her work on behalf of Zionism and her new homeland. She was thrilled with her work, but by 1941, her marriage had fallen apart. Golda and Morris separated. The children lived with Golda in Tel Aviv, but also stayed close with their father. At seventeen, Menachem was a talented cellist and on his way to becoming a professional musician. This pleased Morris. Sarah, who was more like her mother, secretly worked for a Haganah youth group at fourteen years of age. The Haganah was the secret Jewish army in Palestine.

Difficult Times for Her

While Golda was becoming a leader in Palestine, terrible things were happening to Jews in Europe. Hitler's first attacks on Jews, between 1933 and 1936, caused 70,000 Jews to flee to Palestine. They brought many skills and their personal wealth to the growing Jewish community in Palestine. Many of those people were professionals – doctors, teachers and lawyers – while others were wealthy businesspeople.

Many Arabs were against Jewish settlement in Palestine. They agreed with Hitler and his policies, especially his persecution of Jews. At the same time, they were worried to see that his policies caused so many Jews to flee Europe to settle in Palestine. They demanded that the British government, which controlled Palestine, limit the amount of land Jews could live on. Throughout Palestine, the Arabs attacked Jewish settlements, burning and robbing them. Although the British tried to protect the Jewish settlers, they were often unsuccessful.

The British finally appointed a commission to investigate the Arabs' concerns. In 1939 they decided, in a document called the White Paper, that between 1939

and 1944 only 75,000 Jews would be allowed to live in Palestine. After that, Jews could continue to immigrate there only with the approval of the Arabs, and the Jews would not be able to buy any more land in Palestine. It also stated that while a new Jewish state would be established there in ten years time, the number of Jews who would be allowed to live there would be decided by the Arabs.

No one liked the White Paper. The Jews in Palestine were furious, while the Arabs thought the British had not gone far enough in limiting the number of Jcws allowed to live in Palestine.

Hundreds of thousands of Jews were being murdered in Nazi concentration camps throughout Europe. The Palestinian Jewish leader, David Ben-Gurion, urged Jews in Palestine to obtain weapons and fight Arabs who attacked them. He was determined that Jewish immigration from Europe remain open. Golda agreed.

Her Work for Her Country

During the period after Golda's return from the United States in 1934 with Menachem and Sara, she was given more and more responsibility in her work with the Histadrut. By 1936, she was in charge of all the mutual aid programs, and she also coordinated the work policies and trade unions of many kibbutzim. She was also in charge of the Workers' Sick Fund, which provided medical care for the members of the Histadrut and their families. More than half of the Jewish community in Palestine were members of the Histadrut. Golda loved her work now. She felt a sense of hope and purpose in working toward the goals of Zionism: the establishment of a Jewish State in Palestine.

At the same time, she did a lot of secret work in order to save Jews. During and after the war, she worked with others to help smuggle Jewish refugees from Europe into Palestine whenever and however possible. The British were afraid of allowing the Jewish population in Palestine to grow because they feared Arab riots.

Before, during, and after World War II, homeless Jews from Europe were trying to enter Palestine to live. In 1940, Golda said: "We must do all in our power to help the illegal immigrants. Britain is trying to prevent the growth and expansion of the Jewish community in Palestine, but it should remember that

Jews were here two thousand years before the British came."

When the British learned what was happening, they arrested the male leaders of the Jewish Palestinian community. Golda was one of the few leaders who remained free.

It was at this point that the Jews in Palestine learned how capable Golda was. She was chosen to serve as acting director of the Political Department of the Jewish Agency in Jerusalem. The Jewish Agency made decisions for the Jewish Palestinian community. Golda was not sure she could handle that delicate job, but she agreed to try. She was among those who negotiated with the British from time to time on behalf of the Jewish citizens of Palestine. She also kept in contact with the Jews who were against British policies and fought against Arab terrorists. She continued doing this work until the State of Israel was created in May, 1948.

The British were now capturing boats coming to Palestine carrying thousands of Jews who had survived the concentration camps in Europe. The British sent the captured Jews to internment camps on the island of Cyprus, several hundred miles from Palestine. The camps were overcrowded and some of the people suffered from disease.

The Jewish Agency was worried that the children in the internment camps might not survive. Golda worked hard to convince the British to allow families with babies and young children to settle in Palestine, and in the end she was successful.

In 1947, the Arabs were well prepared for war. They had a great deal of British and American guns and ammunition left over from World War II, together with about 50,000 soldiers who were ready to fight. They also had artillery, armored vehicles and an air force. The Jews in Palestine had almost nothing. The Haganah had only 3,000 soldiers, 10,000 rifles, 1,900 Sten guns and 66 mortars. They had no artillery, tanks, aircraft or navy.

The United Nations was planning to divide Palestine into three parts: an independent Jewish state (which would become Israel), an independent Arab state and an international city, Jerusalem. The British planned to leave Palestine when these were established.

Now Golda agreed to undertake a delicate and dangerous mission. She traveled secretly to Trans-Jordan (present-day Jordan) disguised as an Arab woman

so that she could meet secretly with King Abdullah. She hoped to persuade him not to join the other Arab states if they attacked Israel. When they spoke, he asked her not to hurry with her mission. She replied, "We have been waiting for two thousand years. Is that hurrying?" Unfortunately, Abdullah broke his promise not to attack the new state of Israel.

Her Love of Public Speaking

Golda first learned of her love of public speaking when she returned home from Denver to Milwaukee at the age of eighteen. She spoke enthusiastically in support of Zionism and socialism. Her remarkable ability to speak in public came not only from her natural talent to speak beautifully and easily, but also from her belief in the importance of the establishment of a home in Palestine for Jews everywhere. Her speeches often recalled the days of pogroms in Russia under the rule of the Czar, the ruler of Russia who was often cruel to the Jews. She never forgot the terrible pogroms that she had witnessed as a child. She told her audience: "If there is any explanation necessary for the direction which my life has taken, perhaps it is the desire and the determination to save Jewish children from a similar scene and from a similar experience."

From 1932 to 1934, while Golda was in the United States, she worked as the National Secretary of Pioneer Women, a women's organization that supported Israel. She spoke before thousands of women, helping them to understand the dedication of young Jewish men and women who were building Palestine. Her sincerity and devotion to the Zionist cause won sympathy and support.

At first, Golda was not confident in her ability to speak publicly. However, her audiences' wonderful responses and the tremendous amounts of money they contributed to her cause soon convinced her.

Golda had still another important opportunity to see the results of her public speaking talents. In 1947, when it became clear that a war of independence was about to break out, she volunteered to travel to America to raise money to buy weapons. She knew that as soon as the new state was declared, it would face an all-out war against the Arabs. Palestinian Jews desperately needed money with

which to buy weapons. Without this money, they would have no way to defend themselves.

Golda's more experienced colleagues told her that she should not expect much help from American Jews. They had used nearly all of their money to rescue Hitler's victims. When Golda spoke at the Council of Jewish Federations in Chicago early in 1948, she used no notes. She looked at the faces of those in the audience and said: "Every Jew in the country knows that within a few months a Jewish state in Palestine will be established. ... You cannot decide whether we will fight or not. We will. ... You can change only one thing – whether we shall be victorious."

Now she believed in her ability to convince the audience. She told them, "Yes, whether we fight or not, this is a decision we have to make. Whether we live or not, this is a decision you have to make."

When she finished speaking, the crowd rose to their feet and cheered. Someone in the audience said, "We had never seen someone like her, so plain, so strong, so old-fashioned – just like a woman out of the Bible."

After two and a half months of traveling throughout the United States, Golda had collected $50 million, an enormous amount of money at that time.

David Ben-Gurion said of Golda: "Someday, when history will be written, it will be said that there was a Jewish woman who got the money which made the state [of Israel] possible."

Independence for Her Country

Golda was one of the thirty-seven people who signed Israel's Declaration of Independence. When thinking back on that time, she remarked, "After I signed, I cried. When I studied American history as a schoolgirl and I read about those who signed the Declaration of Independence, I could not imagine those were real people doing something real. And there I was sitting down and signing a Declaration of Independence."

Israel's independence was to be announced at a ceremony in the Tel Aviv Art Museum on Friday, May 14, 1948. Although Golda wished she could stay in Israel for this wonderful moment, she knew though that she needed to go to the United States on yet another urgent mission. She had been so successful in

speaking to groups there that now she was asked again to help raise money to buy weapons to protect the new country.

Once again, whenever Golda spoke, she was greeted by cheering crowds and generous support. American Jews were celebrating the birth of the new state of Israel and they wanted to support Golda and the new country.

The United States government had forbidden the sale of weapons to Palestine. It did not want to take sides by selling to one group or the other. Palestinian Jews felt they had no choice but to find a way to buy weapons to protect themselves.

Haganah teams from Palestine came secretly to the United States, where they bought guns, planes and armored vehicles to send to the Jewish community in Palestine. Golda was able to raise the money for those purchases.

When the Arabs attacked, the Jews in Palestine were ready. The first battles between Arabs and Israelis lasted for approximately one month, when the United Nations Security Council ordered a cease-fire. After that, periodic fighting continued for several months.

Her Role in the New State of Israel

Golda could not wait to return to Israel. Just as her trip to America was ending, the Israeli government asked her to become Israel's ambassador to Moscow. Even though she wanted to return home, she felt that she could not refuse this appointment. The Soviet Union was one of the first countries to recognize the state of Israel. Golda quickly returned to Israel, learned about her duties in Moscow and chose the staff for her embassy. She was thrilled that the Israeli government offered to send her daughter Sarah and Sarah's new husband, Zachariah, along with her to serve as radio experts.

When they arrived in Moscow in September 1948, and the flag of Israel was flown from the rooftop of the Israeli embassy, Golda smiled and said, "If only the Czar could have seen that!" She was so proud to return to the country from which her family had run away, this time as the representative of a new Jewish country.

On Rosh Hashanah 1948, Golda and her staff went to the synagogue in Moscow. About 50,000 Russian Jews met in the synagogue and in the street

outside to celebrate the establishment of the state of Israel and to greet Golda. She was excited as the crowd chanted her name.

After services, she went among the crowd of crying, cheering and laughing Jews. She was so emotional that she could hardly speak. Finally, she said in Yiddish, "Thank you for having remained Jews." The people in the crowd passed her message on from one to another.

Afterwards, when the Israeli embassy staff met in their hotel room, they sat together silently, some of them weeping at what they had just witnessed. Those brave Jews whom they had seen could have been severely punished by their government simply for going to the synagogue.

Golda was successful in building good relations between the Soviet Union and Israel. Still, she was not happy being away from Israel. After David Ben-Gurion was elected Israel's first prime minister in January 1949, he asked Golda to become Israel's Minister of Labor. She was overjoyed that now she could at last go back to her home.

Since Israel had never had a Minister of Labor before, Golda worked hard creating this new government agency. She was an outstandingly successful leader. Israel's population more than doubled during those early years of Israel's existence. An important part of Golda's job was to help new immigrants find housing and jobs. Her goal was to build houses just outside the cities so that workers could live near their jobs. They received free job training and money to help support their families.

Golda was energetic and ambitious. She supervised the building and administration of these programs and raised money in America to support them. She wanted to improve the lives of all who had immigrated to Israel. She said, "Every unemployed man or woman is one hundred percent unemployed. Every family that lacks decent housing is one hundred percent miserable. Economic problems are not problems of numbers but problems of flesh and blood – human problems."

The seven years during which Golda was Israel's Minister of Labor were among the most satisfying years of her life. By 1953, her ministry had provided job training to 30,000 immigrants, and built 52,000 temporary housing units and 82,000 apartments in permanent buildings. It had provided grocery stores, synagogues and schools to serve the neighborhoods.

Fighting for Her Country

The Arab states on Israel's borders began to threaten Israel in early 1956. The Egyptians, under President Gamal Abdel Nasser, had bought Russian planes, tanks, and guns and had begun to train its soldiers. Arab terrorists attacked Israeli settlements. In July 1956, the Egyptians prevented Israeli ships from crossing the Suez Canal, an important passage for trading. By October, Egypt announced that Jordan and Syria had joined with Egypt to "tighten the death noose around Israel."

Some members of the Israeli government and military met secretly and decided that Israel must strike first. Golda explained: "Not only the well-being of Israel, but perhaps the peace of mankind, demand that the question of responsibility for unrest in this part of the world be faced and the causes of tension removed."

Fighting began between Egypt and Israel on October 29, 1956. In four days of fierce fighting, Israeli soldiers defeated the Egyptians and Israel captured the Sinai Peninsula, which is four times Israel's size. It also captured the Gaza Strip, which Egypt had occupied in 1948.

On November 1, the United Nations Security Council ordered a cease-fire. Later that month, the U.N. Security council adopted a resolution demanding that Israel withdraw from the occupied territories.

Golda was stunned and sad that Israel had so few friends in the U.N. She said: "We are a very small people in a small barren land which we have revived with our labor and our love. The odds against us are heavy; the disparity of forces is great; we have, however, no alternative but to defend our lives and freedom and the right to security. We desire nothing more than peace, but we cannot equate peace merely with an apathetic readiness to be destroyed." She appealed to Arab delegates at the United Nations, "Does hate for Israel and the aspiration for its destruction make one child in your country happier? Does it convert one hovel into a house? Does culture thrive on the soil of hatred?"

Her Role as Israel's Foreign Minister

At this time, Prime Minister Ben-Gurion asked Golda to become foreign minister. Golda did not want to leave Israel and her family and friends again.

She knew that she would need to travel abroad frequently in this position, but she accepted it in order to serve her country. She wanted to win friends for Israel.

As foreign minister, Golda's life changed yet again. Ben-Gurion asked the members of his government to take Hebrew names. Golda chose the name Meir, which was similar to Meyerson and means "illuminate" in Hebrew. She wanted others to see her as an Israeli with an Israeli name as she traveled abroad in her new position. She then moved to a large elegant house in Jerusalem where she could receive distinguished guests while she was in Israel.

When she traveled to Africa, she was extremely well received because of her warmth, energy and charming personality. She said she hoped to help these new African countries in their "drive toward social justice, reconstruction and rehabilitation that is at the very heart of Labor Zionism – and Judaism."

Golda loved her role as representative of her beloved country. She started an International Cooperation Program, recruiting Israeli experts to work together with their counterparts in other countries. The Israelis taught the others important survival skills.

Golda explained: "We've sent our experts in agriculture and building to over eighty countries, and we'd be more than happy to share our knowledge with those around us. God knows – and the people in our neighboring countries know – how much they need this help. They have the same problems we have, the same lack of water, the same desert, exactly the same."

When people asked her if she felt handicapped at being a woman minister, her answer was "I don't know – I've never tried to be a man." She explained, "It has been my good fortune ... to work from an early age mainly among men, and it is to their credit, I suppose, that I always felt pretty good about it." Then she added, "I never expected any privileges from anybody because I was a woman, and the men with whom I worked never treated me less kindly because I was a woman. They never gave in to any argument because I was a woman, and they always had the courage to accept my idea if they thought it was right."

David Ben-Gurion said about her, "Golda Meir is the only man in my cabinet," meaning that she showed greater strength than anyone else.

Golda loved to visit many of the projects in which Israel was involved worldwide. However, after some time, the strain of constant travel began to

be difficult for her. She wrote in her autobiography: "I seemed always to be either en route to somewhere or from somewhere or sick."

In addition, Golda was diagnosed with cancer of the lymphatic system in 1963, although very few people knew of it. One year later, at age 66, after 43 years of working for Israel, she began to consider retirement. She wrote that her work had been "sixteen hours a day, thirty days a month."

Following Levi Eshkol's election as Prime Minister, Golda resigned from her position as foreign minister. But only a few months later, the Labor Party asked her to help them with a problem. Convinced that her country needed her, she became the Labor Party's secretary general.

Israel's Arab neighbors now began to wage a constant war of words and deeds against the Jewish country. All Israelis were worried about the threat to their country's existence.

On May 27, 1967, Egypt's President Nasser ordered the United Nations peacekeepers to leave their posts on the border between Israel and Egypt. They had been monitoring the situation there since 1956. It was clear that Egypt was preparing for war when the Egyptian army of 100,000 men and hundreds of tanks assembled in the Sinai Desert. It was an anxious time for all in Israel and Jews throughout the world as well.

Golda remembered: "Three or four days before the 1967 war I went down to the Negev [in southern Israel] to visit my daughter and grandchildren – just to see them, not being sure what might happen. I said three things to them: 'I don't see how war can be avoided. Nobody is going to help us. I'm convinced we will win.'"

On June 5, 1967, Israel's defense forces conducted a surprise attack against Egypt. The brilliant attack was launched by land and air where the Egyptians least expected it. Most of Egypt's air force was destroyed in just a few hours. Jordan, Syria and Iraq, joining in the war against Israel, suffered badly too. The war ended so quickly that it is referred to as the Six Day War.

Her Role as Israel's Prime Minister

When Prime Minister Levi Eshkol died suddenly of a heart attack in March 1969, Golda was asked to serve as prime minister of Israel until regular elections

could be held. This was a difficult time for her. She knew that Israel needed a strong leader at this crucial time, but she was reluctant to take on the exhausting demands of that job. After spending a long night consulting by phone with Menachem and his wife, who lived in Connecticut, and with Sarah and her husband in Israel, she agreed to accept the position.

On March 7, Golda Meir received a huge majority of the vote as Prime Minister. She wept openly, feeling honored and grateful for the support she received. She was also frightened by the responsibilities of her new job. She later admitted that being prime minister was "an awful job. It is not the work. God knows, before I came to this office, I was not given an opportunity to be spoiled by leisure. I only dreamt about it. But the responsibility, it is an awful strain."

In her new position, Golda worked day and night without stopping. She even had important meetings at night around her kitchen table. In the middle of a meeting, she would sometimes make sandwiches or chicken soup. And wherever she was, she was a powerful speaker with definite ideas. She felt that she had no choice. At this time, Israel was surrounded by Arab enemies and she needed to lead her people to safety. She explained this attitude when she wrote: "When people ask me if I am afraid that because of Israel's need for defense the country may become militaristic, I can only answer that I don't want a fine, liberal, anti-colonial, anti-militaristic, *dead* Jewish nation."

There were times when Arabs broke the cease-fire that had been agreed upon after the Six-Day War, shooting periodically at Israeli soldiers and civilians. Golda warned: "Anyone who fails to honor the cease-fire agreement and shoots at us cannot claim immunity from the results of his aggression. Those who attack us should not be surprised if they are hit sevenfold in response." She was firm and kept her promise. After each act of Arab terrorism, she fought back even harder.

Whenever Israeli soldiers were involved in military operations Golda wanted to know about their welfare. She explained. "We count each one. And each sorrow is not only of the mother, but of all mothers, of everybody in the country. They're everybody's sons." She still insisted that Israel be firm in its fight with its neighbors.

Yet Another War

As the military situation in Israel worsened in 1973, Golda's cancer was spreading. She received treatments in almost total secrecy because she knew that her country depended upon her.

In September 1973, Syrian troops were assembling upon the Golan Heights at Israel's northeastern border. Egyptian troops were also gathering along the Suez Canal on Israel's southern border. Israel's intelligence officers and military advisers, including Defense Minister Moshe Dayan, were convinced that the Arabs would not attack and advised against a call-up of Israeli troops. But their advice was wrong. The Arabs attacked at both borders on October 6, 1973 – Yom Kippur.

Golda wrote in her autobiography, "That Friday morning, I should have listened to the warnings of my own heart and ordered a call up [of soldiers]. ... I shall never again be the person I was before the Yom Kippur War."

With the help of American weapons and warplanes, Israel's soldiers finally won that battle, but the losses were terrible. More than 2,500 Israelis were killed. There was great sorrow and criticism in Israel over those losses and over the fact that Israel had been unprepared. Hurt, angry and discouraged, Golda resigned as prime minister on April 10, 1974, saying: "I have come to the end of the road. It is beyond my strength to continue carrying the burden."

Her View of War

Golda was never happy to send Israel's soldiers to war, but she fulfilled that obligation when it was necessary. She explained: "We have been obliged to become good soldiers, but not with joy. We are good farmers with joy. It is a wonderful thing to go down to a kibbutz deep in the Negev and remember what it was – sand and sky, maybe a well of brackish water – and to see it now green and lovely. To be good soldiers is our extreme necessity, but there is no joy in it." Then she added, "The only thing we have ever wanted to conquer, and did to a certain extent, is the desert. It is the only joy we have in conquest, and we do something about it."

She noted "From the outset the pioneers [early settlers in Israel] sought to

achieve their goals in complete friendship and cooperation with the Arab population. ... My country remains ready at all times to put aside the rancor of the past and to work out with the Arab leaders a better future for the Middle East as a whole."

The End of Her Life

After Golda resigned, she still had no time to enjoy the quiet life for which she had hoped. Members of the Labor Party called her for advice every day! Even though her telephone number was unlisted, some people learned what it was, and then she needed to change it. She changed her telephone number four times.

Now her life was filled with disappointments. She was sad to see her old political enemy, Menachem Begin, become prime minister. When Egyptian President Anwar Sadat decided to come to Jerusalem to discuss peace with the new Begin government, she was disappointed that Sadat had never responded to her efforts to make peace. She was deeply hurt when Begin critics accused her of having missed opportunities to make peace.

She decided to correct the inaccurate information, facing her critics and presenting the facts. Even though she was now often ill and tired, she began preparing for a press conference in which she would defend her actions as prime minister. Although she often had to go to the hospital, she continued with her plans.

But Golda was never able to complete them. She became more ill and tired as time went on, and entered Hadassah Hospital in Jerusalem for the last time on October 19, 1978.

Golda Meir died at the age of eighty after having fought cancer for fifteen years. Her family and closest friends were with her. She was buried on Tuesday, December 12, 1978, praised by her family and friends, leaders from around the world and all those who knew how much she did to build the Jewish nation.

Remembering Golda Meir

Egyptian President Anwar Sadat met Golda Meir in 1977 when he came to Jerusalem to discuss a peace treaty between Israel and Egypt. He said: "Golda

Meir was a noble foe who always proved that she was a political leader of the first category, worthy of occupying her place in your history and worthy of the place she occupied in your leadership."

US President Richard Nixon said of her: "Golda Meir showed simultaneously the qualities of extreme toughness and warmth."

Questions to Think About:

- *What would you speak favorably of in public?*

Think about a subject you want to promote and the points you would like to make. Make a list of them. Practice giving the speech. Go over it several times. When you feel comfortable doing so, present your speech to a family member or a friend. Ask him or her for feedback.

- *What things would you like to accomplish, but are not sure that you are capable enough?*

Think about all the parts of the task that need to be done. Make a list of all of those parts. Start completing the task, part by part. When the entire task is completed, evaluate how you can improve.

To Learn More:

- Visit these websites:
www.wic.org/bio/gmeir.htm and www.jewishvirtuallibrary.org/jsource/biography/meir.html

9 ANNA TICHO *a'h*

Artist Who Captured the Spirit of Jerusalem on Canvas

A Woman to Admire

"I chose the landscape and I also felt that it had chosen me." This was how Anna Ticho explained her love for painting Jerusalem, which is expressed in all of her drawings and paintings. She said that Jerusalem, where she lived from the time she arrived there in 1912 at the age of eighteen until her death in 1980, was the first place where she had ever felt at home. Her artistic expressions of her love for Jerusalem and the hills surrounding it have given thousands of people throughout the world a sense of that city. Through her work, Anna Ticho has brought images and feelings of Israel and Jerusalem to the homes and lives of people throughout the world in a way that no one else has ever done.

Anna Ticho's friend, Elisheva Cohen, noted: "Her work [demonstrates] the Israeli landscape, particularly the Judean Hills and Jerusalem, the scenery of which she never tired of drawing during the sixty-odd years she lived here."

The sculptor Jacques Lipchitz wrote to Anna Ticho after a visit to her studio in 1962: "As soon as I started to look at your drawings, I felt that I was in the presence of a master draughtsman. Without love you could not have done it, despite your masterhood."

Her Childhood and Family

Anna Ticho was born in Brunn, Austria, in 1894, to a wealthy and educated

family. She was one of seven children. From the time she was very young, she was a strong-willed person, always wanting to have her own way. Her mother tried to discipline her, but her father and older brothers could not help but spoil her.

In 1904, when Anna was ten years old, her family moved to Vienna, Austria, a very exciting city for her. She loved the theatre, the museums and the concerts there. At the age of twelve, she began to study painting and drawing at home. Three years later, she began studying in an art school. This was a turning point for her, one that determined her career.

While her mother encouraged her to study art, her father, a banker, felt differently. He wanted Anna to be more practical and choose a more traditional profession. When Anna was fourteen years old and studying art, her father asked her what she planned to do with a degree in art. She answered, "I'm prepared to give up the money (for an artistic profession)." He then asked, "Do you think anyone would marry you without money?" She answered, "I'm certain of it." She was successful in convincing him to permit her to continue her art studies.

In 1912, she left her family in Vienna and immigrated to Palestine in order to marry her cousin, Dr. Albert Abraham Ticho, in Jerusalem. Anna was only eighteen years old, while her new husband was twenty-nine.

Since Dr. Ticho had strong Zionist feelings, he was happy at the thought of spending the rest of his life in Jerusalem. He had studied medicine in Vienna, which at that time was filled with young people who were excited by the Zionist idea. In the summer of 1912, at the end of his medical internship period, Dr. Ticho accepted an offer from an organization called Le-ma'an Zion ("For the Sake of Zion") to run an eye clinic in Jerusalem. He was thrilled to move to Jerusalem and begin his medical work there.

Anna came to Jerusalem out of love for her future husband, saying later on: "Love was the motivation." Albert Ticho wrote love letters to Anna while she was still in Vienna, urging her to join him in Jerusalem. She agreed, and several months after Dr. Ticho arrived in Jerusalem, he and Anna were married. Their wedding was held in what was then the Kamenitz Hotel.

Anna remembered that although Jerusalem was a tiny city at that time, "From the first day, I felt the influence of its rare beauty." She believed that her first impression of Jerusalem was what influenced her future as an artist.

Her Husband's Success

Albert Ticho established his eye clinic in Jerusalem and became immediately successful and well-known. Not only did he have excellent relationships with his patients, but he was also successful in fighting against eye diseases that were common in the Middle East.

However, the First World War broke out soon after his arrival. Albert Ticho had remained an Austrian citizen and therefore had to serve as an officer in the Austrian army. Anna and her husband were sent to Damascus, where they lived for several months. Albert Ticho served as the official eye surgeon to the Austrian army units stationed in Lebanon and Syria and was awarded the Medal of Honor for his service.

While in Damascus, Anna suffered a severe case of typhoid fever and repeated attacks of malaria, which endangered her life and left her weak and ill.

In 1919, Anna and Albert left Damascus and returned to Jerusalem. Upon their return, they found that the money that was used in Damascus was worthless. Albert Ticho had hoped to open his own eye clinic, but he could not afford it. He therefore decided to work for a salary in order to save enough money to open a clinic. He was one of the founders of the Hadassah Hospital Eye Clinic in Jerusalem and worked as head of the eye department there from 1919 to 1921.

By 1921, Albert Ticho had saved enough money to open a private clinic. During the 1920s he became known as the greatest ophthalmologist in Palestine. He was particularly famous for his miraculous cures of eye diseases that were common in the Middle East.

Albert Ticho soon became one of the pioneers in the war against trachoma, a disease that affected both Jews and Arabs throughout the Middle East. People throughout the Middle East. wealthy and poor alike, wanted to be treated by him. Thousands of patients of all ethnic, religious and social backgrounds traveled great distances to be treated by the famous doctor. Patients came from Palestine and also from Turkey, Syria, Egypt, Persia and India.

Albert Ticho also served as the doctor of King Abdullah of Jordan. His wealthy patients gave him many valuable gifts, including a horse, which was presented to him by a sheik (the chief of an Arab tribe). However, many of his patients were poor, and he did not charge them for treatment.

Anna always worked with her husband as his nurse, particularly in the operating room. Her husband had trained her as an operating-room nurse when they lived in Damascus, where there was a shortage of trained nurses. Anna was content to help her husband, who was the more famous of the couple during the early years of their marriage. It was only later, when Anna was recognized for her artistic abilities, that she became the more famous of the two.

Although the Tichos had no children, Anna loved them and enjoyed spending time with them whenever possible.

Her Home

In 1924, Albert Ticho bought the Aga Rashid mansion from a wealthy Arab who had never lived there but instead had rented it to other people for many years. The home, which was located in the center of Jerusalem, had a beautiful garden.

After purchasing the home, the Tichos renovated it completely. The ground floor of the building housed the eye clinic until Albert Ticho's death in 1960. Anna and her husband shared the upper floor with Anna's mother, who had come to live with them and was in charge of the hospital kitchen.

Their beautiful home became a popular meeting place for people of many faiths, opinions and professions who lived in Jerusalem. Guests from abroad loved to visit as well. Physicians, scientists, writers, artists, Zionists leaders and statesmen of every political position frequently met there.

Jerusalem's population of German-born immigrants often visited as well because of the Tichos' European background. When the Nazis came to power in the 1930s, a stream of German Jews began to arrive in Jerusalem. Many of the educated and cultured among them found their way to social gatherings at the Ticho home. Albert and Anna were always extremely hospitable to their many guests.

In the 1930s the Tichos bought a vacation home in Jericho, which is today a short drive from Jerusalem. Later, in the early 1950s, they purchased a small country home in Motza, near Jerusalem. It was a simple, small, Arabic style house with a spectacular view of the Judean hills. Albert and Anna loved to spend time there, where Anna felt closer to nature and to the hills that she loved to draw and paint. Even though Anna worked hard helping her husband treat

patients in the clinic, she continued to practice her art. She and Albert loved to get away to enjoy the relaxing and inspiring views of their vacation home.

A Sudden Change in Her Life

In the mid-1950s, Albert Ticho fell ill and was forced to stay in bed until his death on October 15, 1960. Although Anna felt the loss of her husband deeply, she continued to be a gracious host, keeping her door open to her many guests.

After the reunification of Jerusalem in 1967, it became clear how much the entire population of Jerusalem had loved and respected Albert Ticho. Once the partition between the two parts of the city was removed, Arab acquaintances from the old days began to visit the Ticho home once more. They wanted to learn about Albert Ticho's life since they had last seen him, and they also wanted to pay a visit to Anna.

After Albert Ticho's death, Anna's life took a new turn. She spent less time in the house in Motza, choosing to work mostly in her studio on the second floor of their Jerusalem home.

Her Career

The eight years that Anna Ticho spent as a child and young woman in Vienna made a great impression on her as an artist. Vienna at that time was a beautiful and exciting city. Its rich cultural life, with its museums, opera, concerts and theatre, were all part of the European heritage that always stayed with her. Later, when Anna lived in Jerusalem, where she painted and drew her impressions of the scenery in her new home, she continued to remember the cultural excitement of the city of her childhood.

Anna lived and worked in Jerusalem from 1912 until her death in 1980. When she arrived there, it was a small remote city, barely larger than a village, on the edge of the Turkish Empire, which had ruled that area for many decades. The city had narrow and dusty streets that were filled with churches and mosques.

At first, Anna felt at a loss. There was almost no artistic life there and the few artists who lived in Palestine at that time had art styles that were different from anything she knew. She did not share the life-style of the young pioneers who were

building up their new country. She was a shy and modest person who needed time to adjust to her new life. In addition, although she eventually learned to speak Hebrew, she always felt much more comfortable speaking German or English. She was fluent in both of those languages and enjoyed communicating in them.

Still, as culturally limited as Jerusalem seemed in comparison with Vienna, from the very first day of her life in Palestine, Anna felt tremendously impressed with Jerusalem's beauty.

She remembered, "I came to Palestine when it was still 'virgin land,' with vast, breathtakingly beautiful vistas." Then she added "When I speak of Israel, I really mean Jerusalem. ... When I came to Israel I was impressed by the grandeur of the scenery, the bald hills, the large, ancient olive trees and the clefted [sharply cut] slopes ... the sense of solitude and eternity."

She was at first surprised and fascinated by the unfamiliar sights in and around Jerusalem. The size and beauty of the Judean hills impressed her. They were so different from European landscapes. She was so moved by what she saw that she found it hard to express her excitement through her art. She was surprised with the amount of strong light the natural environment offered. In Europe, the countryside was green and there was continuous outside light only during the summer. She found that Jerusalem had nine months of summer and little green in the city or on the Judean hills.

For a long time, Anna was unable to do her artwork. She wanted only to observe and find ways to understand her new surroundings. During her first four years in Jerusalem, she did not paint. She explained, "I was dumbfounded and overcome with emotion, and could not work." It seems that the abrupt move from the lush green European scenery of her childhood years to the harsh Palestinian landscape shocked her. She spent those early years observing her new home and its surroundings. This early experience determined her future as an artist in her new home.

Resumption of Her Artwork

Anna began to draw once more when she moved to Damascus with her husband during World War I. When they returned to Jerusalem, she continued her artistic work. Once back in Jerusalem, she tried to become familiar with it by sketching

in the streets and from rooftops of the walled Old City. She studied Jerusalem in every detail.

She walked the streets and the hills, sitting on rooftops and working under the burning sun. She was so involved in her work that she never worried about causing harm to herself by overexposure to the sun or falling from a high place. One time as she walked through the old city streets in East Jerusalem, an Arab man asked her, "Aren't you afraid?" She answered, "You're a gentleman, so I'm not afraid." Actually, the Arabs among whom she spent time as she painted never bothered her. Thinking that she was insane because of her tendency to sit on rooftops and paint, they left her alone.

When Anna was finally able to deal with what she saw, she began to create small, simple pencil-and-paper drawings. After one year, she drew more detailed sketches. She remembered: "They weren't very good, but I kept at it." Her development was slow and gradual, and she was slow to find self-confidence, too. She did not paint in public until the late 1930s, and it was not until the 1950s that the public began to know Anna as a painter.

Anna chose her subjects carefully and drew with detail all that she observed. Gradually, she became more comfortable drawing and painting the scenery around her. She loved to draw and paint the narrow courtyards, small houses with domed roofs and odd windows and crowded alleys. She remembered, "After the First World War, I worked constantly in Jerusalem, always in Jerusalem. I went out of doors to work with nature. It was not easy. The heat could be oppressive. ... I was always alone." As the years went on, she also began to feel more comfortable experimenting with different drawing materials.

Her Sketches

When patients came to see Albert Ticho, they waited for their appointments in the Tichos' garden. There were always long lines of people waiting. As they waited there with their donkeys and camels, Anna would speak with them and ask them to sit as models for her drawings. She preferred elderly models who looked like they had had a hard life. Sometimes she found a beggar in the street. After bringing him home and giving him something to eat, she would ask him to sit for her. Then she would study and draw his head from every angle. She would carefully

study her models' faces, chatting with them as she worked. She listened to them and tried to get to know them. She tried to learn what was going on in their minds as she observed their exterior. Then she felt prepared to draw them, with expressions on their faces that reflected their inner thoughts and feelings.

Her Landscape Drawings

The variety of the landscapes in and around Jerusalem stimulated Anna's imagination. She always felt challenged to find a way to express the simplicity and beauty of her new homeland. She was always searching for methods to express the dry and scorched look of the hills in the summer, and the way the hills turned green and were dotted with colorful flowers in the rainy months. When she spent time in the house in Motza, on the slopes of the Judean Hills at the entrance to Jerusalem, she felt closer to nature. She loved observing the open hills and vegetation. She explained: "For many years I contemplated the scenery, drawing it repeatedly and faithfully."

Painting in Her Studio

In the mid-1950s, as Albert's health worsened, Anna discontinued her habit of observing nature and worked only in her studio. It was difficult to get to their house in Motza since Albert Ticho needed to stay in bed. Now Anna drew only from memory. In a way she felt freer doing this, painting more abstractly rather than realistically.

After Albert Ticho died in 1960, Anna worked mainly in her studio. She stopped going out in the oppressive heat with her little chair and parasol. Now her work changed. She no longer drew from nature or observed the landscape. She did not need to look outside for ideas anymore. Although nature continued to inspire her, her drawings were based upon her imagination.

Anna felt that she had taken a very important step forward as an artist by working only in her studio. "It was very daring of me," she noted. Once inside the studio she needed to rely on her memory of nature rather than to paint what she saw.

In her studio, she created large-scale drawings of the Judean Hills. While most of her earlier drawings had been done in black and white, during the

last ten years of her life she painted in color: brown for the parched earth, green for the olive trees and violet for the tinge of the hills at the end of the day. For many years after she came to live in Jerusalem, she was known for her sketches rather than for her paintings. Now, at the end of her life, Anna became famous as a Jerusalem painter.

Her Artistic Techniques

In the beginning Anna used only a pencil, but when her pictures became larger and more detailed, she started using charcoal. Eventually, she did hundreds of very large drawings in charcoal.

Sometimes she used a felt pen. Later she used other techniques, such as brush and wash. This technique required quick movements of the brush. She found it exciting to try it because it enabled her to create different shades of color. Some of her most dramatic drawings use this technique.

Anna Ticho is best known for her detailed charcoal drawings. She always loved working with charcoal. She loved flowers and had them all around her her home and studio. She created many beautiful paintings of flowers.

Although Anna was always independent as an artist—trying new techniques, materials and subjects and working on her own—she did not remain alone as an artist. She traveled frequently to Europe, particularly to Paris, London, Amsterdam and Vienna, and to the United States. As she traveled, she came into regular contact with international artists and their works. She was always ready to learn and accept stimulation from other artists' work, seeing that as an opportunity to be inspired as an artist.

Anna Ticho never established a school or taught students. She was a master of a highly personal style of painting. She first became known as an artist in Amsterdam, where her work was shown in galleries. Her fame then spread to America, and Israelis started to become familiar with her work at last.

Her Life as a Community Leader

Anna Ticho's life was extremely busy. She helped her husband for many years. Their lovely old house in the center of Jerusalem was a meeting place

for Jerusalemites of all faiths as well as for visitors from abroad. It brought together people who enjoyed an international, cultural and educated atmosphere.

Anna always took an active interest in public and cultural affairs. She was one of the founders of the new Bezalel School, later called Jerusalem's Bezalel Art Academy, which opened in 1932. She had her first exhibition at Steimatzky's gallery in Jerusalem in 1934.

Anna received many prizes for her work, including the Erest Prize for Painting and Sculpture in Jerusalem in 1964, and the Sandberg Prize for Israeli Art from the Israel Museum in 1975. In 1970, Jerusalem awarded her honorary citizenship.

The End of Her Life

Although Anna suffered from several life-threatening illnesses, she lived to the age of 86. She continued to work almost to the end of her life, and she died on March 1, 1980.

After living in the beautiful Ticho house in the middle of Jerusalem for more than fifty years, Anna Ticho donated it to the Israel Museum in Jerusalem. She and her husband had wanted it to serve the residents of Jerusalem as a cultural and recreational center, as an expression of their love for the city of Jerusalem. They wanted residents and visitors to the city to enjoy the beautiful house and its lovely garden.

Anna Ticho approved of the restoration of her home in order to prepare it for its new function as a meeting place for citizens of Jerusalem who would gather for exhibitions and cultural events. With the assistance of Jerusalem architect David Kroyanker, the house was restored to its original plan, the large garden was tended and the management of the building was transferred to the Israel Museum.

There is a charming restaurant and gift shop on the first floor. The restaurant extends into the beautiful garden, where weddings, bar and bat mitzvah celebrations and other events often take place. The second floor, where Anna Ticho lived with her husband, is today the gallery with a permanent exhibition of her work. Albert Ticho's large collection of Hanukkah menorahs is on

display there. Artists, musicians, and storytellers are often invited there to present their works to the public.

Anna's friend, Elisheva Cohen, explained: "Being childless, [Anna Ticho] wanted the house to bear the Ticho name which had, in the span of two generations, become something of a legend in Jerusalem, the city so dear to her and Dr. Ticho."

Remembering Anna Ticho

Irit Salmon, curator of Ticho House, noted: "Anna Ticho was a born artist." Nevertheless, it took a very long time for her to gain enough confidence to express her talents fully. She reached her peak as an artist only at a rather advanced age. While her husband was alive, she divided her time between her artistic activity and her daily work as his assistant in the operating room.

Elisheva Cohen explained: "Her creative work always enjoyed the full support and encouragement of her husband, who set great store by it, but he depended on her for his own work, and she undertook this commitment wholeheartedly."

After Albert Ticho died, Anna's art became the focus of her life. Elisheva Cohen said "It is … in a sense, tragic that Anna Ticho attained the height of her success only after her husband's death." Anna survived her husband by more than twenty years, and during that time "matur[ed] artistically and arriv[ed] at a new freedom of expression that not only gave her great personal satisfaction, but also secured her place among Israel's foremost artists."

Elisheva Cohen noted: "Art was the overriding interest in the life of Anna Ticho, followed by the Ticho home, which was so close to her heart."

Anna Ticho's neighbor in Jerusalem and fellow artist, Jacob Pins, remembered that "people liked her … she was a friendly person … and her art was wonderful."

Teddy Kollek, the former mayor of Jerusalem, remembered her as "… small in height, but far the opposite in stature. She was warm and funny." Kollek noted: "Her feeling for Jerusalem was a love story told by her drawings and paintings."

Questions to Think About:

- *Could you tell a story about something you love in a way that does not require discussing or writing about it?*

Think about what it is you would like to tell others. Think of ways that you could tell others about it without writing or talking about it (drawing, painting, singing, dancing, miming, building a sculpture).

- *Have you ever moved to a new place and found it so different from the place that you left that it was hard to adjust to it?*

Think of the ways that Anna Ticho found to adjust to her new life. Remember her as you walk around observing your new home, taking time getting to know and appreciate it. Use a method for understanding your new environment that feels comfortable (writing about it, drawing it, discussing it with others).

To Learn More:

Visit a website that tells about the Ticho House: http://www.imj.org.il/eng/branches/Ticho_house/index.html and http://www.go-out.com/ticho/

When you are in Jerusalem, visit the Ticho House on 7 Ha-Rav Kook Street. It is best to phone there to make sure the house is open for visitors. Call 02-624-5068 or 02-624-4186. You will be able to see Anna's work and Albert Ticho's collection of Hanukkah menorahs, and you might be able to enjoy a special cultural program. You will certainly be able to enjoy a wonderful meal.

10 NAOMI SHEMER a'h

First Lady of Israeli Music

A Woman to Admire

Naomi Shemer was a very special Israeli songwriter and composer. She was able to express her people's pride, pain, joy and hope in her songs. Her lyrics were simple enough that those who heard them could to sing along, and at the same time they were full of wisdom, emotion and rich linguistic sophistication, using special words in wonderful ways. Naomi Shemer wrote nearly four hundred songs.

Naomi Shemer could not separate being Jewish from being an Israeli. Her life in Israel began before the country's War of Independence in 1948. She remembered the thrill of living in a new, independent Jewish country afterwards and the sadness of the other wars that followed. Throughout her career, she wrote songs that captured the changing moods of the Israeli people. Sometimes her songs showed admiration for Israel's important sites, as in the song "Yerushalayim shel zahav" (Jerusalem of Gold), which was written just before the Six Day War. At other times, they expressed a longing for peace, such as the way people felt during the Yom Kippur War, as in "Lu yehi" (May It Be).

Naomi's friend and fellow songwriter, Ehud Manor, remembered her as "the most important artist in the history of Hebrew song." Israel's Education Minister Livnat Limor reflected that, "Naomi has left us an immortal legacy of Hebrew works on which many generations of Israelis will be raised."

Her Childhood and Family

Naomi was born on July 13, 1930, at Kibbutz Kinneret. Her parents, Meir and Rivka Sapir, came to Palestine from Vilna, which was then part of Poland. Meir arrived in 1920 and Rivka came five years later. They met at Kibbutz Kinneret, which they helped establish on the shores of Lake Kinneret (also called Sea of Galilee) in Israel. Both of them had a rich Jewish and Hebrew education and a close attachment to Jewish history and Hebrew language.

The Sapir family was recognized by fellow kibbutz members as "hardworking and devoted to the kibbutz." Her parents were very devoted to their Jewish homeland and the Jewish people. Her father served as the commander of an organization that smuggled Jewish Holocaust survivors out of Europe and brought them to Palestine after World War II.

Naomi had a brother, Yaakov, and a sister, Ruth. Yaakov and his wife, Zahava, and some of their children still live on the kibbutz. Ruth and her family live in Moshavat Kinneret nearby.

Naomi's parents loved music. Rivka played the flute and Meir loved to sing. Rivka was eager to encourage her daughter to develop musical skills. When Naomi was six years old, her mother arranged for a piano to be donated to the kibbutz by her American friends. She recognized Naomi's talent and made sure that she had a piano on which to practice.

Naomi is remembered by those who lived at Kibbutz Kinneret as "a small and slim girl" who played the piano every morning. It must have been hard for the young Naomi to wake up before the other children so that she could practice, but she did it because of her mother's determination. Some of her neighbors at the kibbutz remember that she often practiced at night too.

The kibbutz piano was kept in the children's house. The children on the kibbutz lived together there, apart from their parents. The children's house and the piano inside it were the center of life for the children of the kibbutz.

For years, Naomi played the piano not only for the other children when they sang Shabbat songs, but she also lead sing-alongs on Friday evenings and on Jewish holidays for the whole community. She later recalled, "No one taught me how to do that." She was good at improvising and had per-

fect pitch. She believed that living at Kibbutz Kinneret and singing there gave her the best possible training for her future career.

Naomi remembered that singing together as a group was an important part of life in Israel. She explained that in Israel "There was a mish-mash, songs from Germany, Russia, Bedouin songs, and songs in Yiddish. Everything was turned into Hebrew and it became ours. We would sing endlessly."

Fellow Kibbutz member Diti Lean remembers Naomi Shemer's energy and musical professionalism. "When my classmates and I graduated from elementary school, Naomi, who was in her thirties, helped us create a musical show. She created all the music and the words right on the spot, while she sat at the piano. She did not teach us, she led us – and with tremendous energy. She never needed to read notes. She created them, and she did it effortlessly." Diti added, "She was not only creative, but the songs came from deep in her heart. Music was in her soul and in her body."

Preparing for Her Career

As a teenager, Naomi traveled to Haifa once every two weeks to study with pianist Hans Neumann. A few years later, when she finished high school, she hoped that she would be able to continue her musical studies. Her mother agreed with her. The importance of this, however, was not so clear to other members of their kibbutz. In fact, this was such a new idea for them that there were actually three meetings during which all members of the kibbutz met to discuss whether to permit Naomi to leave the kibbutz to study music.

The kibbutz movement at that time insisted on equality for all of its members. Some felt that it would be unfair to offer specialized study to only some of its members. Offering music lessons to only one child was not done on a kibbutz. This was a time when kibbutz members were appreciated for their dedication to working the land. They were needed to be farmers and workers. Being a musician was not thought to fit in with kibbutz life. "None of the other members on that kibbutz played an instrument at that time," Diti Lean recalled.

However, by the third kibbutz meeting, the decision was made to permit Naomi to leave in order to study music. It was clear that she was a truly gifted musician. She then began her studies in Tel Aviv and at the Rubin Academy, an

outstanding music academy in Jerusalem, planning to become a pianist and a music teacher.

Some people at the kibbutz believed that a person's worth is measured by how hard she works on behalf of the community. Noami turned back to the Kibbutz after graduation and was a music teacher. Her love for Lake Kinneret and the surrounding mountains was intense. She combined her love for music with her intense passion for Kibbutz Kinneret by writing songs about it.

Naomi joined the Israeli army in 1953. She served in the Nahal entertainment troupe, where she played and sang for the other solders and wrote songs for many performances. She served as musical coordinator for shows that the soldiers performed at new settlements and kibbutzim around the country. It was during this time that she met the actor Gideon Shemer.

Her Marriages

In 1954, Naomi and Gideon Shemer were married, and their daughter Halely, known as Lely, was born. Naomi returned to Kibbutz Kinneret in order to teach rhythm and to write children's songs based on kibbutz life.

Naomi had hoped to continue living at the kibbutz, the life that she loved, After she finished her studies and army service. However, this was not to happen, and the young family left the kibbutz and moved to Tel Aviv.

In the mid-1960s Naomi and her husband separated. They divorced in 1967.

After separating from Gideon, Naomi flew to Paris and spent a few months there with her daughter. While there, she found that the French language and culture began to influence some of her songs, including "Ha-ir be-afor" (The City in Gray).

Naomi later returned to Israel and married Mordecai Horowitz, a writer and lawyer. Their son Ariel was born from that marriage.

Her Career

After Naomi left the kibbutz, she became very busy composing songs. Now that she was becoming recognized for her work, she had no problem finding singers who were eager to perform her songs.

Her songs were usually filled with images of the kibbutz from her childhood. After having lived there for twenty years, she felt connected to Kinneret. She never forgot her friends and family there or the beautiful landscape surrounding the kibbutz. The beauty of nearby Lake Kinneret, the Jordan Valley, the eucalyptus grove, her old house and the people connected with the kibbutz stayed in her memory as she created her music and lyrics.

Naomi's professional life was very productive. Throughout her career, she continued to write songs – both the words and the music – for children and adults. She wrote for her friends, for her family and for her country.

Naomi's songs often had a story attached to them, and she loved to honor family members and friends with them. She honored her brother, Yaacov (or Yankeleh as his family called him), by writing the song "Ohr" (Light). She wrote for her friend, the singer Hava Alberstein, the song "Lu yehi" (May It Be) at the outbreak of the Yom Kippur War.

Ehud Manor described Naomi as "unbelievably sensitive and intuitive." Her ability to write songs that people could identify with was remarkable. Listeners often wept or laughed, or both, as they sang along. Naomi wrote hundreds of songs that became part of the Israeli culture over the years, including many well-known children's songs.

She often looked to Hebrew literature for inspiration when she wrote her songs. She set the poems of Israel's writers to music, and she especially loved the work of Israel's national poet, Hayyim Nahman Bialik.

In 1964, Naomi set the poem "Kinneret," written by the famous Israeli poet, Rahel Bluwstein, to music. Rahel Bluwstein, who was born in Russia in 1890, lived at Kibbutz Kinneret, died there in 1931 and is buried in the kibbutz cemetery. Her poetry describes the landscape of nearby Lake Kinneret and the Jordan Valley. Later in her career, Naomi composed music for many more of Rahel's poems.

"Al kol eleh" (For All These Things), one of Naomi Shemer's most famous songs, is a personal plea to God. The journalist Nira Rousso wrote of her reaction when she heard it on the radio for the first time. She remembered that as she and her friend listened to the song, "We both froze at the sound of this perfect thing that was so pure and emotional, and then we wept out loud. The words, the performance, simply contained too much beauty for one song."

Other songs for which Naomi Shemer has become famous are "Mahar" (Tomorrow) and "Horshat ha-ekaliptus" (The Eucalyptus Grove). However, her most famous song is "Yerushalayim shel zahav" (Jerusalem of Gold).

Naomi often commemorated events in Israeli life by composing memorable songs in their honor. In 1996, she wrote a Hebrew version of "O Captain, My Captain," a poem written by the American poet Walt Whitman after the assassination of Abraham Lincoln in 1865. Naomi set her Hebrew translation of the poem to music for the first anniversary of the assassination of Prime Minister Yitzhak Rabin.

May It Be

Naomi occasionally translated the words of foreign songs and sang them in Hebrew.

On the third day of the Yom Kippur War in October 1973, she wrote a song that was inspired by the Beatles' song, "Let It Be." She later recalled: "I put on paper all the anxiety that we felt during those first three days of the war. I sat at the piano and I sang the painful lines, still with the original tune of 'Let It Be.'"

When her husband, Mordecai, returned from the war, he urged her to compose a Jewish melody for the song so that it could be associated more appropriately with the 1973 war. The song she composed, "Lu yehi" (May It Be), was very different from the Beatles song that had inspired its writing. When Naomi wrote the new music for the translated words, the song was instantly accepted throughout Israel as the anthem of the Yom Kippur War.

Naomi hoped that this haunting song would inspire optimism in Israel. The country was saddened by the heavy loss of life from the Yom Kippur War and needed a song of hope.

In 1979, the inhabitants of the Israeli settlement of Yamit in the Sinai often quoted a phrase from another famous song by Naomi, "Al kol eleh." This phrase was "al-na ta'akor natua" (Do not uproot what has been planted). The settlers, who did not want to leave their homes in the Sinai, hoped that Naomi's song would become their anthem. However, in an interview, she said that she had written the song to encourage her sister Ruth, whose husband had died.

Jerusalem of Gold

In 1967, Teddy Kollek, the mayor of Jerusalem, asked Naomi to write a song for the Israel Song Festival, an annual contest where artists would present their music, and the best songs would be chosen. Mayor Kollek knew that Naomi was not planning to write a song for the competition that year. Since she was one of the most popular Israeli songwriters, he hoped she would write a song just for entertainment of the audience that night. He wanted the song to be about Jerusalem.

This was a challenging task for Naomi. She recalled, "I worked desperately hard on this because I was scared. It was too great a responsibility because so many beautiful things had already been written about Jerusalem. I thought about it, I searched my soul." She wrote nothing for two months. As she went through her daily activities she continuously thought about the Jerusalem she knew as a young girl. She remembered the smells, the sights and the feelings associated with Jerusalem.

Finally, just when she was about to give up, the idea came to her. She composed a song based on a recollection from her school days. The song was based on a story from the Talmud about Rabbi Akiva and a promise he had made to his wife, Rachel. Akiva and Rachel, who lived approximately 2000 years ago, were extremely poor. Still, Rachel encouraged him to study Torah. Because they were so poor, she sold her hair to pay for his studies. Akiva was so grateful that he promised Rachel that he would buy her a "Jerusalem of gold," a golden ornament with an engraving of Jerusalem on it, when he returned from his studies. When Akiva returned home as a famous scholar twenty-four years later, he fulfilled his promise to Rachel.

Naomi took the Talmudic phrase, *Yerushalayim shel zahav,* and used it as the theme of the song she wrote for the festival. She also quoted the medieval poet, Yehuda Halevi, when she added the phrase "Let me be a violin for all your songs." Naomi did not mention the Old City in her song at first, but she added a verse about it later. In this verse, she talked about Jerusalem's Old City, including the Temple Mount. At that time, most Jews had never seen the Temple Mount or been to the Western Wall. Since 1948, Jerusalem had been divided, and the Old City, with its Jewish holy sites, had been under the

control of the Jordanian army, who would not allow Jews to enter the Old City.

After writing the song, Naomi chose a young woman soldier with a clear and beautiful voice, named Shuly Nathan, to present it for the first time. Naomi, Mayor Teddy Kollek and everyone involved in putting the performance together wondered how the public would receive the song.

After Shuly Nathan finished the song, the audience sat absolutely still, stunned into silence. The music and the picture that the words created were unlike anything they had ever heard before. Then someone started clapping, and others joined in. Gradually, more and more people applauded louder and louder, without stopping.

Journalist Nira Rousso remembered: "Anyone who, like me was [there] that night, will never forget the quiet that descended upon the vast, crowded auditorium. And then the tremendous outburst of applause." The members of the audience rose to their feet and, with tears streaming down their faces, refused to stop applauding until Shuly Nathan sang the song again. This time, they sang with her. Even though they had heard the song only once, they were able to sing its lyrics from their hearts. Those who were in the auditorium that night never forgot the experience.

> Now the cisterns have dried out, the market square is empty ...
> [literal translation]

The hearts and souls of those in the audience were touched by the words:

> No one goes up to the Temple Mount in the Old City. ...
> Let me not forget thee, O Jerusalem, that is all of gold.

The new song spread throughout Israel overnight and was an instant success. It was played repeatedly on all the radio stations. Everyone wanted Shuly Nathan to sing Naomi's song, which expressed the feelings and memories of the people of Israel.

The Six-Day War began three weeks later, on June 5, 1967. Israel had been forced into a crisis as Egypt, Jordan and Syria jointly grouped their armies on Israel's borders, calling for the destruction of Israel.

Naomi's new song was now being played constantly on the radio to make

listeners feel hopeful and proud. Naomi was asked to sing for the troops stationed around Jerusalem in order to encourage them.

On June 7, 1967, the third day of the war, the Old City of Jerusalem was freed from Jordanian rule. The Israeli soldiers who had captured the Old City soon found themselves standing at the Kotel. As the news spread throughout Israel and the world, Israelis and Jews everywhere were ecstatic. When the news reached Naomi, she decided to rewrite the second stanza of her song. Jerusalem belonged to Israel once more, and her song would announce it to the country and to the world. Later that evening, when the Israeli soldiers had gathered at their base, she stood before them and said, "I'll sing for you a verse that I just added to 'Yerushalayim shel zahav.'"

Then, as the soldiers listened, she sang:

> *We have returned to the cisterns, to the market and to the square,*
> *The shofar calls out from the Temple Mount in the Old City.*

The soldiers cried and applauded without stopping until she told them, in rhyming Hebrew: "I should be applauding you, because it's easier to change a song than it is to change a city."

"Yerushalayim shel zahav" is considered by many as Israel's second national anthem, after "Hatikvah," and has become the anthem of the Six Day War.

Natan Sharansky, a former political prisoner from the Soviet Union who now lives in Israel, remembered what it was like to hear "Yerushalayim shel zahav" for the first time. "It was the most Israeli thing we could think of, and we knew that in Israel the song had become something of a national anthem." This song gave those who were not permitted to leave the Soviet Union a sense of pride in being Jewish.

Her Awards and Contributions

In 1983, Naomi was awarded the Israel Prize for her contribution to Israeli music. Over the years, she received four honorary doctorates. This is a way that universities honor special people who have contributed to society even though they have not necessarily studied at that institution.

Naomi was a member of the Hebrew Language Academy. This organization, which has existed for more than fifty years, gathers Hebrew language scholars together in order to create standards for the use of Hebrew. Among its goals is to improve Hebrew vocabulary, pronunciation and grammar. Naomi Shemer was known for her beautiful and accurate use of Hebrew. Writer Doron Rosenblum wrote about, "her mellifluous [sweetly and smoothly flowing] Hebrew." Her songs show how beautifully she was able to create a picture with words. Listeners have always found the words of her songs easy to remember and sing.

The End of Her Life

Towards the end of her life, Naomi was ill with diabetes. But in 2002, she was back on stage with the show Eleph Shirin Va'shir with the producer and singer Dudu Elharar and the musicians Rami Hareel and Ronit Roland.

She became the director of ACUM, a non-profit organization that represents the professional interests of Israeli artists. She was pleased to contribute to the society she loved once again.

Naomi Shemer died on June 26, 2004, at the age of seventy-four. She is survived by her husband, Mordecai Horowitz, two children and four grandchildren.

The day after she died, she was buried at Kibbutz Kinneret, where she was born. Just as she wanted, she was buried near her parents' grave, Meir and Rivka Sapir, and near the poet Rachel's own grave, which was only a few steps away from the house in which Rachel had lived. She chose this beautiful place overlooking Lake Kinneret and the Golan Heights because of her deep attachment to it.

On the day of her funeral, thousands of Israelis, including friends, neighbors, admirers, artists, entertainers and politicians came to Kibbutz Kinneret to honor her memory. Her friend, Dudu Elharar, sang four of her songs – "Kinneret," "Horshat ha-ekaliptus," and "La-shir zeh kemo lihiyot yarden" (To Sing Is Like Being the Jordan) and "Noa." Many of those at the funeral stayed after it was over, singing her songs for two hours.

Remembering Naomi Shemer

Israel's Education Minister, Limor Livnat, noted: "We have had a great privilege that a giant like Naomi Shemer has lived and created in our generation." Shimon Peres, a member of the Knesset (Israel's governing organization), said: "She left us with song, taught us to mourn and to rejoice as a nation and as individuals." Ehud Manor described his friend and fellow artist as "an especially charming woman." The singer Hava Alberstein said of Naomi: "As a musician she was an astounding composer who integrated jazz, cabaret and great wealth into her songs."

After Naomi Shemer's death, Israel's prime minister, Ariel Sharon, said: "With marvelous lyrics and melodies, she succeeded in connecting us to our roots, to our origins, to the beginnings of Zionism."

Naomi Shemer gave Israel and the world a way to remember Israel with pride and respect. Writer Meron Benvenisti wrote that she "succeeded in expressing the essence of the Israeli spirit." President Moshe Katzav said: "Her songs expressed an intense love for the country and for the people of Israel."

Kibbutz Kinneret published a memorial book in Naomi's honor. In it, her friends and neighbors wrote their memories and thoughts of their beloved Naomi. Tzipporah Ohr-Tal wrote:

> *You were loved and idolized by all, always,*
> *Because the people knew the difference between gold and base metal.*

Questions to Think About:

- *Have you ever wanted to express your feelings through the arts (by writing a story, a poem or a song, drawing a picture, creating a dance)?*

Think about how you could express your ideas and feelings. As you think of a way to do that write down your thoughts. Keep the list going until you think you have thought of all possible ways to express your ideas and feelings.

- *Would you like to help preserve the important contribution of Naomi Shemer?*

Learn her songs. Read the English translations so that you can fully understand them. Sing them, and, if you play an instrument, learn to play them. Teach them to your family and friends.

To Learn More:

- Visit these websites:
http://www.jewishvirtuallibrary.org/jsource/biography/
shemer.html and
http://www.jafi.org.il/education/100/people/BIOS/ shemer.html

- *Listen to songs by Naomi Shemer and others who sing in tribute to her. Here is a partial list of recordings that contain her music:*

Shirei Naomi Shemer (Songs of Naomi Shemer); CD and cassette
Naomi Shemer: Asif (Naomi Shemer Collection), Vol. 1 and Vol. 2; 2 CDs.
Naomi Shemer: Ha-osef ha-shalem (Naomi Shemer: The Complete Collection); 5 CDs
Lehem ha-ohavim (Lovers' Bread): Songs of Naomi Shemer; CD and cassette

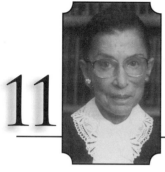

11 RUTH BADER GINSBURG

Quiet Strength and Gentle Power in America's Highest Court

A Woman to Admire

What makes a person who suffered the losses of those closest to her when she was only a child rise above such tragedies? What helps her keep going, quietly achieving her goals, even though she has had such sadness in her life? How is she able to face injustice while making important decisions that improve not only her own life but the lives of others as well?

On June 14, 1993, President Bill Clinton nominated Ruth Bader Ginsburg to the position of Justice of the United States Supreme Court. He explained that she was his choice because she has "repeatedly stood for the individual, the person less well-off, the outsider in society, and has given those people greater hope by telling them they have a place in our legal system." After having gone through such difficult experiences, how was she able to become a hopeful person whom others honored and respected?

Let us search for the answers to these questions as we learn about the life of Ruth Bader Ginsburg.

Her Childhood and Family

Joan Ruth Bader was born on March 15, 1933 in Brooklyn, New York. Ruth, as she is known today, lived with her parents, Nathan and Celia, in the Queens neighborhood of Belle Harbor, New York, for the first two years of her

life. Then the family moved to the Flatbush section of Brooklyn.

Ruth became known to her friends and family as "Kiki," a nickname given to her by her older sister Marilyn, who unfortunately died of meningitis at the age of eight, when Ruth was only two years old.

Ruth was born into a bittersweet world. Those around her had suffered during the Great Depression of the early 1930s. This was a terrible time for millions of Americans who had no work, money or hope. Their lives were ruined because they lacked enough money for their basic needs. At the same time, Adolf Hitler had become Germany's new dictator. The entire world, particularly Jews, watched in horror as Hitler destroyed millions of lives. This was the world that Ruth into which Ruth was born.

Inside her home, Ruth was loved and cared for by her parents. Nathan was an extremely involved father. Celia, though equally caring, was more demanding. Above all, she wanted to prepare her daughter to be successful.

The impression that Celia's strong character left on Ruth has stayed with her throughout her life. Ruth later said about her mother: "She was not a career woman, but she had tremendous intelligence." Celia cared tremendously about achievement.

Celia, who loved to read, had been an excellent student, graduating from high school when she was only fifteen. Then and there her formal education ended. While her brother attended college, she went to work to contribute to the support of her large family. At that time, it was unusual for girls to go to college. They were expected to work to help support the family.

Celia and Ruth spent many hours together enjoying books in the neighborhood public library. Celia imparted a lifetime love of reading to her daughter.

Ruth and her parents lived in a hard-working, middle-class neighborhood. Nathan supported his family by manufacturing fur coats while Celia stayed home and cared for her family, as was done in those days, continuing to read and study on her own. During all that time, she was also closely involved in her husband's business decisions.

Ruth attended her neighborhood schools, Public School 238, her elementary school, and James Madison High School. She was pretty, quiet and well liked for her kindness and intelligence.

Her best friend in high school recalled: "She was very modest and didn't

appear to be super-self-confident. She never thought she did well on tests, but, of course, she always aced them." Neither she nor any of her classmates ever imagined that she would later become a lawyer and a defender of women's rights.

While Ruth was very successful in her studies, she also had an active social life, even serving as a baton-twirler at her high-school football games.

Although Ruth was popular with her classmates, she remained a private person. She did not want to share information about her private life even with her closest friends. Perhaps this was because she felt awkward admitting to others that her mother suffered from a fatal disease. She might have felt uncomfortable talking about such things.

In 1946, when Ruth was a freshman in high school and her mother was 43 years old, Celia was diagnosed with cervical cancer. Even as Celia suffered with this illness, she always encouraged Ruth toward hard work and achievement. Knowing that her mother would love nothing better than to see her studying, Ruth often sat at Celia's bedside while she did her homework.

Four years later, in June 1950, only one day before Ruth's graduation from high school, Celia died. Ruth remembered that her mother was "very strong in every way but physical." One can only imagine how upset Ruth must have been during that terrible time. She did not speak at the graduation ceremony, as had been planned. Instead, her teachers brought her many graduation awards to her home.

Many years later, at the time of her nomination for the United States Supreme Court position, Ruth ended her acceptance speech with the words, "I have a last thank you. It is to my mother, Celia Amster Bader, the bravest and strongest person I have known, who was taken from me much too soon. I pray that I may be all that she would have been had she lived in an age when women could aspire and achieve, and daughters were cherished as much as sons."

Her Education

In the fall of 1950, Ruth left her father and her home in Brooklyn to begin her studies at Cornell University in Ithaca, New York. She won a New York

State scholarship and received additional financial assistance from the university. It would have been difficult for her to attend that university if she had not received the scholarships.

Throughout this difficult time, thoughts of her mother stayed with her. She was still recovering from the shock of her mother's death.

Ruth was popular in her new school setting. She joined a Jewish sorority, went to parties and dances and made many friends. Her classmates also recognized her as being incredibly smart.

Ruth decided to major in Government without any idea of later attending law school. Only later, when she worked as an assistant to Professor Robert E. Cushman, who was her teacher, mentor and advisor, did she come to believe a career in law would be possible for her.

During that time, Senator Joseph McCarthy was terrorizing political leaders and other famous Americans. He accused them of having Communist connections, which many people considered treason (betrayal of one's country) at the time. Professor Cushman felt very strongly that McCarthy's actions were harming the important American principles of freedom of speech and thought.

Ruth recalled: "The McCarthy era was a time when courageous lawyers were using their legal training in support of the right to think and speak freely." She was impressed that "a lawyer could do something personally satisfying and at the same time work to preserve the values that have made this country great."

Ruth's father did not encourage her to study law. He was concerned that, as a women, she would not be able to earn enough to support herself in that profession. There were very few women lawyers in the 1950s, as college-educated women often became teachers.

Ruth was not certain that she had the ability to work as a lawyer. She wrote to her cousin, Jane Amster, expressing her "deep doubts on whether she had sufficient aptitude for the law."

In addition to her professor, Robert E. Cushman, who encouraged her to apply to law school, another person believed in her ability to be a lawyer. This was her fellow student at Cornell, Martin David Ginsburg. They met when Ruth was in her first year of college and Martin was in his second. Ruth's

cousin Jane remembers that after three years of close friendship, the couple "had a marvelous romance in her senior year."

June 1954 was a happy time for Ruth. She graduated from Cornell's College of Arts and Sciences, receiving awards and honors. On this occasion, she, Martin, and their families enjoyed the happiness that had been missing from her high school graduation. Several days after graduation, they were married.

Her Marriage

Ruth and Martin were married in a quiet ceremony in Martin's parent's home. Ruth felt fortunate to have had a close relationship with her in-laws, and she especially appreciated her mother-in-law's support.

Ruth and Martin have always seemed the perfect couple although they are different in many ways. Ruth is reserved and quiet, while Martin is outgoing. He is a wonderful cook. She is not. Still, each has always respected the other's intelligence and interests. When talking about her life, Ruth remarked, "I consider myself a fantastically lucky person. So much of my childhood was not happy," she said, referring to the deaths of her sister and mother. However, "in love, I was lucky."

Martin always encouraged Ruth to study law, as she had hoped to do, but that wish had to be set aside briefly. Shortly after their wedding and after Martin had finished his first year at Harvard Law School, his studies were interrupted. The United States was involved in the Korean War and Martin was drafted into the U.S. army. He and Ruth spent the next two years at Fort Sill, Oklahoma.

The Ginsburgs' daughter, Jane, was born a little more than a year later, in July 1955. During the first year after Jane's birth, Ruth stayed home taking care of the baby. In 1954, she applied and was accepted to Harvard Law School, which permitted her to delay starting her law studies for two years. In 1956, after Martin completed his military service, the Ginsburg family moved to Cambridge, Massachusetts. Martin entered his second year of Harvard Law School and Ruth her first.

Law school would have been difficult for anyone who was newly married

and with a new baby, but Martin was very helpful. He did what he could to help Ruth in her studies. He shared the childcare responsibilities with her and cooked when they had guests. Ruth explained, "What Martin did went far beyond support. He believed in me more than I believed in myself."

Ten years later, in September 1965, their family grew again with the birth of their son, James. Jane was then ten years old. At this time, Ruth's father, Nathan, had an accident and recuperated in the Ginsburg home. This was a difficult time for Ruth. She had so many new responsibilities, caring for family members as well as a new baby. Still, she never thought of leaving her job. Martin's encouragement and assistance at home were a great help to her.

Today, Martin is a law professor at Georgetown University Law Center in Washington, DC. He is one of the nation's best-known tax lawyers. Jane teaches law at Columbia University Law School. She is married and the mother of two children. James, who attended law school in Chicago, currently produces classical music recordings. He is married and has two children.

When talking about her life, Ruth remarked, "The two people who were most important in making my life successful were my mother and my husband." She talks lovingly about Martin and her wonderful marriage. She emphasized: "From the very beginning, he thought that my work was as important as his." Ruth is a proud and loving mother and grandmother whose children and grandchildren bring her great joy. Her office at the Supreme Court is filled with photos of the members of her family.

Her Career

Ruth remembered: "I became a lawyer for personal, selfish reasons. I thought I could do a lawyer's job better than any other could. I have no talent in the arts but I do write fairly well and analyze problems clearly."

When Ruth entered Harvard Law School in 1956, she was one of only nine women in a class of more than 500 students. Her intelligence and talents were soon recognized by her classmates. Her classmate, Ronald Loeb, told her: "While the rest of us were sulking around in dirty khaki pants and frayed button-down oxford shirts, missing classes and complaining about all the

work we had, you set a standard too high for any of us to achieve."

Martin, too, was impressed with Ruth's ability. He told friends "My wife is going to make the *Law Review*." (Outstanding students are invited to work on the staff of this important and scholarly law journal.) Martin was right. Ruth became a member of the staff of the *Harvard Law Review* at the end of her first year in law school.

Although Ruth worked hard and was successful while she was a student at Harvard, she never received a degree there. After Martin graduated from Harvard Law School in 1958, he took a job with a New York City law firm. The family moved to New York and Ruth switched to Columbia University for her final year of law school. A Columbia student who is now a justice on the New Jersey Supreme Court remembered: "When you met Ruth, you knew she was very serious and smart and did things with a minimum of fuss."

Soon after transferring to Columbia, Ruth was named to the Columbia *Law Review,* a journal as well-respected as the Harvard one. When she graduated from Columbia at the end of that year, she tied for first place in her class. As had been the case in her previous graduations, she received many honors.

She was made a member of both Phi Beta Kappa and Phi Kappa Phi (scholarly honor societies recognizing the accomplishments of those who have earned the highest grades). She was on both the Harvard and Columbia *Law Reviews*, and she graduated first in her class from Columbia Law School. Nevertheless, she recalled, "Not a single law firm in the entire city of New York bid for my employment." Not even the law office where she had worked offered her a job, even considering she had done outstanding work during the summer!

Trying to understand this situation, Ruth explained: "In the 1950s, the traditional law firms were just beginning to turn around on hiring Jews. In the 1940s it was very difficult for a Jew to be hired in one of the well-established law firms. They had just gotten over that form of discrimination. But to be a woman, a Jew and a mother as well, that combination was a bit much." She felt that being a mother was probably the biggest problem. In the 1950s, employers feared that women lawyers would not be able to give their full time and attention to their work because of family responsibilities.

Still, Ruth refused to accept rejection. In her usual quiet, determined manner, she never gave up her search for the right job.

There was one man who was willing to take a chance on hiring a woman. Edmund L. Palmieri, a United States District Court judge of the Southern District of New York, hired her as a law clerk in his office. This was a few months before Ruth was to graduate from law school. She was delighted to have been given this chance to prove herself, and she worked as carefully and as hard as possible. "I worked harder than any other law clerk in the building," she remembered. This was her opportunity to prove that she could do it, and Judge Palmieri appreciated her dedication. Ruth recalled that he was "a man I deeply admired, whose friendship I cherish to this day."

Several months after she began working for Judge Palmieri, a Harvard Law School professor called to tell her that he wanted to recommend her for a position as a clerk in the office of Felix Frankfurter, United States Supreme Court Justice. This was an extremely desirable position for lawyers just out of law school. Ruth's law school grades and the recommendation from the professor made her a wonderful candidate. Her records were very impressive. Nevertheless, Justice Frankfurter never called her. It was "simply because he wasn't ready to hire a woman," she concluded.

Ruth's two years of work with Judge Palmieri, helped her to begin to overcome the problem of being accepted as a woman lawyer. Her next job presented another wonderful opportunity. She worked with Professor Hans Smit in Columbia Law School's Project on International Procedure. She was to study Sweden's system of laws and its method of processing legal matters, and she was to co-author a book. In preparation for her work, she learned Swedish and then spent two long summers in Sweden. Jane joined her for most of her stay in Sweden. Martin was there for some of it. When she saw the progress that Swedish women had made in their jobs, she was greatly inspired.

When this project was completed, Ruth accepted a job teaching law at Rutgers University Law School in New Jersey. She was delighted to learn that the school already had a woman on its faculty, and saw this as a sign of the school's open-mindedness.

Ruth taught at Rutgers for nine years. She enjoyed teaching because "there

is tremendous luxury in being a law teacher in that you can spend most of your time doing whatever interests you."

While she taught at Rutgers, she developed a particular interest in laws relating to discrimination against women. Her interest was encouraged by students who wanted a course to be offered on Women and the Law. Perhaps her own experiences of having been rejected simply because she was a woman made her interested in that topic as well. At the same time, the New Jersey Office of the American Civil Liberties Union (ACLU) began to receive complaints from women who were suffering from discrimination.

The ACLU was established in 1920 to protect human rights. Men and women could send discrimination complaints to that organization for investigation. The ACLU offered Ruth an opportunity to help eliminate sex discrimination in the law. Her university students also encouraged her to take the job. As she thought about it, she became encouraged by "high hopes for significant change in the next decade."

The decade of the 1960s was an important time for civil rights as well as for Ruth's career. In 1961, President John F. Kennedy created the Commission (investigating group) on the Status of Women. Two years later, after studying the Commission's findings, Congress passed the Equal Pay Act. This required that women receive the same pay as men doing the same type of work. This was the first time that a federal law concerning women's rights was passed since 1920, the year in which women received the right to vote. More important, women were included in the Civil Rights Act of 1964. Women were now more able to defend their rights through legal means than they had ever been before.

During the 1960s, Ruth read a book called *The Second Sex* by the French writer Simone de Beauvoir. After she read the book, she realized that her experiences were symptoms of the broader prejudice of denying women opportunities available to men. The book helped her recall her second-class treatment as a woman in her career. She began to question the unfair practices against women. "My consciousness was awakened. How had I been putting up with them?" she wondered.

In 1971, the ACLU accepted her offer to be the lead writer of a sex discrimination brief (a legal argument supporting or opposing a particular position).

In her typically quiet, professional manner, Ruth worked carefully and steadily developing her argument in the case (called Reed vs. Reed). She won the case. For the first time, the Supreme Court overturned a law in response to a woman's complaint of unfair sex-based discrimination.

This was a major step forward for the women's movement in the courts. The ACLU was so pleased with Ruth's success that it voted to set up a special department, the Women's Rights Project (WRP), to deal with women's issues. Ruth agreed to be co-director of the project.

At the same time, Ruth left Rutgers to accept a tenured teaching position at Columbia Law School. Tenure is offered only to respected professionals. It guarantees that a person will not be fired from the job except for severe behavior problems and then only after a formal hearing. She was the first woman to be tenured at Columbia Law School.

Ruth taught half time at Columbia Law School and worked half time at the Women's Rights Project (WRP), during the 1972-1973 school year. After that, she took a full-time teaching job at Columbia Law School.

In the early 1970s so many sex discrimination cases were brought before the courts that the judges had difficulty deciding which ones to accept. In the end, cases that were accepted included those that concerned equal pay and benefits for equal work, pregnant women keeping their jobs and women having the right to serve on juries. At this time, many women in those positions felt that society was not treating them fairly. Ruth believed those cases were more likely to win in the courts. The WRP hoped to win its cases so that the position of women's rights in the courts would be strengthened.

Ruth worked hard to find the right cases. She looked for those that would have the greatest impact. She hoped to bring them before the most sympathetic judges, whose decisions would help develop law that would free both sexes from prejudice as much as possible. She had a method to her work in bringing attention to the importance of equal protection for women under the law. Her colleague Kathleen Peratis, when talking about Ruth's strategy, said she "had a real vision of where she wanted to go and what she had to do to get there."

In 1973, Ruth argued her first case, Frontiero vs. Richardson, before the United States Supreme Court. She won. This decision was an enormous step

forward for the WRP, which was delighted with the progress they had made on behalf of women's rights with Ruth as their director.

Over the next three years, Ruth came before the Supreme Court several more times. Her manner was always professional, quiet, clear and self-assured. Those who heard her in court reported that with each appearance, the nine judges "grew even more respectful, and ruled in her favor five of the six times she argued." She was considered extremely convincing by all who watched her in action.

Ruth was a strong supporter of women's rights. President Clinton said of her: "Having experienced discrimination, she devoted ... years of her career to fighting it and making this country a better place for our wives, our mothers, our sisters, and our daughters."

However, Ruth does not see her work in this way. She has often represented men, too, since she believes that all people should be treated equally under the law regardless of their sex. She believes that using the skills and talents of all Americans would greatly benefit the nation. She said "Generalizations about the way women or men are – my life experience bears out – cannot guide me reliably in making decisions about particular individuals. ... I have detected no reliable indicator of distinctly male or surely female thinking."

Over the years, Ruth had many opportunities to appear before the United States Supreme Court, sometimes representing women, sometimes men. She was always concerned that there be no gender discrimination. A former ACLU attorney said of Ruth, "She is just the most spectacular lawyer I have ever met. Always she is most appreciative of superior effort."

Her Appointment as a Judge

In 1980, President Jimmy Carter wished to appoint several new judges to serve on the United States Court of Appeals. He hoped to find lawyers who could issue unprejudiced decisions.

President Carter found what he was looking for in Ruth. He nominated her for a vacancy on the United Court of Appeals for the District of Columbia Circuit. Some consider this court to be the second highest court in the United States,

just below the Supreme Court in its power and rulings. When a losing party in a case feels that it did not receive a fair trial in the district court, it can ask an appeals court to review and possibly reverse the decision of the lower court.

Following a President's nomination, members of Congress must approve the President's choice. Ruth's nomination was quickly approved. She took the oath of office on June 30, 1980. In the oath that judges take, they guarantee that they will do all within their power to follow the laws and the Constitution of the United States.

Ruth considers herself fortunate to have been noticed by President Carter. He wanted to change the complexion of the United States court system by nominating women to positions in greater numbers than ever before. Only in President Carter's time had so many women lawyers been appointed judges. Until that time, Ruth had not even considered becoming a judge. She had always thought of herself as a lawyer who would either teach or work for a law firm.

When Ruth accepted her new position, she stated, "One of the most sacred duties of a judge is not to read her convictions [personal beliefs] into the Constitution." Throughout her career as an appeals court judge, she relied on that principle to help her make fair decisions. She felt so strongly about following the laws precisely that her decisions were sometimes hard for others to predict. She had previously been considered a liberal. Once she became an appeals court judge though, she could no longer be thought of that way. She was viewed as a centrist – in the middle of the political scale – independent of the liberal left or the conservative right. She decided each case individually. She based her decisions on laws and facts. She continues to base her decisions not on her own political ideas but rather on laws.

Ruth first came to the attention of President Bill Clinton in 1993. He was looking for a Supreme Court justice (a judge in the highest court of the country) to replace Justice Byron White, who had retired from the U.S. Supreme Court. President Clinton devoted three months to the search, which was one of the longest such searches in United States history.

The eight Associate Justices and one Chief Justice on the nation's highest court are appointed for life. They serve until they die or retire. Their responsibilities are to interpret and explain the nation's laws and the

meaning of the United States Constitution. Most cases presented to the Supreme Court come from the federal appeals courts. When a case is lost in an appeals court the losing side can ask that its records be sent to the Supreme Court for review. This is the highest court in the country.

Of the more than 8000 cases brought before the Supreme Court each year, the justices decide which 70 to 90 cases they will deal with during the year, which runs from the first Monday of October until late June. Through the years, the Supreme Court has decided cases that have had a major impact on American life and history.

People in various political positions were afraid that Ruth would not agree with their opinions. Nevertheless, they all agreed that she had shown talent as a consensus builder (a person who can help others find agreement). There were many times that the nine justices had trouble reaching consensus, or agreement, but it is important for them to work toward agreement as much as possible. Those who knew Ruth felt she could help them reach agreement when they had difficulty agreeing on an issue.

On June 14, 1993, her nomination took place in the White House Rose Garden. President Clinton explained that he had selected her for three reasons; she was one of America's finest judges, in her many years of service to women's rights she "compiled a truly historic record of achievement in the finest tradition of American law and citizenship" and "in the years ahead, she will be ... a force for consensus-building on the Supreme Court."

After the President nominates his choice to be a justice, the Senate needs to confirm (agree with) the President's choice. The confirmation hearings were at the end of July 1993. On August 3, 1993, the Senate voted to confirm her as a Supreme Court Justice, with 96 in favor and 3 opposed. With so many in the Senate in agreement with the nomination, this was the easiest confirmation in many years.

On August 10, 1993, Ruth took the oaths of office that made her the 107th justice. She was only the second woman and the first Jew since 1969 to serve on the Supreme Court.

As Ruth thinks about her work, she calls her most significant goal "the achievement of equal opportunity and responsibility for women and men in all fields of human endeavor."

Facing Discrimination

The discrimination in American society of the 1930s and 1940s must have made a strong impression on a young Jewish woman. The discrimination against women that Ruth met in her life surely influenced her career and her thinking.

Ruth remembers that when she was a child and she traveled with her family in Pennsylvania, she saw signs that said "No Jews or dogs allowed." Of course, this was shocking to her. However, she notes that things in the United States have changed a great deal over the past sixty years and that Jews today would never experience such discrimination. There were other forms of discrimation, though, that continued to exist in Ruth's time.

Soon after their wedding, Ruth and Martin moved to Fort Sill, Oklahoma. Ruth was pleased to have gotten a job with the Lawton, Oklahoma Social Security Office. Shortly after she began her work, she discovered that she was pregnant. When she innocently told this information to her boss, she was changed to a lower-paying job. Her supervisors decided that in her present condition, she would not be able to travel across the country to a training session in Baltimore, Maryland. If she had participated in the training experience, she would have been given a higher-paying job. This injustice made an impression on her that would later affect the way she saw sex discrimination.

When Ruth became a law student at Harvard University, she and her few female classmates were not well received there. She recalled that when the dean invited the female students to his home for dinner, he asked them why they chose to take classrooms places that would otherwise been given to men. At the same time, some members of the Harvard faculty questioned whether women belonged there. Ruth responded modestly, hoping not to offend the law school dean. She explained that she wanted to better understand her husband's work and possibly to find a part-time job.

There were other examples of discrimination at Harvard too. No space was provided for women to live in the dormitories. They had to find housing on their own. Women were not admitted to the Harvard Faculty Club dining room except as the guests of men. One could invite one's father, but not one's mother, to attend the *Harvard Law Review* banquet there.

Ruth remembered that the Old Periodicals Room in Harvard's Lamont Library was closed to women. This room made one think of the old days when women were not permitted to use many of the Harvard rooms. Generally, Ruth had not needed to go there for her work. Late one evening, though, she found that she needed to check for some material there. She pleaded with the guard to allow her to enter the room, or at least for him to bring the journal to her in the doorway. He refused. "There was no outrageous discrimination, but an accumulation of small instances," she remembered.

Still, Ruth does not speak negatively about the setbacks in her life. She notes, "So many turns in my life were a matter of luck even when there were setbacks. When I couldn't get a job in a law firm, that experience led to me another position." She appreciates all of the opportunities that have presented themselves to her throughout her career and that have led her to the position she holds today as a Supreme Court Justice.

Her Heritage

When Ruth speaks of that which guides her in her work at the Supreme Court, she lists "being a woman, a Jew, and a parent."

She speaks proudly about being part of a people for whom "Learning and the importance of the family have always been important values." She reminisced about the importance of family Seders and Hanukkah celebrations that were part of her background and that left an impression on her as she grew up.

Ruth's early upbringing was interwoven with Judaism and its values. Judaism is still an important guiding element in her life today. In a speech to female Jewish philanthropists (those who contribute large amount of money to support various causes) in 2000, she explained that her Jewish background is important to her and that "I am a judge, born, raised and proud of being a Jew. The demand for justice runs throughout the Jewish tradition. I hope in the years I continue to serve on the Supreme Court of the United States that I will have the strength to fulfill that demand."

Ruth Bader Ginsburg has become the independent and successful woman that her mother hoped for, and in so doing, she has given others the tools to do the same.

Her Advice to Younger People

"It is important to realize that at this time in history there are no closed doors for Jews or women in the United States," Ruth said. "People can aspire and achieve, and if they work hard they can make their dreams come true." She noted that this situation is in contrast to the way things were when she graduated from college, and even more so when her mother was a young woman.

Her advice to young women is, "You can be whatever you want to be." To young men she says: "My dream for the world is that men should grow up caring about children as much as women do."

Questions to Think About:

- *Have you ever experienced any kind of discrimination?*

 There are many different forms of discrimination, and there are many ways to react to it. Some people look aside, pretending that it has not happened. Others face it head-on and try to change it. Some possibilities for reactions are:

 Discuss the situation with an adult (your parents, teachers, religious leader) and ask them for direction.

 Decide what you might do should you experience this discrimination.

- *Have you ever had an interest in a field that you thought was out of your reach academically or financially?*

Before you decide against going into that field, research it by reading books on it; researching the internet about it; interviewing family members, friends, neighbors, teachers, community members and others about it. Keep an open mind as you do your research

To Learn More:

- Visit these websites:

 http://www.oyez.org/oyez/resource/legal_entity/107/resources
 and http://en.wikipedia.org/wiki/Ruth_Bader_Ginsburg

- *Here are some books you might like to read:*

Ayer, Elinor 1994. *Ruth Bader Ginsburg: Fire and Steel on the Supreme Court*. Dillon Press

Bayer, Linda. 2000. *Ruth Bader Ginsburg*. Chelsea House Publishers.

Saline, Carol, and Sharon J. Wohlmuth. 1997. *Mothers and Daughters*. Doubleday.

Cook, Mariana. *Mothers and Sons: In Their Own Words*. 1996. Photographs. Published by Chronicle Books.

Cushman, Clare, ed. 2001. *Supreme Court Decisions and Women's Rights*. 2001. Foreword by Associate Justice Ruth Bader Ginsburg. Published by the Congressional Quarterly, Inc.

Vrato, Elizabeth. 2002. *Counselors: Conversations with Eighteen Courageous Women Who Changed the World*. Published by Running Press.

12 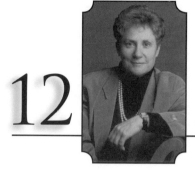 ABBY JOSEPH COHEN

Trailblazer in the World of Finance

A Woman to Admire

Even though Abby Joseph Cohen works long hours and loves her job, her family always comes first. She does not sacrifice special times with those special people in her life for work situations. "Being a happy family person is one of the most important things for me," she says. She also enjoys her Jewish heritage and appreciates having been raised in a traditional family that takes pride in their culture. And as far as her community is concerned, she makes a point of volunteering with many organizations.

Abby Joseph Cohen is well known and admired for her work throughout the United States as well as in many foreign countries. Only a small number of women are known internationally in the business world. Fewer than one-fifth of the leaders in the business world today are women, and Abby Joseph Cohen is one of them. *Fortune Magazine* named her the ninth most powerful woman in the world.

It would seem that such a woman would be too involved in her work to have time for her family, friends and community – but those who know her say that this is not so.

It is exactly this understanding of what is most important and what is the right thing to do that describes her. The care, precision and joy that she brings both to her work and her personal life make her a role model for younger women. Her genuineness and honesty bring her even more praise and respect.

155

Her Childhood and Family

Abby Joseph Cohen was born in 1952 in Queens, one of the five boroughs of New York City. She describes herself as "a first-generation American" (someone whose parents were not born in the United States). Her mother, Shirley Silverstein, was born in Warsaw and moved to Brooklyn, New York as a child. Most of her parents' relatives remained in Poland and were killed in the Holocaust. Abby's father, Raymond Joseph, was born in Brooklyn to immigrants who had recently arrived from Poland and England.

Abby published a short story describing her grandfather's entrance to the United States. The story, entitled "The Silk Hat," describes the way he put on his formal Shabbat clothing, including his tall hat, to impress the immigration officials at Ellis Island in New York, when he first arrived in the United States.

Her parents were bright and hardworking. Her father earned both a bachelor's and a master's degrees in finance from New York University, studying at night after a full day of work. Shirley Silverstein graduated with honors from Brooklyn College. They married shortly after the end of World War II.

Raymond worked as an auditor, someone who reviews the financial statements of major public companies. He specialized in publishing companies and enjoyed working with the creative people who publish books and magazines. He became the financial officer of the leading magazine serving the African-American and Hispanic communities of the United States.

Shirley worked in the financial office of the General Foods Company, which developed many well-known products, including Maxwell House coffee and Jell-O. Shirley opted to become a full-time homemaker when her children were born. Among her many community activities was helping to found and lead a summer camp for neighborhood children.

Like both of her parents, as a young student, Abby became involved in many community activities. She attended Martin Van Buren High School in Queens where she was elected "girl leader" of the school's honor society.

When describing her parents, Abby says about her father, "In our family, we called him 'the sweetest man.' My father had the loveliest disposition and was extremely open-minded." She remembers, "My mother was a very bright

and opinionated woman who studied a situation, made her mind up, and then moved forward."

Her Education

In the 1960s, when Abby was growing up and making decisions about her future, many high school and college-age students were rebelling against various aspects of American society. Abby was not among the rebels. "I felt no need to rebel," she says. "My parents were very aware of the times and we were usually in strong agreement on important issues. They spoke openly about racial injustices and their opposition to the war in Vietnam. "

From an early age, Abby showed great ability in math and science. She loved physics and chemistry, winning two Future Scientists of America awards. With hopes of becoming a scientist, she worked on the National Science Competition, which, at that time, was called the Westinghouse Science Talent Search. Her parents hoped that she would become a doctor.

Abby's parents were extremely supportive of their children's academic achievements. They offered as much help as was needed in the preparation and development of her science experiments. She says, "My parents never set restrictions or directed me or my sister away from activities in which we were interested. Instead, they always encouraged us to do what we wanted. If anything, they were particularly pleased to see their children follow nontraditional paths."

Abby ranked in the top one percent of the more than 1,600 students in her high school graduating class of 1969. At graduation, she received awards for her scholastic achievement in several subjects and for her community service.

Abby spent a great deal of time deciding where to go to college. "The college selection process was an important decision point for me," she recalls. After consulting with her parents, she decided not to apply to the well-known and important women's colleges. Instead, she applied to one of the only two Ivy League universities – Cornell and the University of Pennsylvania – that accepted women in their undergraduate colleges at that time. "I was a physical chemistry major deeply interested in science, and Cornell was the home of

several Nobel Prize winners in physics," she explains. "Also, I was attracted by the diversity in the faculty and the student population." She knew she would enjoy studying with different kinds of people.

Abby entered Cornell University in 1969. She thought at first that she would major in physics, but she soon found that she became intrigued by computer science and by econometrics, a relatively new field that applied rigorous mathematical concepts to the analysis of economics and other social sciences.

At the end of her second year at Cornell, she formally changed her major from physics to economics. She explains, "I had and still continue to have a great curiosity about science, but at that time earning a degree in physics didn't seem to be an easy path toward earning a living." Then she adds, "At that time, it was an unusual concept [to focus on mathematical economics]. Several Cornell faculty members did not fully comprehend or support what I was trying to do." By the time Abby graduated from Cornell in 1973, she had a firm background in econometrics and other computer-related skills.

Her Marriage

During her first year at Cornell, Abby became friendly with David Cohen, a fellow student in her economics class. Throughout their years at Cornell, their friendship strengthened. They began to date, and they were married shortly after graduation. David was a labor relations major. He jokes, "That was the last economics course I needed to take."

After Abby and David were married, they moved to Washington, DC, where David attended law school and Abby worked as an economist for the Federal Reserve Board. The "Fed," as it is called, is the central bank of the United States. It determines policies for interest rates and the nation's banking system. At the same time, Abby studied for a graduate degree in economics, focusing on policy and sophisticated statistical methods.

After giving birth to her first child, she went right back to work. She explains: "The culture had changed since my mother's day. She was content with her choice to be a stay-at-home-mom, but I still wonder how far she could have gone in the business world." Abby continued with her career after the birth of her second child.

Abby was fortunate to have many job possibilities. After four years of working at the Federal Reserve Board in Washington and seven years at the T. Rowe Price financial company in Baltimore, David felt that moving to New York City was the best choice for Abby's career. "Thanks to his flexibility," she explains, "we were able to optimize career decisions for both of us."

The Cohens moved back to Queens in 1983, not far from where Abby had spent her childhood. They wanted to be near her parents, her only sister and many other relatives. They were delighted that they could raise their children near their extended families. David, a lawyer, is director of employee and labor relations of Columbia University in New York City.

Their life is not typical of high-powered financial couples. "We are not a Wall Street family," Abby explains. "A Wall Street career is not the end-all and be-all for us." For many years, she has ridden to work on the city bus. "It's fast, comfortable and convenient. And I was able to concentrate on my reading on the way," she says.

Although her job requires her to travel very frequently, she is grateful that she can arrange her schedule so that she has missed very few of her two children's major school events over the years. When necessary, relatives have been able to fill in for her. She says, "It has been so nice to be able to call a grandmother or grandfather or an aunt or uncle. It has worked out wonderfully well to have family close by, even if it's just to have them come over on a Friday night and sit around and chat after Shabbat dinner."

Her Career

Abby began her career at a time when society was beginning to recognize the important role that women could play in a wide variety of professions in the United States. She explains: "My generation falls on the cusp of the era when women had just begun to work in traditionally male occupations. Among the young women who were barely two to four years older than I, few would have dreamed of preparing for anything other than the typical female professions of teaching, nursing, etc. In my generation, women were just beginning to dream of new pursuits."

After her graduation from college in 1973, Abby had many job offers. Very

few people had trained in computer science and economics at that time, yet there was strong demand for the skills. This was also a time when the field of finance was often closed to women. Because of her strong background in financial studies, she had a greater advantage than many people had.

Of her choice to work at the Federal Reserve Board in Washington, DC, she says: "My experience at the Fed was priceless. At the Fed, I was surrounded by the world's largest group of economists. At the time, it was 'the place' for the best young economists to begin their careers. It afforded tremendous resources, and the work had important practical implication."

While working at the Fed, she studied for a master's degree at George Washington University in Washington, DC, which, she notes "was a fabulous experience. The faculty consisted of individuals who were then, or later became, leaders in setting government policy at places including the White House, the Fed and the Treasury Department."

After she earned her master's degree, she was invited to continue her studies toward a doctorate in economics. However, a new job opportunity, working in the financial markets, became available and she chose to delay further studies.

She left the Fed in 1976 and began working at T. Rowe Price Associates, Inc., a major investment company that managed billions of dollars in mutual funds and other investment accounts. She became a senior economist for this company, located in Baltimore. Her office was about an hour's drive from her home in Washington. She spent seven years working there, learning more about economic developments and helping industry analysts and investment managers with their work.

In 1983, she was ready to move up in the financial world. By this time, she was known in the field for her specialized skills and knowledge and for her careful, thorough work. Although she had many job offers from investment firms and consultants, she chose to join the firm of Drexel Burnham Lambert in New York City.

In her new position as portfolio strategist, she advised professional investors on how to manage their clients' money, as well as which corporate stocks would be the best investment. She thoroughly enjoyed the work. "I loved the strategy role right away," she recalls. "It combined economics with sophisticated

quantitative methods such as models to determine the correct price for stocks. Everybody in this business has a view on the [stock] markets. Now I got to spend my entire day working on my views and forecasts."

As she started her new job, Abby was delighted to note that her new boss "understood that young women wanted a fair shake. He had three daughters of his own." She adds "I was further reassured when I looked around the department and saw that he had hired some high-quality women who seemed to be doing well at the firm."

Her Work

Abby is now a partner and chief investment strategist in a leading investment company called Goldman, Sachs and Co., which is located in New York City. This company provides advice and executes transactions for investors and companies around the world. The firm's clients look for information about how the economy is expected to go, the prices of stocks and other information about investment.

Abby works in the research department that analyzes the economies of the United States and other countries. Her clients include many sophisticated investors who manage investment accounts that hold billions of dollars in stocks and bonds. A stock is a share, or portion, of a business's operations. It usually rises in price when the company does well. The investor may receive a dividend payment [the investor's share of the company's profits] from the company in the form of cash, and may benefit even more if the stock price rises above the purchase price. A bond is a loan that investors make to a company so that it can have funds to expand the business by doing things such as buying new equipment and hiring more workers. A bondholder receives interest payments from the company.

Abby advises investors on the likely direction of stock prices and bond prices. Sometimes it is better to invest in stocks. Sometimes bonds are better investments. There are times when certain stocks are likely to increase in price more than others.

She also looks at other types of investments, especially for sophisticated clients such as large companies that invest on behalf of their clients. Some of

her clients are individuals who invest their own money. She also meets with government officials from many countries who are looking for analysis and advice on the US economy and financial markets.

Abby is one of the top-ranking women in Goldman Sachs, an organization of more than 20,000 employees. She consults with important investors throughout the world. She researches and forecasts financial trends and uses the work of her colleagues who are specialists in other fields, such as specific industries.

Abby is known and respected for her work throughout the United States, as well as in many other countries including China, Japan, Australia, the United Kingdom and Israel. Her opinions on the stock market carry more weight throughout the world than those of most other people.

Her Work Schedule

Abby loves doing intensive research and complicated mathematical models at work. She explains, "I spend an enormous amount of time trying to figure out where I might be wrong. I am always playing devil's advocate [pretending to be on the opposing side of an argument] with my own work. Only once I can convince myself, do I feel comfortable with my conclusions." She has shown throughout her career that she is more interested in getting the job done well rather than in getting attention. When she talks about her work, she says: "I continue to sweat the details because I always want to give clients the right analysis for the right reasons."

Abby begins her typical day at 5:00 am and continues her hectic schedule until 14 or 15 hours later. She travels to Asia and Australia three or four times per year and to Europe four or more times per year. She also travels to a variety of places in the United States.

In addition to her work in her office in downtown Manhattan, she is frequently asked to speak on television programs and at public meetings. She is in demand on several television networks such as PBS, CNN, and CNBC, among others. In her speeches, she advises listeners on ways to understand and benefit financially from carefully-developed investment strategies.

She handles herself well publicly. She has perfected her presentations so

that she can talk appropriately to a variety of different audiences. Her talks often include humor. She is able to speak with authority because she does a great deal of research on her topic and is an expert on the issues she is discussing.

When Abby has spare time, she enjoys teaching finance seminars at Harvard University, Dartmouth College, the Wharton School of Finance, Cornell University and other top graduate business schools. These are schools for students who have already graduated from college and have typically worked for several years before studying finance and other subjects. She has been very successful in the classroom and has enjoyed the teaching experience. Still, she is not ready to leave the work in the stock market that she enjoys so much. Once, when she was offered a full-time teaching position, she responded, "I'm having too much fun to even think about it."

Recognition for Her Work

Abby has been recognized for her outstanding work by being granted honorary Ph.D. degrees in engineering and in humane letters. *Institutional Investor* magazine ranked her number one in a survey they conducted of professional investors. The Harvard Business School has used her career as a model to teach their students about how to succeed in the business world. *Business Week* magazine wrote a cover story about her career. Her name was put into the Wall Street Week Hall of Fame in 1997. She was honored by many groups, including the Financial Women's Association and the New York Stock Exchange, where she was asked to ring the closing bell. Those working in the investment field respect and admire her very much.

Abby's success in her work has come from very careful analysis, together with hard work and determination. Her profession is filled with economists and some of them have what she does not have – a Ph.D. Nevertheless, she is known to work more thoroughly and dig more deeply into data than do most others in her industry. This gives her unusual insights and better knowledge than most others of economic and company information.

She also is in a unique position to gain important information at Goldman Sachs, which has one of the largest and best investment research staffs

in the field. She explains that much of her success comes from her ability to "be flexible in my analysis and to look beneath the usual rules of thumb to the underlying dynamics." She is driven by the satisfaction of her work and the enthusiasm for correctly analyzing and forecasting complex situations.

Her Mentors

Abby had no female role models in her chosen field since she was the first woman in it to reach such a level of excellence. However, her mother offered solid guidance and was a role model in other ways. She remembers: "My mother always spoke her mind and was almost always right in her judgments. She was never afraid to admit an error, but never held back in sharing her views. If she had thought through something and come up with a conclusion different from others, she was happy to stay with her decision. 'If it feels right, don't worry so much about the prevailing wisdom,' she would say. 'Maybe others know what is correct, maybe they don't.'" Abby adds, "Like her, I am willing to go against conventional wisdom. If I've done my homework and I believe that I'm right, I really don't care if people agree with me or not."

The media (television, radio, newspapers and magazines) have actively pursued Abby because she is known to be able to explain complicated concepts in clear English. She says her mother taught her this skill. She recalls:

"When I was studying physics in college, I came home during semester break and tried to explain to my mother what I was working on. My mother, who was an extremely intelligent woman, stopped me midway through the explanation and said, 'If you can't explain it to me in plain English, you don't understand it.' This was an enormous challenge, but I learned the great truth that if you cannot teach it to somebody else, you do not really understand it. If you have to hide behind jargon and technical language, you are probably missing the basics.'

Abby is also grateful for the influence of her sixth-grade public-school teacher, Mr. Frome, who played an important part in drawing Abby's attention to "a wide world out there." She explains: "He always went beyond the call of duty as our teacher. He believed we were capable of much more than what the standard curriculum prescribed. He took the curriculum and doubled

or tripled it for us. If he could not find satisfactory material from which to teach us, he would prepare his own. He really made us think and stretch ourselves."

She recalls other dedicated and inspiring teachers in her early years. When she was a student at her public high school, she "was awed and humbled by the phenomenal teachers there. My teachers were Ph.D.s in chemistry and physics supplementing their teaching salaries by writing textbooks for college-level courses. Many of them had gone to college following World War II, and some were educated on the GI Bill of Rights, which allowed veterans to attend college by offering financial aid. I think they were infused with a sense of giving back to the community by preparing the next generation."

Her Encounter with Discrimination

When Abby entered Cornell University in 1969, it was one of the few Ivy League colleges that admitted women. Still, women were in the minority there. Abby, as a physics major, was one of very few women in that field. Later, when she changed her major to economics and computer science, she was still one of the few women taking the courses.

As she pursued her studies in mathematical economics, she took classes in many different departments of the university. She wanted to study subjects offered in areas not usually welcoming to women. She recalls, "Being one of the few women in these classes was amusing more than anything else. The annoyances, if any, were mild. 'There's no ladies' room in this building,' I would observe. 'Hmmm, that's interesting.'" She enrolled in a graduate level computer science course. At the end of the first class, the professor advised her not to return because she was not an engineering student or in graduate school, and not a man. She remembers, "I was no computer geek, but I was just as good anyone else. I made it my business to finish that class."

Although the business world has gradually become more accepting of women in the workplace, there are still few women in top-level positions. Despite Abby's obvious success, she was not promoted to her position as partner at Goldman Sachs until a few years after many others expected this to happen. Still, the number of women in the field has gradually increased.

Abby notes, "There were some comical advantages [in the days when there were fewer women in the financial field]. At conferences, there wouldn't be a line at the ladies' room and the few women stood out from the sea of men dressed in the dark suits."

It was at T. Rowe Price that she personally witnessed and experienced ongoing and blatant discrimination. She recalls, "I was stunned by the sexism and racial and religious discrimination in the Baltimore community. I realized firsthand that the field on which we were playing was not level. Sometimes the discrimination was so ingrained that others were not even aware of it being a problem. On several occasions, when I arrived at meetings around town, people at the locations would look at me and say 'Sorry, you can't go in there. We invited only the analysts, not their secretaries.' When I would reply, 'I am not the secretary, I am the T. Rowe Price analyst who has been invited,' they would not know what to say or do."

Once, when she was hosting a meeting with the head of the President's Council of Economic Advisors (an important White House position), at a traditional luncheon club, she was shocked by the reception they were given. "We were put in substandard facilities – a tiny room, sweltering hot in August, without air conditioning," she recalls. "When I asked that we be moved to a more suitable room, the club's staff told me that we could not be moved because I was a member of the party and women were not allowed on other floors of the club until six in the evening."

In 1978, despite the sexism that she faced, because of her skills and success in her field, she was named the youngest vice president at T. Rowe Price. Nevertheless, new issues continued to come up. She recalls:

"One of the perks of becoming a vice president was health insurance for the entire family. However, I was initially denied coverage because I was told that men, not women, were the primary wage earners of their families, and only they were entitled to the benefit. When I persisted, I was asked to demonstrate that I was the primary wage earner. I resented the fact that my male colleagues did not have to do so. Still worse, no one in the organization recognized that there was anything inappropriate in what they were doing. My husband, who is a labor lawyer, gave me a copy of a court case that directly addressed this issue and clearly showed that the firm's policy was illegal.

When I showed the case to my direct supervisor, he immediately agreed to support my request and took up the argument on my behalf. Eventually, I got the family health insurance, as did the other women."

Her Heritage

"Judaism has always been something to be nourished and enjoyed," notes Abby, who was raised in a religiously observant family. She explains that Judaism helps to center her, making her feel secure and comfortable with her life.

Abby is a frequent speaker at Jewish functions. Although a capable public speaker with her reputation is often paid very well for public presentations, she does not accept payment for these speeches. She has spoken on behalf of many charitable and community groups. These include the Jewish federations from different cities, including San Francisco, Kansas City, and Chicago. She has also spoken for educational institutions such as Ben-Gurion University of the Negev and the Jewish Theological Seminary in New York. She has spoken every year for more than a decade at the 92nd Street YMHA in New York City

Those who know her have noted, "She is a tireless worker for Jewish causes," and she is very generous in her contributions to Jewish organizations. She has served as chairperson for the United Jewish Appeal-Federation of New York's annual Wall Street Dinner, an event that raises millions of dollars for Jewish causes. She and her family are active supporters of Hillel, an organization based on college campuses providing Jewish services (such as religious services, social events and kosher food) for Jewish students. This cause, which is dear to Abby, comes from her involvement with that organization when she was a student at Cornell.

Her Priorities

Abby is a private person, which is sometimes difficult because so many people know of her work. However, she shares some details with others, including her interests in science and photography. She admits that she enjoys

doing laundry for the family, saying: "I find it relaxing and there's a sense of accomplishment when it's done!" She enjoys long walks and music, ranging from country to opera.

Abby is quite clear about the place her family plays in her life. "My family is my most important client," she explains. "I always made a point to be at school plays or visiting days at camp. Those things go on my priority business calendar." She continues, "My extended family is very close. Perhaps this is because we lost so many during the Holocaust. We cherish one another. Nothing is so important that it should cause a rupture or division." She adds, "Life is all about maintaining balance, whether it is postponing a business trip to Tokyo to see my daughter's rescheduled play (which I once did) or dealing with larger unexpected crises."

In her work, she is quiet, self-assured and determined. Those who know her agree that she is brilliant, modest and soft-spoken. She is well respected for her work and her personality. Her colleagues over the years have been impressed with her sincerity. She tries hard to do a good job and to learn from experience, and she has a calm professional commitment toward her work.

She became a managing director at Goldman Sachs in 1996 and a partner in 1998. Those are very respected positions that many people in her field would be pleased to have gotten. She says that it "felt nice, but didn't change my life." Then she adds, "I take great pride in my work, but work is not my only metric of success." She notes:

"I believe that being part of a warm family gives me greater insight and helps me keep different perspectives in mind. My husband has been a source of strength. Reflecting on how supportive he has been, I advise my younger women colleagues, only half-jokingly, to choose their mothers-in-law carefully. My husband's mother was a working woman. She instilled in him an appreciation of the efforts of women and a respect for their professional careers. My two daughters have always helped me stay grounded in reality. In addition, I have a small number of very dear friends – some since high school and college days, others colleagues in the past – for whom I have a great deal of respect. Many of them are not in the industry – they are people with whom I share personal values."

Her Community Service

Even as Abby's professional responsibilities were expanding, she made a conscious effort to broaden her activities outside her work environment. She explains:

"Balance can best be maintained if you stay connected not just with work but also with your community. One of the regrettable aspects of the financial services industry, especially among young professionals, is that there is such an intense focus on one part of their lives that they really miss out on the others. My community and my synagogue, for example, did a wonderful job of providing support in trying times and reaching out to people."

Most of her community service activities focus on education. She served as chair of the board of the Institute of Chartered Financial Analysts, a group with 75,000 members worldwide. She had first agreed to get involved in that organization to serve as a role model for young professional women.

She serves as a Trustee of Cornell University and is a member of the Board of Overseers of the Weill Medical College of Cornell. She also serves on the board of the Jewish Theological Seminary of America, which is based in New York. This school trains rabbis and cantors, and also includes undergraduate and graduate programs in Jewish Studies.

Abby is a member of the investment committee of the Museum of Modern Art in New York and of two universities with investments totaling more than $5 billion.

Her Future from Her Point of View

Abby should have been promoted to the next level of responsibility at Goldman Sachs much earlier than she was. It took her longer to move up professionally than it did for her male colleagues. She thought about possible reasons why her promotion took more time than the men's promotions did.

"I had no mentor at Goldman Sachs or at other places I had worked. There was nobody looking out or blocking and tackling for me. Now, we work hard to provide mentors – especially to women and minorities – but there was not much awareness or concern at the time that this was missing. My career prog-

rcss has been a function of hard work and persistence. Had I had a mentor or had I been given appropriate resources along the way, who knows what I would have accomplished and at what pace?"

Abby has become a mentor for a younger generation of talented and hardworking women and members of minority groups. She is delighted to add, "Sometimes a woman will come up to me and say 'You don't know me, but you've always been my role model.'"

Although Abby had no role models early in her career, she is happy that "now we are finally at the point where there are some women in senior positions and there is a large enough population of women to move into the next level. We may have the critical mass and the right circumstances to make the profession much more woman-friendly."

Questions to Think About:

• *Do you have role models? Who are those people and why are they your role models?*

Make a list of the people in your life who are role models for you. Write down the reasons why you chose them as your role models.

• *Have you ever felt that you were a role model for others?*

You might be unaware of the important role you play for others who look to you for encouragement and direction. Pay attention to those around you so that you can give them appropriate encouragement.

To Learn More:

• Visit these websites:
http://www.smartmoney.com/pundits/index cfm?story=cohen/ and http://www.businessweek.com/1988/22/63580006.htm/

BIBLIOGRAPHY

Abramowitz, Leah. 2003. Tales of Nehama: Impressions of the Life and Teachings of Nehama Leibowitz. Jerusalem: Gefen Publishing House Ltd.

Amit, Yairah. 1999. Sefer shoftim: emunot ha-arikhah (The Book of Judges). Jerusalem: The Bialik Institute.

Ayer, Elinor H. 1994. Ruth Bader Ginsburg: Fire and Steel on the Supreme Court. New York: Dillon Press.

Bach, A., and J. Cheryl Exum. 1991. Miriam's Well: Stories about Women in the Bible. New York: Delacorte Press.

Baron, Dan. "Israel's national folk singer." Haaretz, online edition, http://haaretz.com, July 2, 2004.

Baum, Charlotte, Paula Hyman, and Sonya Michel. 1976. Great Jewish Women. New York, The Dial Press.

Bayer, Linda. 2000. Ruth Bader Ginsburg. Philadelphia: Chelsea House Publishers.

Ben-Nun, Sagui, and Gidi Avivi. "Naomi Shemer: First Lady of Israeli song." Haaretz, Sunday, June 27, 2004.

Benvenisti, Meron. "A member of a disappearing tribe." Haaretz, Friday, July 2, 2004.

Bianco, Anthony. "The prophet of Wall Street." Business Week (June 1, 1998): 124 – 130.

Blech, Rabbi Benjamin. 2004. Eyewitness to Jewish History. Hoboken, New Jersey: John Wiley and Sons, Inc.

Brooks, Andree Aelion. 2002. The Woman who Defied Kings: The Life and

Times of Doña Gracia Nasi, a Jewish Leader during the Renaissance. St. Paul, Minnesota: Paragon House.

Cashman, Greer Fay, and Ronit Sela. "Naomi Shemer laid to rest." The Jerusalem Post online, http://jpost.com, June 26, 2004.

Cohen, A. (ed.). 1970. The Five Megilloth. London: The Soncino Press.

Cohen, Elisheva. 1986. Anna Ticho. Jerusalem: National Council of Culture and Art, Ha-Kibbutz ha-Meuhad Publishing House, Keter Publishing House.

Cook, Mariana (photographs by). 1996. Mothers and Sons in Their Own Words. San Francisco: Chronicle Books.

Cultural and Scientific Relations Division/Ministry for Foreign Affairs. Ariel: A Review of Arts and Letters in Israel 58 (1984): Jerusalem Post Publications, Ltd.

Cushman, Clare (ed.). 2001. Supreme Court Decisions and Women's Rights. Forward by Associate Justice Ruth Bader Ginsburg. Washington, DC: Congressional Quarterly, Inc.

Davidson, Margaret. 1976. The Golda Meir Story. New York: Charles Scribner's Sons.

Diner, Hasia R., and Beryl L. Benderley. 2002. Her Works Praise Her. New York: Basic Books.

Dori, Shoshana (ed.). "Naomi." Kevutzat Kinneret Newsletter 672 (July 29, 2004).

Felder, Deborah G., and Diana Rosen. 2003. Fifty Jewish Women who Changed the World. New York: Citadel Press Books.

Fink, Greta. 1978. Great Jewish Women. New York: Menorah Publishing Company, Inc., and Bloch Publishing Company, Inc.

Green, David B. "Perfect pitch." The Jerusalem Report (July 26, 2004).

Haeems, Nina (ed.). 2000. Rebecca Reuben: Scholar, Educationist, Community Leader, 1889 – 1957. Bombay (Mumbai): Vacha Trust.

Haeems, Nina (ed.). 2002. Jewish, Indian and Women: Stories From The Bene Israel Community. Mumbai: Vacha Trust.

Henry, Sondra, and Emily Taitz. 1978. Written Out of History. New York: Block Publishing Company, Inc.

Hyman, Naomi M. 1997. Biblical Women in the Midrash: A Sourcebook, Northvale, New Jersey and London: Jason Aronson, Inc.

Lakshmi, C. S. "Selective amnesia." The Hindu, online edition, http://www.hinduonnet.com/, February 4, 2001.

Lowenthal, Marvin. 1977. The Memoirs of Gluckel of Hameln. New York: Schocken Books.

Martin, Ralph G. 1988. Golda Meir: The Romantic Years. New York: Charles Scribner's Sons.

McAuley, Karen. 1985. Golda Meir. New York: Chelsea House Publishers.

Morris, Terry. 1971. Shalom, Golda. New York: Hawthorn Books, Inc.

Musleah, Rahel. "Profile: Abby Joseph Cohen." Hadassah Magazine (February, 2005): 20 – 22.

Nanda, Ashish, and Kristin Lieb. "Abby Joseph Cohen: a career retrospective." Harvard Business School (June 9, 2003): 1 – 17.

Omer, Mordechai (ed.). 1986. Ha-kibbutz ha-Meuhad and Keter Publishing House Ltd. Jerusalem: Keter Press Enterprises.

Palti, Michal. "Oh, Where Is That Land?" Haaretz, Sunday, June 27, 2004.

Philipson, Rabbi David. 1929. Letters of Rebecca Gratz. Philadelphia: The Jewish Publication Society of America.

Ronson, Barbara L. Thaw. 1999. The Women of the Torah. Northvale, New Jersey and Jerusalem: Jason Aronson Inc.

Rosenblum, Doron. "All the light, all the time." Haaretz, Sunday, June 27, 2004.

Rosenblum, Doron. "Naomi Shemer: 1930 – 2004." Haaretz, Sunday, June 27, 2004.

Rousso, Nira. "Moments of chilling magic." Haaretz Magazine, July 2, 2004.

Russo, Yocheved Miriam. "The shared memory of a song." The Jerusalem Post, Tuesday, June 29, 2004.

Saline, Carol, and Sharon J. Wohlmuth. 1997. Mothers and Daughters, New York: Doubleday.

Salmon, Irit. "An artist in Jerusalem." The Israel Museum Journal 14 (summer 1996), Jerusalem 3000 issue offprint.

Salmon, Irit. 1994. Ticho House. Jerusalem: The Israel Museum.

Senesh, Hannah. 1972. Hannah Senesh: Her Life and Diary. Introduction by Abba Eban. New York: Schocken Books.

Idem. 2004. Hannah Senesh: Her Life & Diary. Woodstock, Vermont: Jewish Lights Publishing.

Scherman, Nosson, and Meir Zlotowitz (eds.). 1989. The Megillah: The Book of Esther. Brooklyn, NY: Mesorah Publications, Ltd.

Schur, Maxine. 1986. Hannah Szenes: A Song of Light. Philadelphia: The Jewish Publication Society.

Shemer, Naomi. 1995. Naomi Shemer: Book Four. Or Yehuda, Israel: Shva Publishers.

Shenker, Israel and Mary. 1970. As Good As Golda. New York: The McCall Publishing Company.

Shuman, Ellis. "Israel pays tribute to Naomi Shemer of gold." Haaretz online, June 27, 2004.

Slater, Elinor, and Robert Slater. 1994 Great Jewish Women. Middle Village, New York: Jonathan David Publishers, Inc.

Stadler, Bea. 1967. The Adventures of Gluckel of Hameln. New York, United Synagogue Commission on Jewish Education. New York.

Syrkin, Marie, ed. 1973. Golda Meir Speaks Out. London: Weidenfeld and Nicolson.

Ticho, Anna. Jerusalem: I. M. Cohen Graphic Gallery. The Israel Museum, Spring 1973, Cat. No. 107.

Idem. 1983. Drawings. 1971 – 1980. New York: The Jewish Museum.

Idem. 1971 Jerusalem Landscapes. London: Lund Humphries Publisher, Ltd.

Idem. 1976. Sketches 1918 – 1975. Jerusalem: The Israel Museum.

Tiger, Lionel, and Joseph Shepher. 1975. Women in the Kibbutz. New York: Harcourt and Brace Jovanovich.

Umansky, Ellen M., and Dianne Ashton (eds.). 1992. Four Centuries of Jewish Women's Spirituality: A Sourcebook. Boston: Beacon Press.

Vrato, Elizabeth. 2002. Counselors: Conversations with Eighteen Courageous Women Who Changed the World. Philadelphia, PA: Running Press.

Wolf, Edwin II, and Maxwell Whiteman. The History of the Jews of Philadelphia. Philadelphia: The Jewish Publication Society.

ABOUT THE AUTHORS

Miriam Klein Shapiro, a"h

Born in Springfield, Massachusetts, and raised in Buffalo, New York, Miriam lived in White plains, New York, for the greater part of her life. She was the daughter of Rabbi Isaac Klein, a leading Conservative Rabbi and expert in Jewish law, and his wife, Henriette, a lay leader and educator in the movement.

Dr. Shapiro received bachelor's degrees from Barnard College and from the Jewish Theological Seminary of America in New York, and a master's degree in social work from Columbia University. She also earned a master's degree and a doctorate in Bible studies from the Jewish Theological Seminary.

A master educator, scholar and woman of many accomplishments, Dr. Shapiro was a faculty member at a number of institutions, including the State University of New York and the Academy for Jewish Religion.

In her professional life, she served in many key roles in the world of Jewish education: Hebrew school teacher, day school principal, Board of Jewish Education curriculum specialist and Director of Education at Camp Ramah in the Berkshires. For more than twenty years, Dr. Shapiro worked as a teacher and an educational consultant for the Board of Jewish Education of Greater New York, creating and serving as director of the Board's Jewish Family Education program and its Teacher's Center in Westchester, New York, and educational specialist for the Westchester Association of Hebrew Schools.

Dr. Shapiro was the first chairwoman of the United Synagogue of Conservative Judaism's Education Commission, the second president of the

176 HEAR HER VOICE!

Union for Traditional Judaism, the first woman president of the Conservative Movement's Jewish Educators Assembly and was the president of the National Board of License for teachers and principals in Jewish schools in North America. She also served on numerous boards, including those of the Westchester Hebrew High School and Solomon Schechter Day School of Westchester, and served on the United Synagogue Standards Committee. She also received numerous honors and awards throughout her lifetime. Dr. Shapiro was one of the authors of Emet V'Emunah, the statement of Principals of Conservative Judaism and published numerous scholarly articles.

Although Dr. Shapiro lived in the United States her entire life, her deep love of Israel was expressed in her frequent trips there, where she and her husband enjoyed living in their second home in Jerusalem.

She and her husband Saul, himself a Jewish lay leader of many organizations, were married for forty-seven years, and her children and grandchildren include: Ephraim Shapiro of New York City; Sara and Jonathan, Avishai, Benjy, Yehudit and Elisheva Shuter of New Rochelle, New York; Rachel and Barry, Yakira, Margo, and Dalia Kirzner of Cherry Hill, New Jersey; Sim and Susan, Avigayil and Issac Shapiro of White Plains, New York; and Rivke Shapiro of New York City.

Miriam Polokoff Feinberg

Miriam Feinberg was born in Poughkeepsie, New York, and has lived most of her life in the Greater Washington, DC area. She received a bachelor's degree in early childhood education from Hunter College, a master's degree in Jewish studies from Baltimore Hebrew College, and a doctorate of philosophy degree in early childhood education from the University of Maryland.

Dr. Feinberg spent many years teaching children of all ages, as well as parents and teachers. She served as Director of the Early Childhood Department of the Board of Jewish Education of Greater Washington, DC, 1978 through 2001. She also taught in the Graduate School of Education of the Baltimore Hebrew University in Baltimore, Maryland, for several years.

Dr. Feinberg currently works for the Partnership for Jewish Life and Learning of the Greater Washington, DC, as Early Childhood Educational Consultant,

serving as a nursery school and kindergarten accreditation specialist. An instructor in the Early Childhood Jewish Teacher Training Institute of the Partnership for Jewish Life and Learning, she also provides in-service training for early childhood teachers in Jewish schools in the Washington, DC area.

In addition to being a specialist in Jewish education, Dr. Feinberg has enjoyed many years of instructing teachers of nursery and elementary-school-aged children in far-flung locations such as Israel, India, Thailand and Vietnam.

Dr. Feinberg has published four curriculum books for teachers and three storybooks for children, in addition to numerous articles on teacher and parent education. She currently produces a Jewish holiday and family education newsletter series for families with young children, with thousands of subscribers throughout the United States.

She and her husband of more than 45 years, Mordecai Feinberg, often visit with their children and grandchildren: Jonathan, Leslie, Matan, Vered and Itai Feinberg of Bet Shemesh, Israel; Deborah, David, Briana and Samuel Felsen of Gaithersburg, Maryland; and Joshua Feinberg of New York City.